Computer Graphics

ROCKPORT ALLWORTH EDITIONS

ROCKPORT PUBLISHERS, INC. / ALLWORTH PRESS

DISTRIBUTED BY NORTH LIGHT BOOKS

CINCINNATI, OHIO

THE BEST OF COMPUTER ART AND DESIGN

First published in the United States of America
by Rockport Allworth Editions, a trade name of
Rockport Publishers, Inc.
and Allworth Press.
Rockport Publishers, Inc.
P.O. Box 396
Five Smith Street
Rockport, Massachusetts 01966
Telephone: (508) 546-9590
Fax: (508) 546-7141
Telex: 5106019284 ROCKORT PUB

Distributed to the book trade and art trade in
the U.S. and Canada by
North Light, an imprint of
F & W Publications
1507 Dana Avenue
Cincinnati, Ohio 45207
Telephone: (513) 531-2222

Other Distribution by
Rockport Publishers, Inc.
Rockport, Massachusetts 01966

Art Director Stephen Bridges

Design and Production Eilis Mc Donnell

Production Management Barbara States

Typesetting Imagesetter Inc.

ISBN 1-56496-015-3

10 9 8 7 6 5 4 3 2 1

Printed in Hong Kong

THE COPUBLISHERS WOULD LIKE TO EXPRESS THEIR THANKS TO THE FOLLOWING ORGANIZATIONS THAT ASSISTED

IN THE COLLECTION OF MATERIALS FOR THIS BOOK: ADEPT (ASSOCIATION FOR THE DEVELOPMENT OF ELECTRONIC

PUBLISHING TECHNIQUE), ADOBE, ALDUS, THE CENTER FOR CREATIVE IMAGING, CLARIS ELECTRONIC ARTS, THE

GRAPHIC ARTISTS GUILD, IDEA (INTERNATIONAL DESIGN BY ELECTRONICS

ASSOCIATION), AND MICROGRAFX.

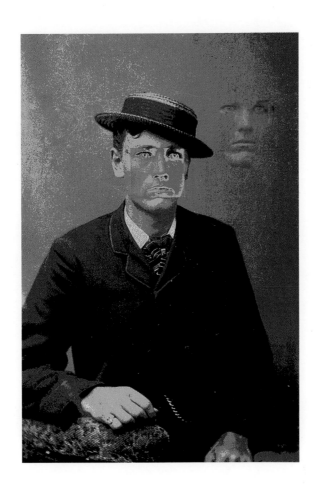

ILLUSTRATION MARK YANKUS
SOFTWARE PHOTOSHOP
HARDWARE MAC IICX, SUPERMAC 19" MONITOR

CONTENTS

INTRODUCTION

THE ADVENTURE CONTINUES . . .

IN LESS THAN A DECADE, PERSONAL COMPUTERS HAVE BEEN TRANSFORMED FROM GLORIFIED TYPEWRITERS INTO FULL-BLOWN CREATIVE WORKSTATIONS. THE PACE OF TECHNOLOGY HAS BEEN FAST AND FURIOUS. WHEN YOU STOP TO REALIZE THAT MOST DRAWING AND DESIGN SOFTWARE PRODUCTS ARE LITTLE MORE THAN SEVEN YEARS OLD, YOU GET A REAL SENSE OF HOW THE WHOLE INDUSTRY HAS BEEN CONVERTED. AND WHO COULD HAVE PREDICTED HOW SWIFTLY THESE CHANGES WOULD EFFECT DESIGNERS AND ILLUSTRATORS? ★ IT'S NOW HARD TO BELIEVE THAT MANY ARTISTS RESISTED COMPUTERS. PAST CONCERNS ABOUT EVERYTHING FROM FONT AVAILABILITY TO QUALITY OF THE FINISHED PRODUCT ARE NOW DISMISSED BY THE MOST CRITICAL PROFESSIONAL. ONLY FOUR YEARS AGO, ONE QUESTIONED PURCHASING A COLOR MONITOR OVER BLACK AND WHITE, BECAUSE THERE WAS LITTLE SOFTWARE TO SUP-PORT IT. NOW, DESKTOP COLOR AND SEPARATIONS ARE BECOM-ING REALITY. ★ CHANGE COMES RAPIDLY BECAUSE COMPUT-ERS AND DESIGN SOFTWARE ARE IN A CONSTANT STATE OF EVOLUTION. WE USERS TEND TO TAKE THE CHANGES AND UPDATES FOR GRANTED. AS DEVELOPERS RESOLVE ONE SET OF ISSUES, WE ANXIOUSLY WAIT FOR THEM TO GET ONTO THE NEXT, AND THE NEXT. THIS BOOK IS A TESTAMENT TO THE CREATIVE VERSATILITY THAT DESKTOP COMPUTERS HAVE WHEN PUT INTO THE HANDS OF COMPETENT ARTISTS. ★ FEARS THAT COMPUT-ERS WOULD REPLACE ARTISTS HAVE NOT COME TO PASS. WHAT THEY HAVE REPLACED ARE SOME OF THE MORE MUNDANE TASKS THAT FEW OF US ENJOYED DOING. SOFTWARE NOW GIVES US UNLIMITED ARTISTIC CHOICES. WELCOME ADDITIONS TO THE TOOLBOX INCLUDE TYPE MANIPULATION AND IMAGE ENHANCE-MENT. BUT THE FACT THAT SOFTWARE OFFERS SUCH FEATURES DOESN'T MEAN AN ARTIST MUST USE THEM. A LACK OF GOOD DESIGN SKILLS IS ALL TOO EVIDENT WHEN THE SOFTWARE'S BELLS AND WHISTLES ARE TAKEN TO EXTREMES. ★ ALL THESE NEW INNOVATIONS HAVE NOT MADE CREATIVITY ANY EASIER THAN TRADITIONAL METHODS. ARTISTS CAN GET CAUGHT UP IN THE DAY-TO-DAY PROBLEMS THAT COME FROM WORKING WITH

COMPUTER—FONT INCOMPATIBILITIES, STEEP LEARNING CURVES, AND EXPENSIVE HARDWARE AND SOFTWARE UPGRADES. BUT FOR THE WELL-EQUIPPED STUDIO. THE EFFORT CAN BE BENEFICIAL BOTH FINANCIALLY AND CREATIVELY. DESKTOP COMPUTERS PUT MORE DECISIONS INTO THE HANDS OF THE ARTIST. IN THE PAST, MANY OF THESE CALLS WERE LEFT TO CRAFTSMEN-RETOUCHERS, TYPESETTERS, AND SEPARATORS. TODAY, COMPUTERS HAVE REPLACED TYPESETTING MACHINES, WITH SOME STUDIOS WILLING TO INCORPORATE RETOUCHING AND SEPARATIONS INTO THEIR WORK. ★ FOR THE ARTIST, CONCERN OVER THE COMPUTER'S COMPLEXITIES ARE QUICKLY ERADICATED WHEN A DESIGN OR AN ILLUSTRATION COMES TOGETHER WITH QUICK CLICKS AND KEYSTROKES. THE CONTROL, LET ALONE THE EXCITEMENT, FAR OUTWEIGHS THE NEGATIVES. THE INSTANT DESIGN GRATIFICATION ACHIEVED ON A COMPUTER IS THE MAIN REASON THAT EVEN THE MOST RESISTANT INDIVIDU-ALS OVERCOME THEIR ELECTRONIC PHOBIA. PEOPLE TEND TO MAKE GRAND PRONOUNCEMENTS WHERE COMPUTERS ARE CON-CERNED. PREDICTIONS PROMISE EVERYTHING FROM A PAPERLESS OFFICE TO A COMPUTER IN EVERY STUDIO. NO MATTER WHAT THE FUTURE HOLDS, IT'S IMPORTANT FOR ARTISTS TO BE READY TO GO WHEREVER THE NEXT WAVE OF ELECTRONIC PROCESSING TAKES US. OUR TOOLS MAY BE DIFFERENT BUT OUR JOB REMAINS THE SAME. WHETHER ON SCREEN OR PRINTED ON A PAGE, THE END RESULT MUST STILL PRODUCE A SHARP, ATTRAC-TIVE IMAGE THAT COMMUNICATES ITS MESSAGE WITH STYLE AND FLAIR.

Michael Meyerowitz

-MM

MICHAEL MEYEROWITZ HAS BEEN INVOLVED IN DESKTOP DESIGN SINCE 1985. HE PUBLISHED ONE OF THE FIRST NATIONAL DESKTOP PUBLICATIONS, "GRAPHICSTUDIO NEWS" AND HAS DESIGNED AND PREPARED PUBLICATIONS FOR TIME, INC., AND LETRASET USA, AMONG OTHER ORGANIZATIONS. HE IS THE CO-AUTHOR OF THE GRAPHIC DESIGNER'S GUIDE TO THE MACINTOSH, PUBLISHED BY ALLWORTH PRESS, NY, AND IS CURRENTLY ON THE FACULTY OF THE SCHOOL OF VISUAL ARTS.

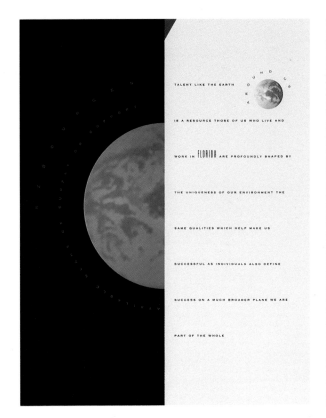

TALENT. LIKE THE EARTH AROUND US IS A RESOURCE THOSE OF US WHO LIVE AND WORK IN FLORIDA ARE PROFOUNDLY SHAPED BY THE UNIQUENESS OF OUR ENVIRONMENT THE SAME QUALITIES WHICH HELP MAKE US SUCCESSFUL AS INDIVIDUALS ALSO DEFINE SUCCESS ON A MUCH BROADER PLANE WE ARE PART OF THE WHOLE

AFFINITY THE QUALITY OR STATE OF ATTRACTION MARKED BY COMMUNITY OF INTEREST AT A CHEMICAL LEVEL AFFINITY BONDS TWO HYDROGEN MOLECULES WITH ONE OXYGEN MOLECULE TO CREATE WATER AT A HUMAN LEVEL AFFINITY CAN BE EXPRESSED IN PERSONAL TERMS OR IN TERMS OF MUTUAL BUSINESS INTERESTS FLORIDA HAS A THIRD MORE NEW MARRIAGES EACH YEAR THAN THE REST OF THE COUNTRY AND NEARLY TWICE AS MANY DIVORCES BY THE SAME TOKEN OVERSEAS TRADE PARTICULARLY WITH SOUTH AMERICA IS ONE OF OUR FASTER GROWING INDUSTRIES

CREATIVITY

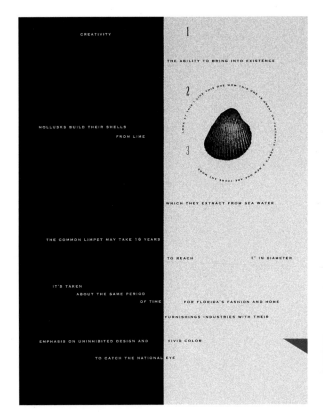

1
THE ABILITY TO BRING INTO EXISTENCE
2
3

MOLLUSKS BUILD THEIR SHELLS
FROM LIME

WHICH THEY EXTRACT FROM SEA WATER

THE COMMON LIMPET MAY TAKE 16 YEARS
TO REACH 1" IN DIAMETER

IT'S TAKEN
 ABOUT THE SAME PERIOD
 OF TIME FOR FLORIDA'S FASHION AND HOME
 FURNISHINGS INDUSTRIES WITH THEIR
EMPHASIS ON UNINHIBITED DESIGN AND VIVID COLOR
 TO CATCH THE NATIONAL EYE

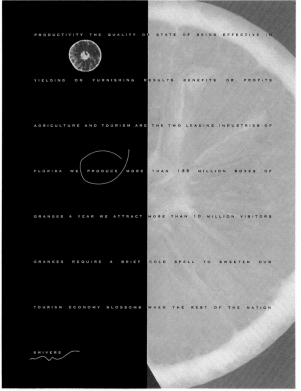

PRODUCTIVITY THE QUALITY OR STATE OF BEING EFFECTIVE IN YIELDING OR FURNISHING RESULTS BENEFITS OR PROFITS AGRICULTURE AND TOURISM ARE THE TWO LEADING INDUSTRIES OF FLORIDA WE PRODUCE MORE THAN 135 MILLION BOXES OF ORANGES A YEAR WE ATTRACT MORE THAN 10 MILLION VISITORS ORANGES REQUIRE A BRIEF COLD SPELL TO SWEETEN OUR TOURISM ECONOMY BLOSSOMS WHEN THE REST OF THE NATION

SHIVERS

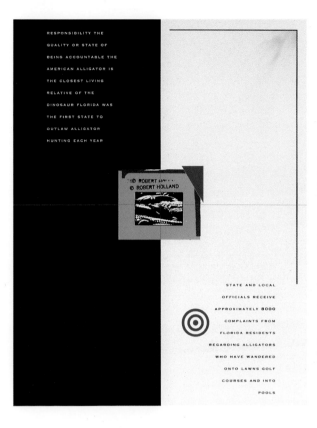

FLORIDA CREATIVE DIRECTORY DIVIDER TABS
DESIGN FIRM URBAN TAYLOR + ASSOCIATES
DESIGNER ALAN URBAN
SOFTWARE FREEHAND, PHOTOSHOP
HARDWARE MAC IICX, QUANTUM 80MB HD, MICROTEK **300Z SCANNER**

GRAPHIC DESIGN

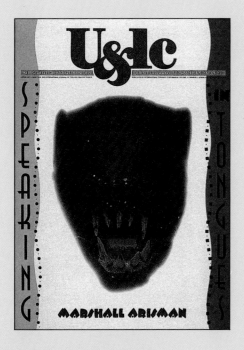

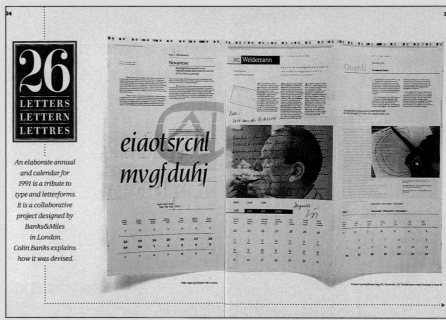

U&lc Cover and Inside Pages

Designer Randall Smith
Design Firm WYD, Inc.
Software PageMaker 4.0, Photoshop 1.0
Hardware Mac IIci

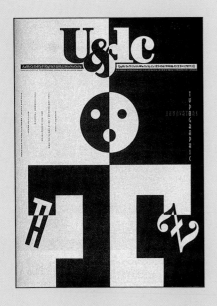

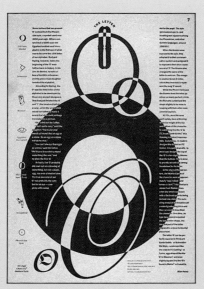

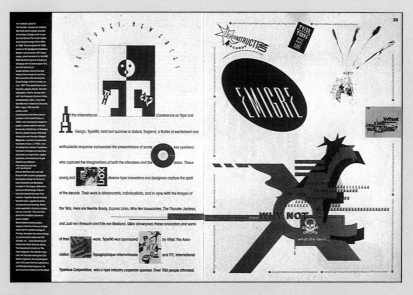

U&lc Cover anl Inside Pages

Designer Woody Pirtle
Design Firm Pentagram Design Inc.
Software Illustrator
Hardware Mac

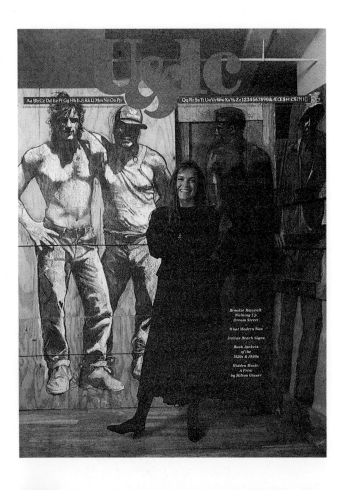

U&lc Cover and Inside Pages

Designer Walter Bernard
Design Firm WBMG, Inc.
Software Quark
Hardware Mac IIfx

Nothing affected 20th century design more deeply than the concept of modernism, but nothing lasts forever. Now that "modern" has taken its place in the historical parade, as identifiable as the baroque or the neo-classical, it has become a style ripe for reassessment. ⊕ So it's a pleasure to find that the current exhibition, "Design 1935–1965: What Modern Was," is much more than an anthology of 30 years of international design. The selection and arrangement of material reveals a sophisticated re-examination of the welter of overlapping, often conflicting ideas which fueled the modernist movement and shaped its artistic manifestations from art and architecture to industrial design, graphics, and furniture. "What Modern Was" now appears at Kansas City's Nelson-Atkins Museum of Art through January; it will then be at the Baltimore Museum of Art from July–August, 1992. (The show made its debut last year at the IBM Gallery of Science and Art, New York City.) ⊕ The exhibition's 250 pieces were taken from the collection of Musée des Arts Décoratifs in Montreal. The show's construction and dominating argument was organized by design historian and curator David Hanks and his associates, who were also instrumental in building the museum's international design collection. ⊕ When the Musée des Arts Décoratifs opened in 1979 as Canada's first exclusively decorative arts museum, historical and critical consideration of 20th century design was just beginning a new phase of dynamic rediscovery. To be sure, certified icons of the international style, like Mies van der Rohe's Barcelona chair, were solidly enshrined in the collection of The Museum of Modern Art.

In fact, starting with its "Good Design" shows in the late 1940s, MoMA had seized a dominant and rarely contested role as chief institutional arbiter of 20th century design, a position it still assumes. But most North American museums had assigned to 20th century design and decorative arts a low priority—what a difference a decade makes! While museums are still catching up, everyone else knows modern design is hot: herds of collectors now covet not only the familiar Eames chairs, but they also know enough to hunt down considerably more rarified stuff like Eva Zeisel's "Museum" dinnerware of 1942–1943. ⊕ "What Modern Was" dishes up a delicious feast for the current crop of design buffs who revel in contemporary stylistic revivalism and haunt international flea markets. But because the finest material from the '40s and '50s is now widely recognized and identified, ardent aficionados may not discover many surprises. ⊕ What they will find is an intellectually invigorating challenge to the narrowness of MoMA's traditional position on modern design hierarchies. This show defines a more expansive and exuberant overview of international design history in the thirty years between 1935 and 1965; one which describes a continuity between pre- and post-war design ideas which didn't abate until the late '50s. In his catalog essay, British historian Paul Johnson stresses the pervasive influence of the era's changing socio-economic, political and technological realities and the rise of the superstate on the democratization of design and its frequently utopian goals. (This essential catalog was edited by Martin Eidelberg and published by Harry Abrams.) ⊕ Hanks and his

"WHY CAN'T SOMEONE, A MUSEUM OF MODERN ART OR A WORLD'S FAIR, PUT ON AN EXHIBITION THAT WOULD DRAMATIZE ALL DESIGN THAT IS AMERICAN?"

⊕ Russell Wright 1938

"WE STARTED OUT AS REVOLUTION-ARIES, WANTING ONLY TO MAKE BRAVE NEW DESIGNS FOR A CONTEMPORARY SOCIETY."

⊕ Jack Lenor Larsen

ISAMU NOGUCHI'S 1947 BIOMORPHIC CHESS TABLE WAS BRIEFLY PRODUCED BY HERMAN MILLER. THE TABLE DERIVES DIRECTLY FROM HIS SCULPTURE AND FROM OTHER SCULPTURAL FORMS LIKE HANS ARP'S 1939 "HUMAN CONCRETION."

"BUT THEN WHY DID IT HAVE TO BE FINE ART? WHY NOT OBJECTS OF USE AND POPULARITY?"

⊕ Isamu Noguchi 1968

THE GREAT AMERICAN DESIGNERS CHARLES AND RAY EAMES CREATED THIS FLEXIBLE AND INEXPENSIVE MODULAR STORAGE SYSTEM (1949), INCORPORATING INDUSTRIAL COMPONENTS AS WELL AS PRIMARY COLORS AND GEOMETRIC SHAPES. IT HAS AFFINITIES TO ABSTRACT PAINTER PIET MONDRIAN'S "COMPOSITION" (1921) AS WELL AS TO JAPANESE CONCEPTS OF SIMPLICITY.

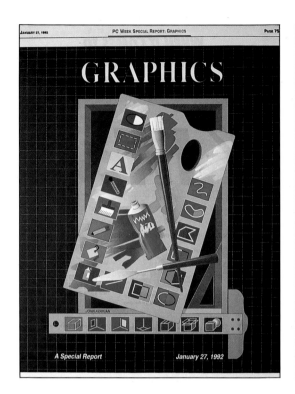

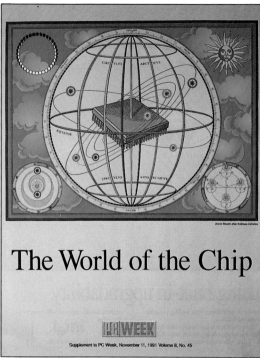

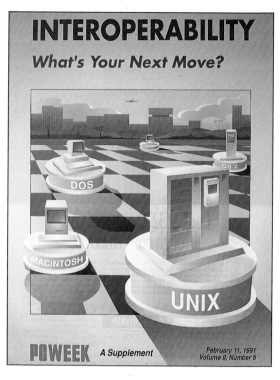

PC Week Magazine Special Report Cover

Art Director **Thea Shapiro**
Designer/Illustrator **John Avakian**
Software **Freehand 2.0**
Hardware **Mac IICI**

PC Week Magazine Special Report Cover

Art Director **Thea Shapiro**
Designer/Illustrator **Annie Bissett**
Software **Freehand 2.0**
Hardware **Mac II**

PC Week Magazine Special Report

Art Director **Thea Shapiro**
Designer/Illustrator **John Avakian**
Software **Freehand 2.0**
Hardware **Mac IICI**

PC Week Magazine

Art Director **Thea Shapiro**
Designer/Illustrator **Annie Bissett**
Software **Freehand 1.0**
Hardware **Mac II**

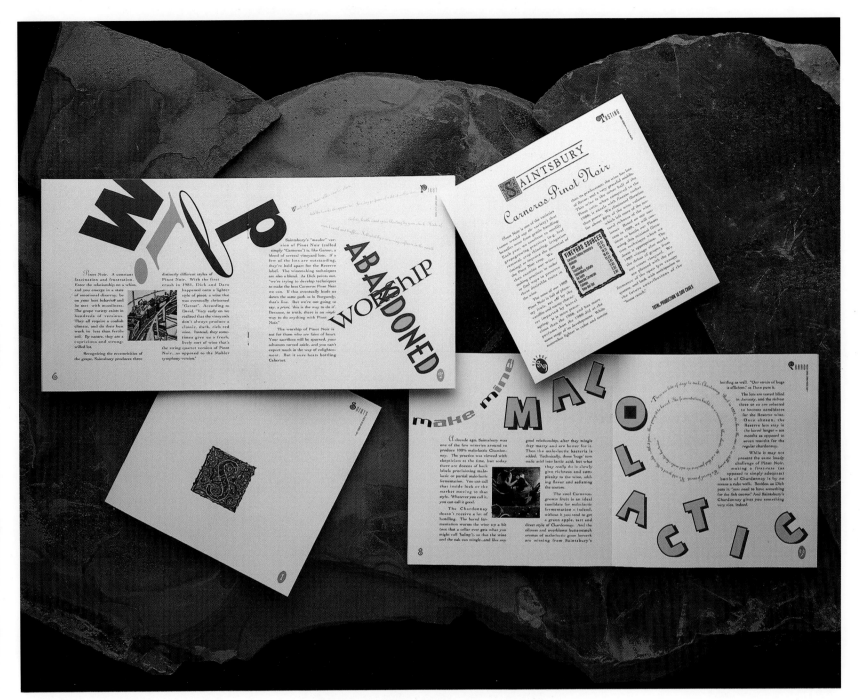

SAINTSBURY BROCHURE

DESIGNERS JIM WALCOTT-AYERS, LIZ POLLINA
DESIGN FIRM THE WALCOTT-AYERS GROUP
SOFTWARE QUARK, ILLUSTRATOR, PHOTOSHOP
HARDWARE MAC IICI, RADIUS 19" MONITOR

EMIGRE MAGAZINE INSIDE SPREAD

DESIGNER/PHOTOGRAPHER RUDY VANDERLANS
TYPEFACE DESIGNER ZUZANA LICKO
DESIGN FIRM EMIGRE
SOFTWARE READYSETGO!

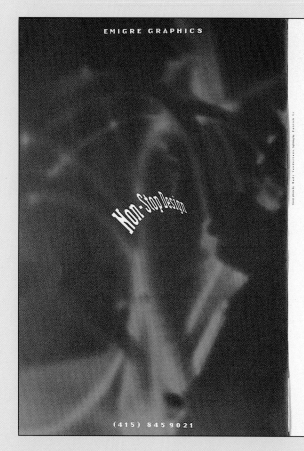

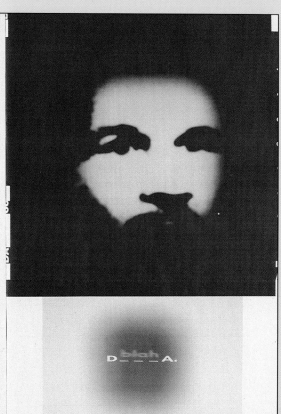

Johnny D.: *Hey, what's going on?* Emigre: I just want to hear your reaction to this page we received from Thirst. Rick Valicenti just... Johnny: *Who?* Emigre: Eh...Rick Valicenti, he designed this page and he used Mike Ditka as a symbol for Chicago. Johnny: *Oh, yeah I saw that.* Emigre: Now, Ditka is not exactly the most popular guy around at this point. Three losses in a row! How do you feel about Ditka as a symbol for Chicago? Johnny: *It's a bit weird especially when I see Ditka talk on Monday Night Football, sorta going Blah, Blah, Blah... But personally I think it's a great tribute to the guy. Because eh...sports is my life, you know; graphic design, I like it, I know a bit about it, but sports is my life, and I love the coach. You know, he's a real strong personality. Unfortunately things aren't going so well at present. So he loses three games. So what?* He'll be back. He's pissed right now, because you know, he's never lost three games in a row. But the guy never gives up, never says no, he never quits. Chicago likes that and coach Ditka stands for what this city is all about. We're a real blue collar town. It's a tough place. Not like San Francisco, those wimps. They have an earthquake and they cancel the World Series, the fucking WORLD SERIES! Come on! Sports is my life, I couldn't deal with that. Emigre: So you think Ditka's sorry he traded McMahon right now? Johnny: Well, I know Mike Ditka, (I mean not personally, of course, we wouldn't get along). But eh...maybe in the back of his mind he might regret it a little bit. I don't know. Ditka's unpredictable. That's what we like about the guy. And anyhow, in San Diego they're gonna bench McMahon this Sunday. So what's there to be sorry about?! Emigre: What do you think Valicenti means with that type on the bottom? Johnny: Yeah, I'm a little bit pissed off about that, cause he's not clear about it. Is he making fun of the coach there with those letters at the bottom, "DA, blah?" I don't know... Emigre: Well, what do you think he means by that? Johnny: *How the hell would I know?!* Well maybe it's about how the coach is

CHICAGO / Rick Valicenti [Thirst] *always on television going like blah, blah, blah. He's always mouth'n off a lot. But eh...he's a motivator, he brings out the best in people. Sometimes he's aggressive, sometimes he's happy, sometimes he's selling cars, sometimes Dristan or house mortgages. Anything! But I think Valicenti's interpretation is eh... you know, what is the coach really saying? And it looks like you got a four letter word there or something.* Emigre: So you like the idea of replacing the Sears Tower with Ditka's face? Johnny: Yeah, to hell with the Sears Tower. Ditka has a very strong presence in town. You see him everywhere, in the papers, on the news, all the time, the guy's everywhere. Emigre: What do you think of that shot Valicenti used? Taken off a television screen, that's not the most flattering picture is it? At least he could have used some sort of promotional 8 by 10 glossy? Johnny: Nah. Well, you know, on the one hand I say great, Ditka's face as a symbol. *Chicago's big brother*, in the city of big shoulders; that's great. But he's not making fun of the guy, or is he? But I guess coach Ditka does the same thing. That's the best part of it. *He's talking to the press everyday*, the cameras are on him all the time, he'll stick a piece of gum on the camera, he'll do this or that, he's always poking fun, and he's *always* on TV. Emigre: So you consider this to be an appropriate design? Johnny: *What? You're asking for my approval? Is that it?* Emigre: Well, is it thumbs up for this one? Johnny: Yeah, sure, come on, the coach gets a full page in some graphic design magazine, *I think that's great!* Although I don't know what the hell's going on in there. What the hell's that all about? You got strange photos and textures here and there. I don't know what route you guys travel on your way to work, and shit, that rag costs quite a fortune, I mean jeezus! Emigre: Well the moment we can produce it for fifty cents a copy we'll sell them for two bucks a piece. Johnny: Nah, don't worry, I like that entrepreneurial attitude, take whatever you can get. Anyway, I gotta check out. Talk to you later, and eh... don't forget about the friggin' World Series on Friday night, OK? LaDeDa.

EMIGRE MAGAZINE INSIDE SPREAD

DESIGNER RUDY VANDERLANS (LEFT PAGE), RICK VALICENTI (RIGHT PAGE)
TYPEFACE DESIGNER ZUZANA LICKO
DESIGN FIRM EMIGRE
SOFTWARE READYSETGO!

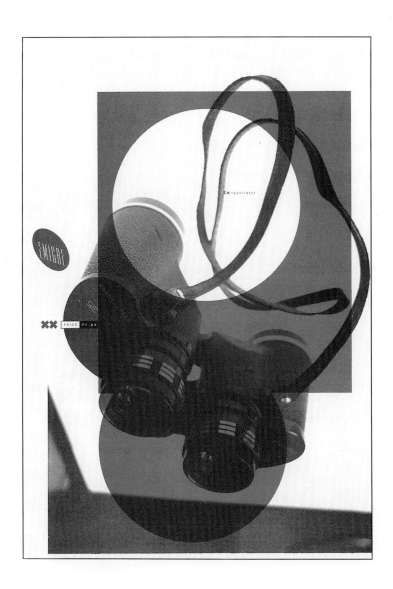

EMIGRE MAGAZINE COVER

DESIGNER/PHOTOGRAPHER **RUDY VANDERLANS**
DESIGN FIRM **EMIGRE**
SOFTWARE **READYSETGO!**

EMIGRE MAGAZINE COVER

DESIGNER/PHOTOGRAPHER **RUDY VANDERLANS**
TYPEFACE DESIGN **BARRY DECK**
DESIGN FIRM **EMIGRE**
SOFTWARE **READYSETGO!**

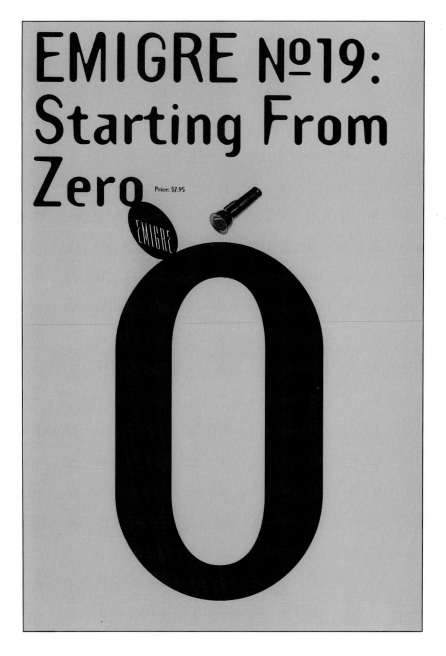

GRAPHIC DESIGN

URBAN TAYLOR + ASSOCIATES SELF-PROMO NEWSLETTER

DESIGNER ALAN URBAN

DESIGN FIRM URBAN TAYLOR + ASSOCIATES

SOFTWARE PAGEMAKER 4.01, FREEHAND 3.0, WORD 4.0

HARDWARE MAC IICX (80MB) QUANTUM HD, 20MB SUPERMAC

COLOR MONITOR

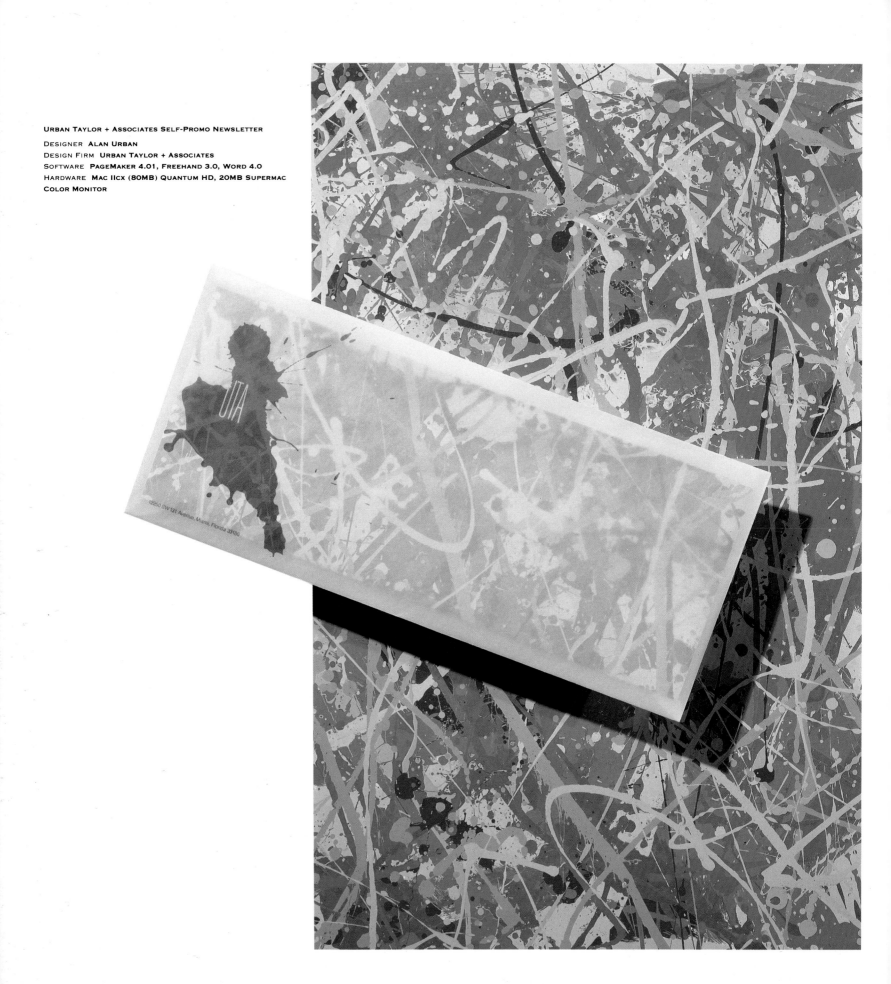

Awards and Honors ••• **Pageproof wins yet another award** Pageproof recently won a HOW Magazine Self Promotion Award. This is Pageproof's second national design award. ••• **UTA wins 2 ADOY Awards** Projects cited for awards this year were; the Royal Viking Line *Barbados Brochure* and the Kloster Cruise Line *Now Hear This* newsletter, both created by Tere Benach & Associates ••• **Party poster selected for inclusion in international exhibition** UTA's 1985 Party Poster has been selected for inclusion in 'Design Excellence, 50 Posters of the 80's'. The touring exhibition is comprised of just fifty posters, selected from national and international competitions during the 1980's, and includes the work of such design luminaries as; Milton Glaser, McRay Magleby, Ivan Chermayeff, Paul Rand, Seymour Chwast and others. ••• **Two national design magazines honor UTA** Graphic Design: USA awarded UTA with 3 DESI 12+1 Awards for the Royal Viking Line *Explorer Series* and *Barbados Brochures* created for Tere Benach & Associates, and the *UTA Fish Poster*. (Copies of the award-winning Fish Poster are available upon request). Print's Regional Design Annual, the annual comprehensive profile of design in the U.S., will include the Sentek de Mexico, S.A. de C.V. box/brochure package created for Grayson Business Communications and the Haff-Daugherty Graphics "There's Gold..." ad insert. The Print award for the H&D ad is UTA Junior Designer Suzanne Joseph's first national design award. ••• **UTA wins in AIGA/** South Florida's "Design Marches On" 2 year retrospective of graphic design Urban Taylor & Associates placed well with 9 entries displayed in the 84 piece juried show at the Main Library in the Metro-Dade Cultural Center, Miami, this summer. Winning projects include: annual reports for Hughes Supply, Inc. and Video Jukebox Network, Inc.; the Royal Viking Line *Explorer Series Brochure* and Norwegian Cruise Line *Kid's cruise* created for Tere Benach & Associates; *Everglades, The Park Story* book; The Sentek de Mexico box/brochure package for Grayson Business Communications; two posters, one for Haff-Daugherty Graphics — the *Han Dynasty Horse* and the *UTA Fish*; and the invitation for the "AIGA Designers and Computers" event.

New Staff ••• **Terry Stone joins UTA** Urban Taylor & Associates is pleased to announce the appointment of Terry Stone (pictured) as Senior Vice President. Terry comes to UTA from Atlanta where she was Director of Client Services and Marketing for Cohen & Company, an Atlanta design firm specializing in corporate communication. With over ten years of experience in the design field, Terry has worked on the accounts of American Express, Bell South Corporation, Cox Enterprises, GTE, IBM and a variety of financial and medical institutions throughout the Southeast. Terry has sat on the Board of Directors of both the South Florida and Atlanta chapters of the American Institute of Graphic Arts (AIGA) and is currently Vice President of AIGA/South Florida. In her role as UTA Senior Vice President, Terry will strengthen our long-standing commitment to quality design and client service and form the cornerstone of UTA's expansion efforts in the decade ahead. ••• **Elizabeth Lane joins UTA as Designer** With over 5 years experience and several Addy Awards in design and advertising, Beth is the newest member of our creative team and will be involved with design and production management at UTA. Beth comes to Urban Taylor & Associates from Frank Schulwolf Advertising. Currently, Beth is serving on the Board of Directors of AIGA/South Florida as Elections Chairman.

Annual Reports ••• **UTA to provide annual report profiles through Chicago consulting firm** Corporate policy, communications and investor relations are becoming more complex every day. Today, sophisticated corporate executives realize more than ever the importance of fine tuning their annual report message to best influence their target audience: They want performance profiles of past annuals, and strategic guidance for future annuals. They want to know what the potential investor thinks, be they members of the investment community, attorneys, other corporate heads, accountants, entrepreneurs, potential recruits or stock holders. Beginning in the first quarter of 1990, Urban Taylor & Associates will recommend CEO Assistance, Inc. in Chicago to provide this important consulting service. As a leading Chicago firm specializing in high level consulting to corporate executives, CEO Assistance, Inc's experience — particularly in the banking, investor relations and real estate areas — make them eminently qualified to provide profiles and strategic guidance for annual reports based on sound research and real-world target market sampling. We see CEO Assistance, Inc. as an ideal initial contact for potential annual report clients in the Chicago/Midwest region and as a terrific resource for existing and potential annual report clients in both UTA's Miami/Southeast region and Dan Smigrod's New York/Northeast region. UTA will include Dea Edwards (CEO Assistance, Inc. Chairman) as the Chicago/Midwest contact person in all of it's future advertising and promotion materials. We feel it is an important adjunct to our creative services to be able to recommend CEO Assistance, Inc.'s consulting services to our clients while offering potential clients in the Chicago area our level of design and production services. In either case both firms will operate independently, allowing the potential client to lead the way as to how they will use each firm's services. The relationship will be one of two respected firms serving as informed referral and initial contacts for each other in order to network resources and provide clients with the highest level consulting services across a broad range of corporate needs.

Great Clients ••• **Great design comes from great clients** Graphic designers are only part of the team in creating and producing effective communications. A designer analyzes their clients' needs and builds on their clients' ideas. The best design is the product of a close working relationship between them. Organized planning, open communication and mutual respect as well as creative expression makes the difference between a good and a great relationship. Getting a design project done at the uppermost quality level while staying within budgetary and scheduling parameters has to be a concerted team effort. To clearly communicate the project's goals in the early stages, then step back and let the design firm provide appropriate communications solutions, is a client's best approach. When a client relies on the designer's instincts and experience, then responds with clarity and trust to their proposed graphic concepts, the working relationship is optimum. A client who has the foresight to choose a designer who can do a great job for their particular needs and shows the restraint to let them do it, is the kind of courageous client it takes to do really great design. In today's competitive market place, the success of a client's business may very well be determined by the perceived image of their product or service created in their target audiences' mind. Because words will carry information, but design can transmit image, trusting a professional designer's judgement and experience to formulate an intelligent, creative and appropriate strategy can make all the difference. A designer who has the freedom given to them by their clients to do good work is afforded a wonderful opportunity but also takes on a tremendous responsibility which demands the best possible design and communications thinking. Clients and designers who take risks graphically — pushing the limits of the creative process — can reap the rewards great graphic design has to offer. In terms of results, innovation is seldom as risky as mediocrity. Both clients and designers benefit from working with people who share the belief that good design matters, but great design matters more.

pageproof

Corporate ID ••• There is a new look for the 90's at UTA With the new decade upon us and a continuing commitment to growth and service, UTA has redesigned our own corporate identity. The new look reflects both our corporate attitude and a fresh tropical point of view. The project includes the design of more than a dozen new forms and a total re-thinking of the more than thirty other internal and external forms UTA uses to monitor client projects. UTA will use specially designed computer software to automatically fill-in the forms once a client code is entered. The new forms will create superior and timely documentation for our client's projects. A new Project Briefing form was created especially for client use, to help them prepare and communicate their project schedules and objectives to UTA or any design firm.

3

©1990, Pageproof is published 4 times a year by Urban Taylor & Associates, 12250 SW 131 Avenue, Miami, Florida 33186. (305) 238-3223. UTA is a Miami-based Communication Design firm specializing in corporate communication projects, annual report design, corporate identity projects and publication design. We welcome your comments.

HOW, the national magazine of ideas and techniques in graphic design, has chosen UTA as a winner in their annual self-promotion contest. Winning projects were: UTA stationery, UTA business forms and the UTA 1989 holiday poster. The work was published in the special HOW 1990 Self-Promotion Annual. PRINT, America's design magazine chose two UTA projects for inclusion in their PRINT'S REGIONAL DESIGN ANNUAL '90 — an ad insert for Haff-Daugherty Graphics and sample box package for Sentek de Mexico, S.A. de C.V. created for Grayson Business Communications. PRINT also quoted UTA's president Alan Urban on trends in South Florida communication design. FLASH magazine, which provides national coverage of the advertising and graphic design industries, announced URBAN TAYLOR & ASSOCIATES as a winner in their Creative Excellence Awards. The Video Jukebox Annual Report, The Royal Viking Queen brochure created for Tere Benach & Associates and UTA's Pageproof were honored for excellence and innovation in graphic design and will be featured in the upcoming FLASH CREATIVE EXCELLENCE ANNUAL. This is Pageproof's third national design award. PHOTO/DESIGN, the U.S. magazine which spotlights unique ideas and trends produced by leading creative advertising and design teams selected the Video Jukebox Network Annual Report, designed by UTA, as a merit award winner in Their Annual PHOTO/DESIGN Awards Competition. The VJN Annual Report was one of only three awards given in the annual report category. UTA's own corporate graphics program of stationery, business forms and labels will be featured in the second edition of the book The Graphic Artist's Guide to Marketing and Self-Promotion published by North Light Books. The book features marketing and promotional materials successfully used by artists/designers. Corporate Showcase 9, the corporate sourcebook of creative services, published UTA Senior Vice President, Terry Stone's essay "The Consequences of Design." This article calls for continued dialogue regarding corporate America's look towards designers to help gain back their leadership position in the marketplace. Samples of all of UTA's award winning work are available upon request by calling Terry Stone (305)238-3223.

GROWTH IN RECESSION?

GRAPHIC DESIGN

URBAN TAYLOR + ASSOCIATES SELF-PROMO NEWSLETTER

DESIGNER ALAN URBAN
DESIGN FIRM URBAN TAYLOR + ASSOCIATES
SOFTWARE PAGEMAKER 4.01, FREEHAND 3.0, WORD 4.0
HARDWARE MAC IICX (80MB) QUANTUM HD, 20MB SUPERMAC
COLOR MONITOR

URBAN TAYLOR + ASSOCIATES SELF-PROMO NEWSLETTER

DESIGNERS ALAN URBAN, ELIZABETH LANE
SOFTWARE PAGEMAKER 4.01, FREEHAND 3.0, PHOTOSHOP 1.0.7
HARDWARE MAC IICX (20MB), 80MB QUANTUM HD, SUPERMAC
COLOR MONITOR

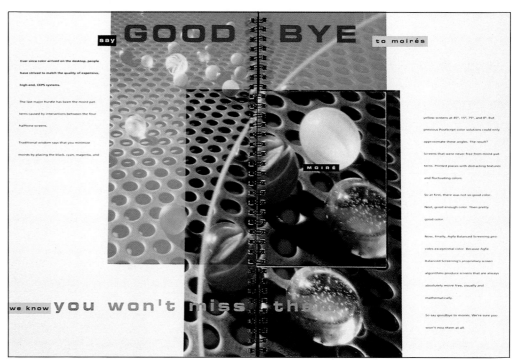

AGFA COMPUGRAPHICS BROCHURE

DESIGNERS STEPHANIE WADE, LYNN RIDDLE WALLER
DESIGN FIRM CLIFFORD SELBERT DESIGN
SOFTWARE QUARK, FREEHAND
HARDWARE MAC IIFX

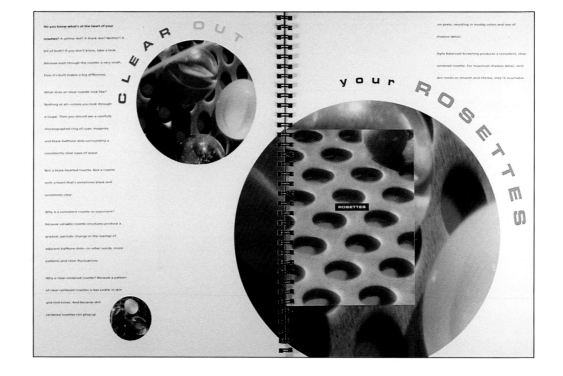

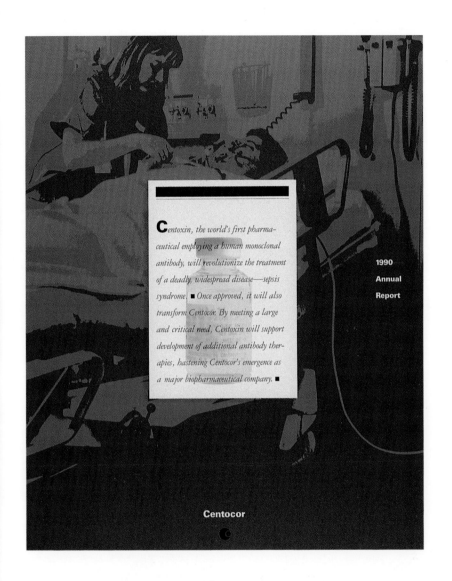

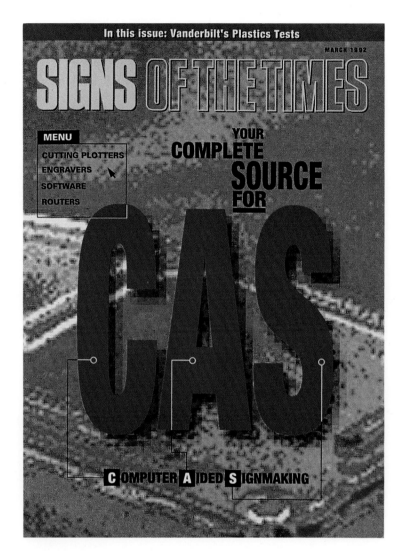

CENTOCOR, INC. ANNUAL REPORT

DESIGN FIRM THE GRAPHIC EXPRESSION, INC.
DESIGNER JOHN BALL
SOFTWARE ILLUSTRATOR
HARDWARE MAC

SIGNS OF THE TIMES MAGAZINE

DESIGNER MAGNO RELOJO
ILLUSTRATOR/PHOTOGRAPHER ALAN BROWN, PHOTONICS GRAPHICS
SOFTWARE PHOTOSHOP
HARDWARE MAC IIFX

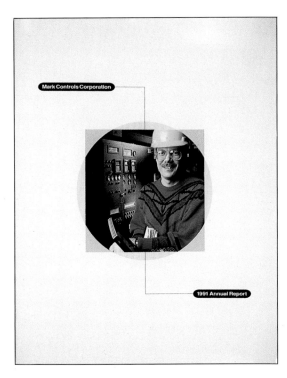

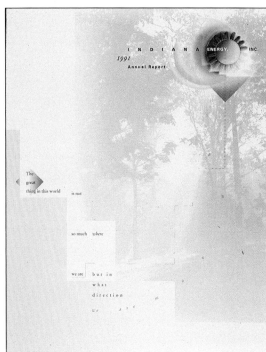

INDIANA ENERGY, INC. ANNUAL REPORT

DESIGNER MOLLY SCHOENHOFF
DESIGN FIRM ZENDER + ASSOCIATES, INC.
SOFTWARE QUARK, PHOTOSHOP, FREEHAND
HARDWARE MAC II, IICX, IIFX

MARK CONTROLS CORP. ANNUAL REPORT

DESIGNERS JEFF SEMENCHUK, TONY MORELLO, DAVE WOZNIAK
SOFTWARE PAGEMAKER, FREEHAND
HARDWARE MAC IIFX

COLUMBIA UNIVERSITY GRADUATE SCHOOL OF BUSINESS
CORPORATE IDENTITY

DESIGNER EUGENE J. GROSSMAN
DESIGN FIRM ANSPACH GROSSMAN PORTUGAL, INC.
SOFTWARE QUARK
HARDWARE MAC IICX

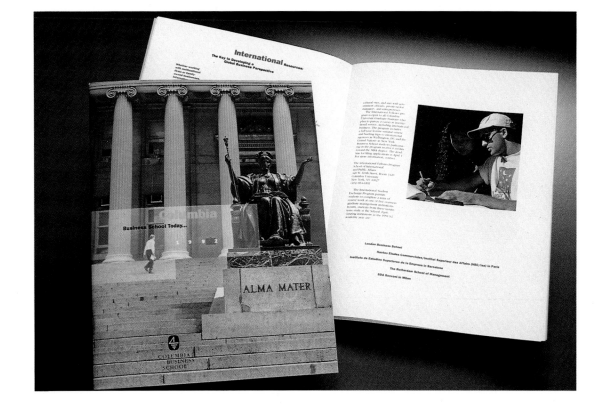

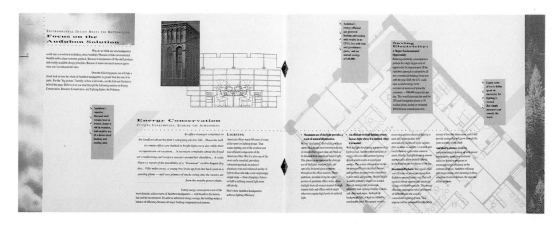

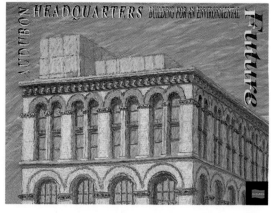

National Audubon Society Brochure

Designers Clara Kim, Andrzej Olejniczak
Design Firm O&J Design, Inc.
Software Photoshop, Illustrator
Hardware Mac fx

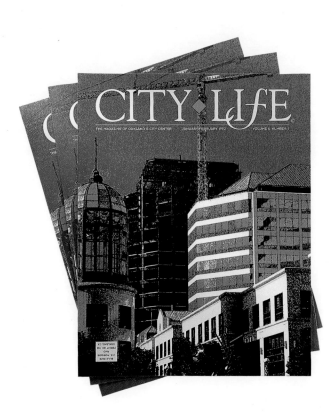

Bramalea Pacific Magazine Cover

Designers Jim Walcott-Ayers, Liz Pollina
Design Firm The Walcott-Ayers Group
Software Photoshop, Illustrator
Hardware Mac IIfx, Radius 19" Monitor

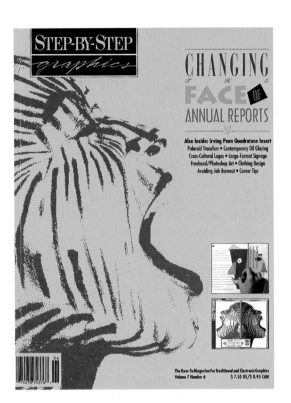

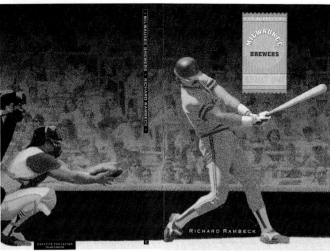

STEP-BY-STEP GRAPHICS MAGAZINE

DESIGNER MICHAEL HAMMER, WYD DESIGN

DESIGN FIRM STEP-BY-STEP PUBLISHING

SOFTWARE QUARK, PAGEMAKER, PHOTOSHOP, WORD, FREEHAND

HARDWARE MAC IICI (5MB), 80MB, RADIUS 19" COLOR MONITOR

STEP-BY-STEP GRAPHICS MAGAZINE

DESIGNER MICHAEL HAMMER

ILLUSTRATOR ROB DAY

DESIGN FIRM STEP-BY-STEP PUBLISHING

SOFTWARE QUARK, PAGEMAKER, PHOTOSHOP, WORD

HARDWARE MAC IICI (5MB), 80MB, RADIUS 19" COLOR MONITOR

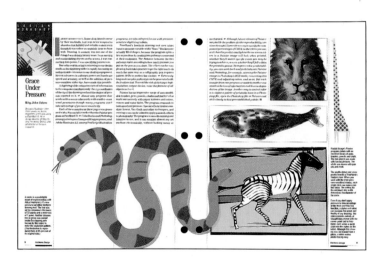

STEP-BY-STEP ELECTRONIC DESIGN NEWSLETTER

DESIGNERS MICHAEL ULRICH, JOHN ODAM

DESIGN FIRM STEP-BY-STEP PUBLISHING

SOFTWARE QUARK, PHOTOSHOP, FREEHAND, WORD

HARDWARE MAC IICX (8MB), 80MB, RASTER OPS 16"
COLOR MONITOR

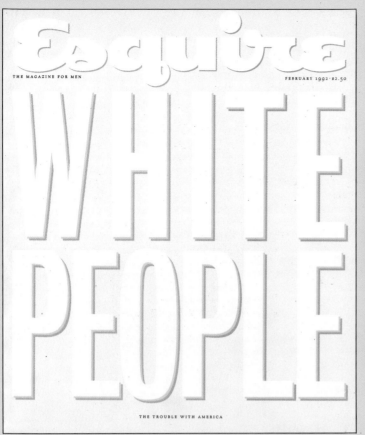

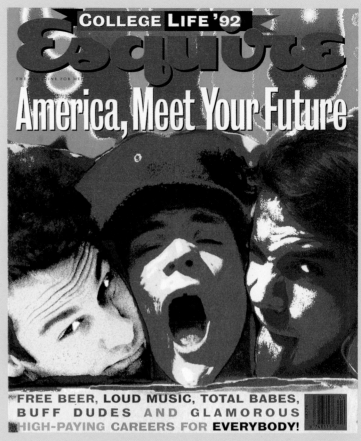

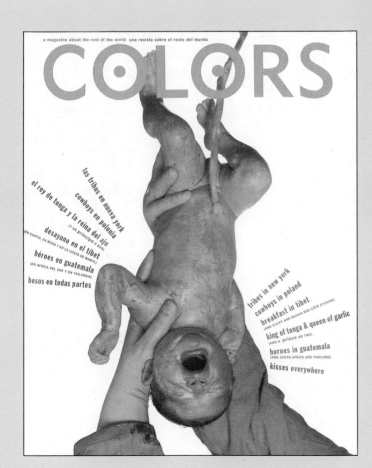

Esquire Magazine Covers

DESIGNER ROGER BLACK
DESIGN FIRM ROGER BLACK, INC.
SOFTWARE QUARK, ILLUSTRATOR, PHOTOSHOP
HARDWARE MAC IIX

Benetton Colors Magazine

DESIGNERS TIBOR KALMAN, EMILY OBERMAN
DESIGN FIRM M & CO.
SOFTWARE QUARK, PHOTOSHOP
HARDWARE MAC IIFX

7

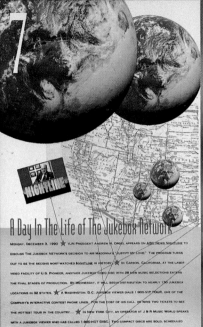

NIGHTLINE

"VJN is a showcase cable service..., giving viewers an opportunity to see up-and-coming groups that they would not see otherwise."
— Barden Cablevision's John Rawcliffe, quoted in Multichannel News

A Day In The Life of The Jukebox Network

MONDAY, DECEMBER 3, 1990. VJN PRESIDENT ANDREW H. ORGEL APPEARS ON ABC NEWS NIGHTLINE TO DISCUSS THE JUKEBOX NETWORK'S DECISION TO AIR MADONNA'S "JUSTIFY MY LOVE." THE PROGRAM TURNS OUT TO BE THE SECOND MOST-WATCHED NIGHTLINE IN HISTORY. IN CARSON, CALIFORNIA, AT THE LASER VIDEO FACILITY OF U.S. PIONEER, ANOTHER JUKEBOX VIDEO DISC WITH 28 NEW MUSIC SELECTIONS ENTERS THE FINAL STAGES OF PRODUCTION. BY WEDNESDAY, IT WILL BEGIN DISTRIBUTION TO NEARLY 130 JUKEBOX LOCATIONS IN 32 STATES. A WASHINGTON, D.C. JUKEBOX VIEWER DIALS 1-900-VIP-TOUR, ONE OF THE COMPANY'S INTERACTIVE CONTEST PHONE LINES. FOR THE COST OF HIS CALL, HE WINS TWO TICKETS TO SEE THE HOTTEST TOUR IN THE COUNTRY.... IN NEW YORK CITY, AN OPERATOR AT J & R MUSIC WORLD SPEAKS WITH A JUKEBOX VIEWER WHO HAS CALLED 1-800-HOT-DISC. TWO COMPACT DISCS ARE SOLD, SCHEDULED FOR DELIVERY WITHIN 5 DAYS. IN ATLANTA, JUKEBOX MUSIC CONSULTANT MIKE COOPER MAKES LAST MINUTE ADDITIONS TO THE NEXT WEEK'S PLAYLIST. IN ALL, 40 NEW VIDEOS WILL BE INTRODUCED TO JUKEBOX VIEWERS IN THE FOLLOWING WEEK, AUGMENTING A LIST OF OVER 400 DIFFERENT TITLES AVAILABLE FOR VIEWER SELECTION. BILL STACY, VJN VICE PRESIDENT, LOW POWER TELEVISION, VISITS BOULDER, COLORADO, PREPARING FOR THE LAUNCH THE FOLLOWING DAY OF CHANNEL 54, ANOTHER JUKEBOX AFFILIATE. IN GLENDALE, CALIFORNIA, VJN DIRECTOR OF FIELD ENGINEERING, JIMMY ORTON, UPGRADES THE JUKEBOX SYSTEM

INTERACTIVE TV NEXT EDUCATION —Daily Variety

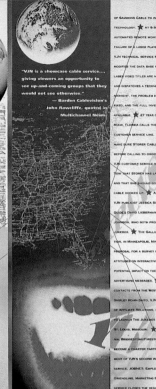

OF SAMMONS CABLE TO INCORPORATE LASER VIDEO TECHNOLOGY. AT 9:38 P.M., THE JUKEBOX AUTOMATED REMOTE MONITORING SYSTEM DETECTS A FAILURE OF A LASER PLAYER IN LANHAM, MARYLAND. VJN TECHNICAL SERVICE REP FRANK BLANCO, MODIFIES THE DATA BASE FOR THAT SYSTEM SO THAT LASER VIDEO TITLES ARE NOT SCROLLED ON-SCREEN AND DISPATCHES A TECHNICIAN TO THE SITE. BY MIDNIGHT, THE PROBLEM HAS BEEN IDENTIFIED AND FIXED, AND THE FULL INVENTORY IS ONCE AGAIN AVAILABLE. 27 YEAR OLD TONI BIANCA OF MIAMI, FLORIDA CALLS THE JUKEBOX'S TOLL FREE CUSTOMER SERVICE LINE, 1-800-ASK-JUKE, TO MAKE SURE STORER CABLE OFFERS THE JUKEBOX BEFORE CALLING TO ORDER A CABLE INSTALLATION. VJN CUSTOMER SERVICE REP DAVID EZE ASSURES TONI THAT STORER HAS LAUNCHED THE JUKEBOX AND THAT SHE SHOULD GO AHEAD AND GET HER CABLE HOOKED UP. AS PRESS INTEREST BUILDS, VJN PUBLICIST JESSICA SCHWARTZ SPEAKS TO TV GUIDE'S DAVID LIEBERMAN AND USA TODAY'S PETER JOHNSON, WHO BOTH PRODUCE STORIES ABOUT THE JUKEBOX. THE GALLUP RESEARCH ORGANIZATION, IN MINNEAPOLIS, MINNESOTA, REVIEWS A FINAL PROPOSAL FOR A SURVEY ON ADVERTISING AGENCIES' ATTITUDES ON INTERACTIVE TELEVISION AND ITS POTENTIAL IMPACT ON THE DELIVERY OF TARGETED ADVERTISING MESSAGES. FOLLOWING UP CONTACTS FROM THE WESTERN CABLE SHOW, SHIRLEY ROHN-SAITO, VJN WEST COAST DIRECTOR OF AFFILIATE RELATIONS, FINALIZES ARRANGEMENTS TO LAUNCH THE JUKEBOX ON TCI CABLE IN ST. LOUIS, MISSOURI. IN WAYNE, PENNSYLVANIA, BRIDGESTONE/FIRESTONE, INC. AGREES TO BECOME A CHARTER PARTICIPANT IN THE DEVELOPMENT OF VJN'S SECOND INTERACTIVE TELEVISION SERVICE, JOBNET: EMPLOYMENT TELEVISION. HARRY GRENDLING, MARKETING DIRECTOR OF THE NEW SERVICE CLOSES THE DEAL.

8

The Players

AFTER A YEAR OF STAFF GROWTH IN 1989 AND EARLY 1990, VJN PLAYED A PAT HAND FOR THE BALANCE OF THE YEAR. HOWEVER, GREAT STRENGTH WAS ADDED TO THE COMPANY'S BOARD OF DIRECTORS AS WELL AS TO THE OWNERSHIP PICTURE. NEW BOARD ADDITIONS INCLUDED TRYGVE MYHREN, PRESIDENT/CEO OF THE PROVIDENCE JOURNAL COMPANY, A PRIVATELY-HELD NEWSPAPER, BROADCAST TELEVISION AND CABLE TELEVISION COMPANY, AND FORMER CHAIRMAN/CEO OF AMERICAN TELEVISION AND COMMUNICATIONS CORPORATION (ATC), ONE OF THE NATION'S PREMIERE CABLE TELEVISION MULTIPLE SYSTEM OPERATORS. NEW BOARD MEMBER JULES HAIMOVITZ IS PRESIDENT/COO AND A BOARD MEMBER OF SPELLING ENTERTAINMENT, INC. HE PREVIOUSLY WAS PRESIDENT OF THE VIACOM NETWORKS GROUP AND HAS SERVED ON THE BOARDS OF LIFETIME, A CABLE TELEVISION NETWORK, AND ORION PICTURES CORPORATION. ALSO A NEW BOARD ADDITION WAS DAVID O. DEUTSCH OF MIAMI-BASED COSTA CRUISE LINES N.V. THE DECISION BY TELE-COMMUNICATIONS, INC. TO INVEST $5 MILLION IN THE COMPANY, IN EXCHANGE FOR JUST OVER 1 MILLION SHARES OF COMPANY STOCK WAS MORE THAN A MERE FINANCIAL SHOT IN THE ARM. SUBSEQUENT TO COMPLETION OF THE INVESTMENT, DISTRIBUTION OF THE JUKEBOX NETWORK INTO TCI SYSTEMS BEGAN. NEW MARKETS ADDED AS A RESULT INCLUDE CHICAGO, BUFFALO, DALLAS, WASHINGTON, D.C., AND ST. LOUIS. VJN PRESIDENT/CEO ANDREW H. ORGEL, NOW IN HIS THIRD YEAR WITH THE COMPANY, IS A VETERAN OF THE CABLE TELEVI-

-SION INDUSTRY, HAVING PUT IN STINTS AT MTV NETWORKS (MTV: MUSIC TELEVISION, NICKELODEON AND THE MOVIE CHANNEL) AND ARTS AND ENTERTAINMENT TELEVISION NETWORK. LES GARLAND, THE ORIGINAL SENIOR PROGRAMMING EXECUTIVE OF MTV: MUSIC TELEVISION AND ITS SISTER SERVICE VH-1: VIDEO HITS ONE, JOINED THE COMPANY IN EARLY 1990 AS VICE PRESIDENT, PROGRAMMING AND IS CREDITED FOR VASTLY IMPROVING THE COMPANY'S VITAL RECORD COMPANY RELATIONSHIPS AND BRINGING ENHANCED ON-AIR CONTINUITY TO THE PROGRAMMING OF THE JUKEBOX NETWORK. CONTINUING THEIR ROLES WITH THE COMPANY WERE CHERYL GREENE, VICE PRESIDENT, AFFILIATE RELATIONS, BILL STACY, VICE PRESIDENT, LOW POWER TELEVISION OPERATIONS, JOSE FELIPE, VICE PRESIDENT, FINANCE, ADMINISTRATION AND OPERATIONS/CFO, JOHN ROBSON, DIRECTOR, CORPORATE COMMUNICATION, PROGRAMMING AND PRODUCTION, AND PAUL SARTAIN, DIRECTOR, SYSTEM OPERATIONS & INFORMATION SYSTEMS. THE INCREASED STRENGTH OF THE BOARD AND THE FINANCIAL UNDERPINNINGS OF THE COMPANY LEAVE IT WELL-POSITIONED FOR CONTINUED GROWTH AND EXPANSION THROUGHOUT 1991.

Remembering Cheryl Greene, her contributions and her energy. 1946-1991

5

The Products

1990 WAS THE YEAR WHEN VJN TRULY BRANCHED OUT INTO A FAMILY OF PRODUCTS, WITH THE JUKEBOX NETWORK REMAINING THE CORNERSTONE OF THE COMPANY. EXPANSION OF THE JUKEBOX NETWORK SAW IT GROW FROM 72 UNITS REACHING 6 MILLION HOUSEHOLDS AT YEAR END 1989 TO 131 UNITS REACHING 11 MILLION HOUSEHOLDS AT YEAR END 1990 AND 148 UNITS GOING INTO 12 MILLION

Video Jukebox Network has stepped in where MTV feared to tread.
—Cablevision

6

HOUSEHOLDS BY THE END OF THE FIRST QUARTER OF 1991. AUDIOTEX BECAME A NEW PRODUCT OF VJN, AS THE NEW BUSINESS DEVELOPMENT UNIT, UNDER THE DIRECTION OF STEVE WILLIAMS, DEVELOPED 900 PHONE PROGRAMS LIKE 1-900-HOT-DISC AND 1-900-VIP-TOUR. HOT-DISC, IN PARTICULAR, ATTRACTED ATTENTION AS IT HELPED THE RECORD COMPANIES BY EXPOSING NEW MUSIC AND PERMITTING CALLERS TO ORDER NEW MUSIC PRODUCT OVER THE PHONE FOR DELIVERY WITHIN 10 DAYS. ADVERTISED BOTH ON THE JUKEBOX NETWORK AND ON OTHER CABLE NETWORKS, THESE AUDIOTEX PROGRAMS REPRESENT THE COMPANY'S FIRST FORAY INTO AN INDUSTRY THAT IS PROJECTED TO GENERATE OVER $2 BILLION IN 1993. ALSO BASED ON 900 PHONE TECHNOLOGY WERE A SERIES OF CONTESTS AND PROMOTIONS INVOLVING

SOME OF THE HOTTEST ARTISTS FROM THE MUSIC WORLD. CALLERS TO THESE PHONE LINES WERE ELIGIBLE TO WIN M.C. HAMMER'S PORSCHE, GO BACKSTAGE WITH PUBLIC ENEMY, HANG OUT ON THE ROAD WITH SUICIDAL TENDENCIES, TAKE A SHOPPING SPREE ON RODEO DRIVE WITH EN VOGUE OR 'CHILL' WITH VANILLA ICE. LOOKING TOWARD THE FUTURE OF INTERACTIVE TELEVISION, THE COMPANY ALSO ANNOUNCED PLANS TO DEVELOP A SERIES OF INTERACTIVELY PROGRAMMED TELEVISION MODULES UNDER THE BANNER OF INPHONET. THE FIRST MODULE, SCHEDULED TO UNDERGO ON-AIR TESTING IN 1991, IS A CAREER AND EMPLOYMENT MATCHING SERVICE CALLED JOBNET: EMPLOYMENT TELEVISION. OTHER MODULES TO BE DEVELOPED IN THE FUTURE MAY INCLUDE TRAVEL, CLASSIFIED ADVERTISING, AND REAL ESTATE.

ATLANTIC RECORDS RECORDING ARTISTS LINEAR

EPIC RECORDS RECORDING ARTISTS SUICIDAL TENDENCIES

VIDEO JUKEBOX NETWORK, INC. ANNUAL REPORTS

DESIGNER ALAN URBAN
DESIGN FIRM URBAN TAYLOR + ASSOCIATES
SOFTWARE PAGEMAKER 4.01, PHOTOSHOP 1.0.7, FREEHAND 3.0, WORD 4.0
HARDWARE MAC IICX (20 MB), 80MB QUANTUM HD, SUPERMAC COLOR MONITOR, IBM TARGA R10

President's Message

DEAR SHAREHOLDERS, AFFILIATES AND FRIENDS: ALTHOUGH 1990 WAS ONLY THE SECOND YEAR OF OUR NATIONAL DISTRIBUTION, THE JUKEBOX NETWORK BROKE NEW GROUND AND RECEIVED SUBSTANTIALLY INCREASED RECOGNITION FOR ITS ACHIEVEMENTS WITHIN THE COMMUNICATIONS AND ENTERTAINMENT INDUSTRIES. IT WAS THE CABLE INDUSTRY'S FASTEST GROWING NETWORK. IT LED THE U.S. MEDIA BUSINESS IN INCREASED REVENUES (256%) OVER 1989. IT WAS FEATURED ON ABC, CBS, NBC, FNN, CNBC AND IN FORBES, FORTUNE, ROLLING STONE AND TV GUIDE FOR ITS LEADERSHIP IN INTERACTIVE TELEVISION. ★ IT WAS A YEAR FOR BREAKING NEW MUSIC AND BREAKING THE RULES. A YEAR OF ATTRACTING 5 MILLION NEW HOUSEHOLDS AND A 95 MILLION EQUITY INVESTMENT BY TELE-COMMUNICATIONS, INC. A YEAR OF NATIONAL ROLL-OUT OF ADVANCED LASER TECHNOLOGY IN ALL JUKEBOX SYSTEMS AND A ROLL-OUT OF DISTRIBUTION BY TIME WARNER THAT MADE THAT COMPANY THE LARGEST JUKEBOX AFFILIATE. A YEAR OF INCREASED SUPPORT FROM CUSTOMERS AND SUPPORT FROM THE MUSIC COMPANIES OF THE NETWORK AS A TRUE ALTERNATIVE VIDEO OUTLET AND MARKETING TOOL. ★ BUT, WHILE THE NETWORK AND ITS VISION OF THE FUTURE OF TELEVISION RECEIVED STRONG PRESS ATTENTION, SO DID THE IMPENDING GULF WAR. THE FIRST TROOPS MARCHED INTO KUWAIT ON THE SAME DAY TCI ANNOUNCED ITS INVESTMENT IN VIDEO JUKEBOX NETWORK, INC. (VJN). IT WAS A WAR THAT GREATLY IMPACTED DISCRETIONARY SPENDING AMONG YOUNG ADULTS WELL INTO 1991 AS EVIDENCED BY DECREASED RECORD SALES, CONCERT ATTENDANCE, MOVIE ATTENDANCE AND JUKEBOX CALL VOLUME. AND, ALTHOUGH JUKEBOX CALLERS EXERCISED MORE CAUTION WITH THEIR SPENDING, THE COMPANY'S 900 AUDIOTEX ANCILLARY REVENUE STREAM MORE THAN MADE UP FOR THE SHORTFALL. ★ BUT, OURS IS MORE THAN THE STORY OF AN EMERGING INTERACTIVE TELEVISION NETWORK. IT IS THE STORY OF THE AGE OF PERSONAL TELEVISION. INTERACTIVE TELEVISION WILL HAVE A MAJOR IMPACT ON THE WAY WE USE TELEVISION. IT WILL BE THE MAIN INGREDIENT IN THE COMING 150-PLUS CHANNEL ENVIRONMENT. IT WILL HELP MAKE THE DELIVERY OF NICHE PROGRAMMING A REALITY; INDIVIDUAL CHOICE AN OBSESSION; ON-DEMAND SERVICES A FACT OF LIFE. ★ WE BELIEVE TELEVISION WILL BECOME THE MOST POWERFUL INDIVIDUALIZED DIRECT MARKETING VEHICLE ON THE PLANET. MANY INDUSTRIES ALONG WITH RECORDED MUSIC/ENTERTAINMENT WILL HARNESS THE NEW TOOL TO REACH AUDIENCE SEGMENTS WITH MORE TARGETED, RELEVANT MESSAGES THAN EVER BEFORE. ★ AND, ADVERTISERS WILL LOOK AT THE MEDIUM WITH A NEW SET OF RULES AND A NEW ARSENAL OF OPPORTUNITIES. CLIENTS WILL DEMAND A PIECE OF INTERACTIVITY WHEN THEY SEE THE VALUE OF TARGETING THEIR MESSAGES ALONG WITH THE MEDIUM. ★ THE EXPLOSION OF THE NEW AGE OF PERSONAL TELEVISION WILL OCCUR BECAUSE OF INTERACTIVITY, LOCALIZATION AND A NEW UNDERSTANDING BY ENTERTAINMENT AND INFORMATION VENDORS OF THE BENEFITS OF TRANSACTIONS. OTHER INDUSTRIES UNDERSTAND THAT THE FLOW OF TRANSACTIONS IS A VALUABLE CELL OF ECONOMIC ACTIVITY. TRANSACTIONS ARE MORE VALUABLE, MORE DYNAMIC THAN HOUSEHOLD CABLE SUBSCRIPTIONS. ★ THE LANDSCAPE OF CABLE TELEVISION IS CHANGING. TWO YEARS AGO, AT THE BEGINNING OF OUR NATIONAL DISTRIBUTION, CHANNEL CAPACITY WAS THE BIGGEST HURDLE CONFRONTING ANY NEW CABLE NETWORK LAUNCH. NOW, WITH

SYSTEM REBUILDS AND ADVANCES IN VIDEO COMPRESSION TECHNOLOGY, THERE ARE PLANS FOR CABLE SYSTEMS WITH CHANNEL CAPACITIES RANGING FROM 150 TO 600 CHANNELS. AS THE POTENTIAL AUDIENCE IS INEVITABLY FRAGMENTED BY THIS EXPLOSION IN VIEWING OPTIONS, THE EMPHASIS WILL SWITCH FROM HOUSEHOLDS REACHED TO TELEVISION TRANSACTIONS MADE. ★ YOUR COMPANY IS POISED TO OFFER VIEWERS TELEVISION PRODUCT GEARED TO TELEVISION TRANSACTION VENDING. WE WILL SEEK TO PATTERN OUR BUSINESS ON THE STATISTICAL MODELS OF OTHER TRANSACTIONAL BUSINESSES. IN THE U.S. ALONE, THERE ARE 458 BILLION PHONE CALLS MADE ANNUALLY, 50 BILLION BANK CHECKS PROCESSED, 12 BILLION STATE LOTTERY TICKETS SOLD, 5.2 BILLION ATM TRANSACTIONS...EVEN 174 MILLION 900 NUMBER TELEPHONE CALLS AND 20 MILLION EMPLOYEE HIRES. ★ BY TAKING ADVANTAGE OF INTERACTIVE TECHNOLOGY, INCREASED CHANNEL CAPACITY, AND THE PUBLIC'S UNDIMINISHED DESIRE FOR TELEVISION PRODUCT AND CHOICE, VJN PLANS TO PLAY A KEY ROLE IN THIS NEW AGE OF PERSONAL TELEVISION. ★ THIS HAS BEEN OUR MANDATE SINCE THE BEGINNING. LOOK FOR VJN TO CONTINUE IN A LEADERSHIP POSITION IN DEVELOPING AND DISTRIBUTING SERVICES THAT ANTICIPATE AND MEET THE DEMANDS OF CONSUMERS, ADVERTISERS AND DISTRIBUTORS IN THE AGE OF PERSONAL TELEVISION.

ANDREW H. ORKIN – PRESIDENT/CHIEF EXECUTIVE OFFICER

"One of the most fascinating ideas for 1991" – Fortune Magazine

2

TABLE OF CONTENTS

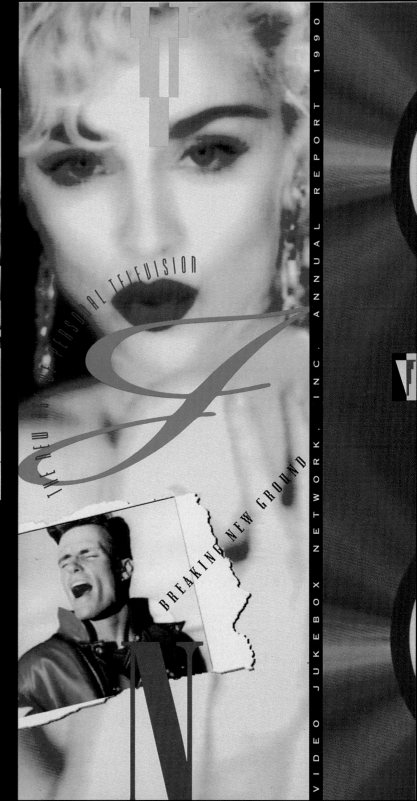

THE NEW AGE OF PERSONAL TELEVISION

BREAKING NEW GROUND

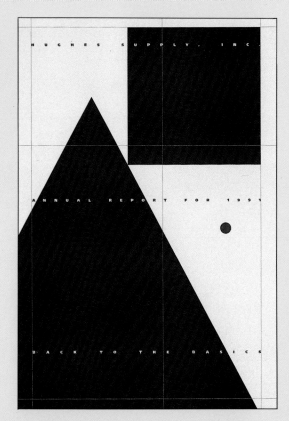

HUGHES SUPPLY, INC. ANNUAL REPORT

DESIGNER ALAN URBAN
DESIGN FIRM URBAN TAYLOR + ASSOCIATES
SOFTWARE PAGEMAKER 4.01, FREEHAND 3.0, WORD 4.0
HARDWARE MAC IICX (20MB), 80MB QUANTUM HD, SUPERMAC
COLOR MONITOR

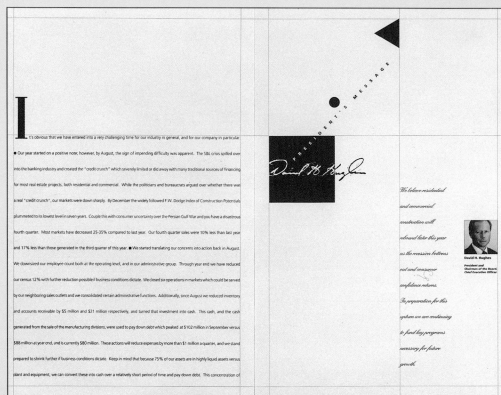

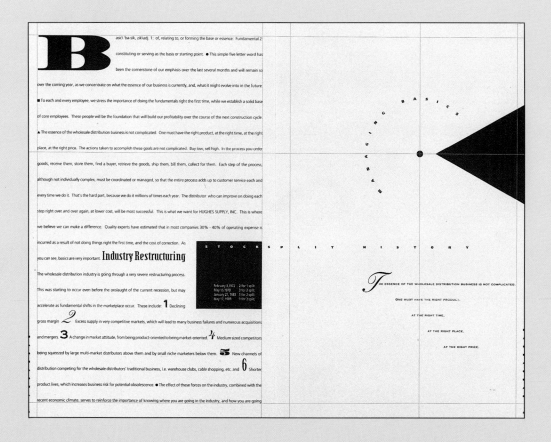

MTA NEWSLETTER

DESIGNER GIL LIVNE

DESIGN FIRM NOTOVITZ DESIGN, INC.

SOFTWARE PAGEMAKER 3.0, ILLUSTRATOR 1.9.3

HARDWARE MAC IICX, QMS 810, APPLE SCANNER

I.D.E.A. NEWSLETTER

DESIGNER MICHAEL MEYEROWITZ

DESIGN FIRM MICHAEL MEYEROWITZ + CO.

SOFTWARE QUARK, ILLUSTRATOR, FREEHAND

HARDWARE MAC IICI, QMS COLOR LASERPRINTER

SCITEX CORP. OF AMERICA BROCHURE

DESIGNER MICHAEL CARR
DESIGN FIRM KOLLBERG/JOHNSON ASSOCIATES
SOFTWARE QUARK 2.12, ILLUSTRATOR 88 1.9.3, MACDRAW II 1.0,
ADOBE TYPEFACES
HARDWARE MAC IIFX, PLI INFINITY 40 TURBO, SHARP 450
SCANNER, QMS 100/30 COLOR PRINTER

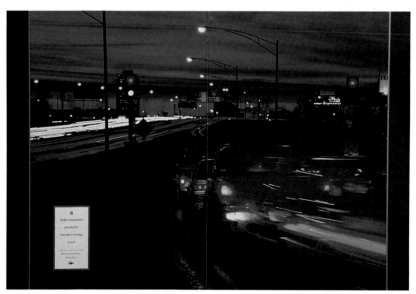

BRW BROCHURES

DESIGNERS JOHN REGER, KOKE
DESIGN FIRM DESIGN CENTER
SOFTWARE QUARK
HARDWARE MAC

Hi-Shear Industries Inc.
1986 Annual Report

Aerospace Fastening Systems

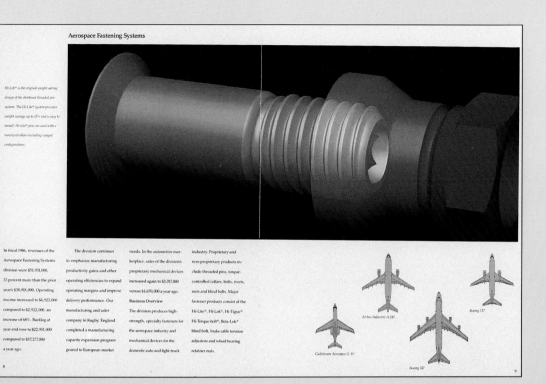

Hi-Lite® is the original weight-saving design of the shortened threaded pin system. The Hi-Lite® system provides weight savings up to 15% and is easy to install. Hi-Lite® pins are used with a variety of collars including swaged configurations.

In fiscal 1986, revenues of the Aerospace Fastening Systems division were $51,931,000, 33 percent more than the prior year's $38,918,000. Operating income increased to $4,923,000 compared to $2,922,000, an increase of 68%. Backlog at year end rose to $22,951,000 compared to $17,277,000 a year ago.

The division continues to emphasize manufacturing productivity gains and other operating efficiencies to expand operating margins and improve delivery performance. Our manufacturing and sales company in Rugby, England completed a manufacturing capacity expansion program geared to European market

needs. In the automotive marketplace, sales of the division's proprietary mechanical devices increased again to $3,017,000 versus $1,670,000 a year ago.
Business Overview
The division produces high-strength, specialty fasteners for the aerospace industry and mechanical devices for the domestic auto and light-truck

industry. Proprietary and non-proprietary products include threaded pins, torque-controlled collars, bolts, rivets, nuts and blind bolts. Major fastener products consist of the Hi-Lite®, Hi-Lok®, Hi-Tigue® Hi-Torque bolt®, Beta-Lok® blind bolt, brake cable tension adjustors and wheel bearing retainer nuts.

Airbus Industrie A.310

Boeing 737

Gulfstream Aerospace G-IV

Boeing 747

Aerospace Fastening Systems *Continued*

Beta-Lok® blind bolts are used to assemble airframe structures where there is inadequate access or clearance to install a nut onto a bolt or a collar onto a pin. The Beta-Lok® is produced in titanium, stainless and alloy steel materials to provide compatibility with the materials being fastened.

McDonnell Douglas F/A-18 Hornet

Sikorsky UH-60 Black Hawk

Bell Boeing Vertol V-22 Osprey

McDonnell Douglas F-15 Eagle

The Hi-Lite® fastener is meeting our expectations of becoming the leading structural fastener in the industry. The advantages of lighter weight and flexibility of installation have been recognized by the major aircraft builders. This broad-based acceptance of the Hi-Lite®

is a significant division accomplishment.
Commercial Airliner Outlook
Production of commercial aircraft is forecasted to remain at strong levels through 1990 as the commercial airlines replace aging fleets with fuel-efficient and lower-maintenance air-

craft. In 1985, Boeing booked orders for 390 jetliners, its highest level since 1978. This trend continued into 1986 with major orders for the Boeing 737 narrow-body and Boeing 747 wide-body aircraft. Orders for McDonnell Douglas MD-80 series aircraft are also strong domestically.

The increasing aircraft production schedules, plus the excellent customer acceptance of the Hi-Lite® and other division proprietary fasteners, along with a reputation for quality, result in the division being positioned well for continued growth in revenues and earnings.

HI-SHEAR INDUSTRIES, INC. ANNUAL REPORT
DESIGN FIRM THE GRAPHIC EXPRESSION, INC.
SOFTWARE PROPRIETARY
HARDWARE IBM

GRAPHIC DESIGN

UNIVERSITY OF MINNESOTA BROCHURE

DESIGNERS MARC KUNDMANN, NANCY WHITTLESEY
DESIGN FIRM LARSEN DESIGN OFFICE, INC.
SOFTWARE QUARK 3.0, COLOR STUDIO
HARDWARE MAC IICI, MICROTEK COLOR SCANNER

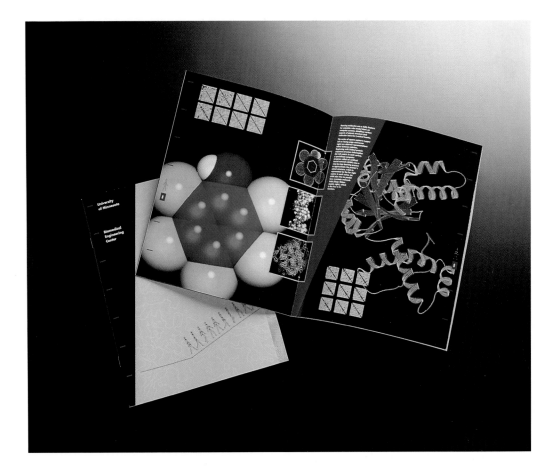

Two years of research and study has produced a color proofing system capable of merging continuous tone images along with Postscript™ type and line art. No more jagged type and halftoned images, instead full color pictures and high quality type for your color comps and presentations. The Type Two color proofer outputs to many kinds of stock up to 32 pound text as well as transparencies and transfer materials. Call 647-8880 for more information.

PostScript is a trademark of Adobe Systems Incorporated~Macintosh is a trademark of Apple Computer, Incorporated~Type Two is a trademark of Typotronics Incorporated.

TYPE TWO MAILER

DESIGNER NIDA ZADA
SOFTWARE PHOTOSHOP, ILLUSTRATOR
HARDWARE MICROTEK SCANNER, MAC IIFX

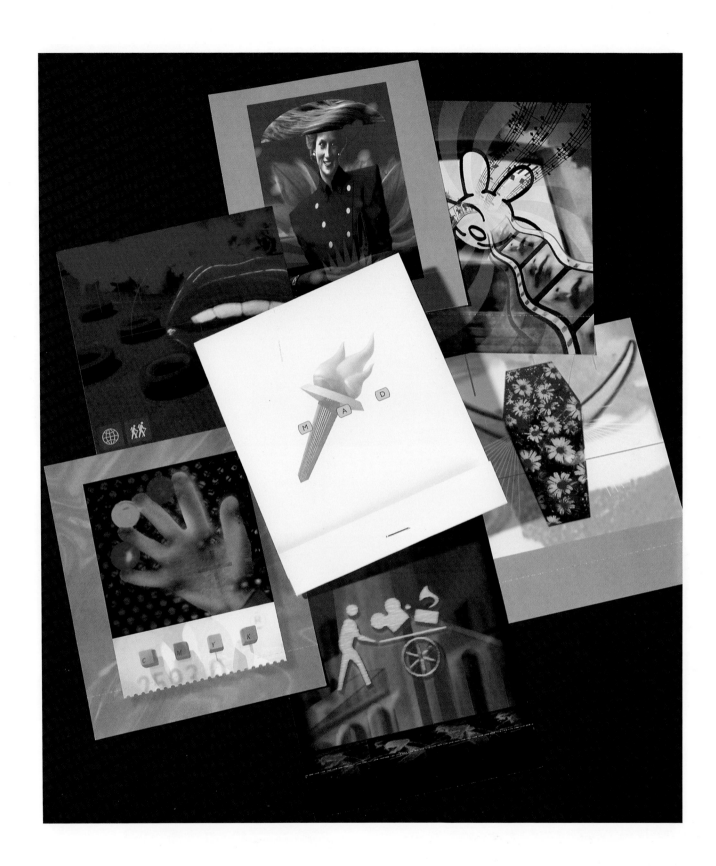

UNISOURCE PROMOTIONAL PIECE

DESIGNERS ERIK ADIGARD, PATRICIA MCSHANE
DESIGN FIRM M.A.D.
SOFTWARE PAGEMAKER, ILLUSTRATOR, PHOTOSHOP
HARDWARE MAC IIFX, MICROTEK COLOR/GREY SCANNER

LIFECO TRAVEL SERVICES BROCHURE

DESIGNERS PEAT JARIYA, SCOTT HEAD
DESIGN FIRM PEAT JARIYA DESIGN
SOFTWARE PAGEMAKER, ILLUSTRATOR, FREEHAND
HARDWARE MAC

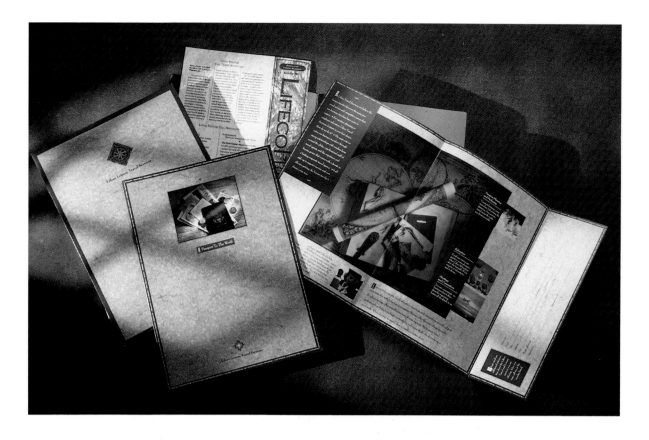

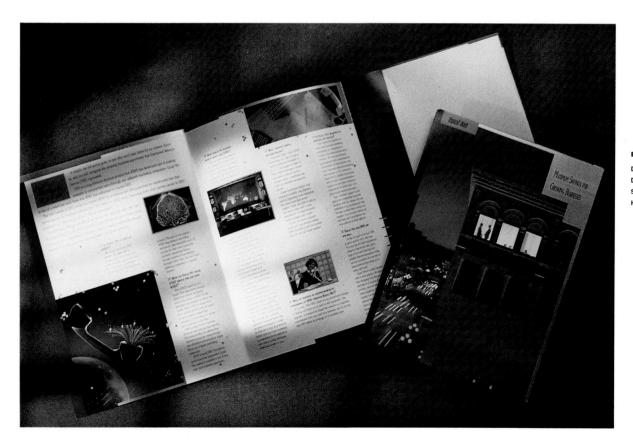

EQUALNET CORP. BROCHURE

DESIGN FIRM PEAT JARIYA DESIGN
DESIGNER PEAT JARIYA, SCOTT HEAD
SOFTWARE PAGEMAKER
HARDWARE MAC IIX, IISI

34

CBS Marketing Pamphlet

Designer **Yasuo Kubota**
Design Firm **Kubota & Bender**
Software **Illustrator, Quark, Photoshop**
Hardware **Mac IICX, Crossfield Studio System**

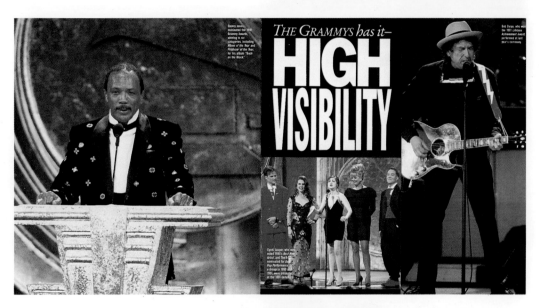

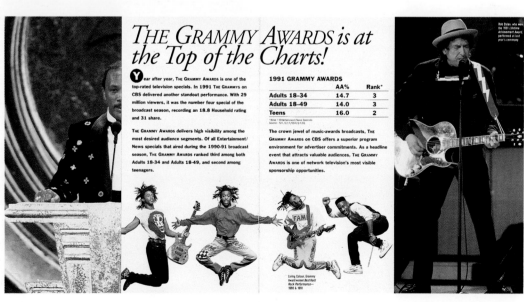

ADEPT MAGAZINE

ART DIRECTOR MICHAEL WAITSMAN
COVER DESIGN GREG THOMPSON
DESIGNER BILL BARRICK
DESIGN FIRM EXOGRAPHIC
SOFTWARE QUARK 3.0, FREEHAND 2.02, PAGEMAKER 4.0, FH2.02
HARDWARE MAC IICX, MAC SE

GENERAL ELECTRIC ANNUAL REPORT COVER

ILLUSTRATOR MARC YANKUS
SOFTWARE PHOTOSHOP
HARDWARE MAC IICX (32MB), SUPERMAC 19" MONITOR

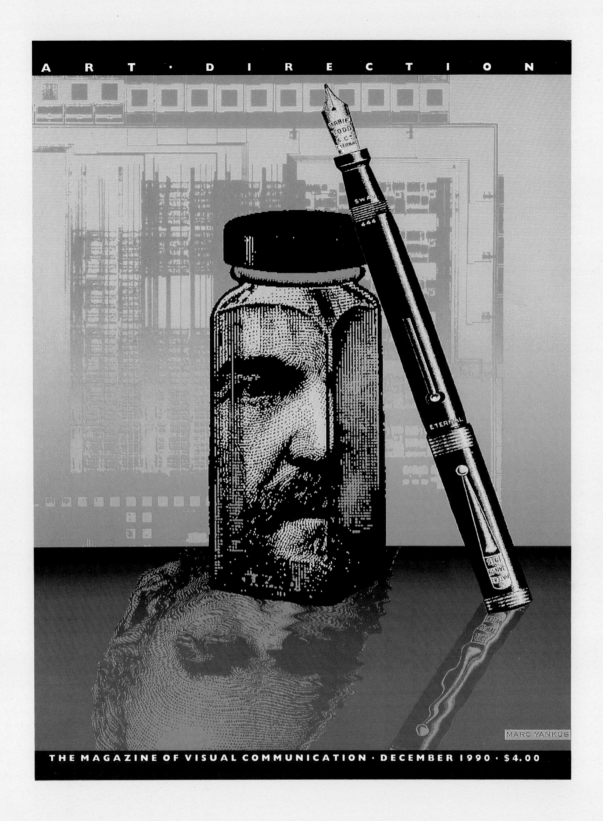

ART · DIRECTION

THE MAGAZINE OF VISUAL COMMUNICATION · DECEMBER 1990 · $4.00

MARC YANKUS

ART DIRECTION MAGAZINE

ILLUSTRATION MARC YANKUS
SOFTWARE PHOTOSHOP
HARDWARE MAC IICX (32MB), DAYSTAR 50MB POWERCARD

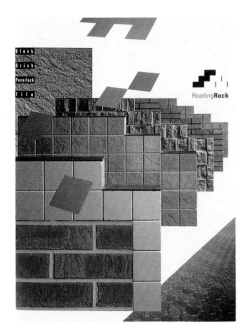

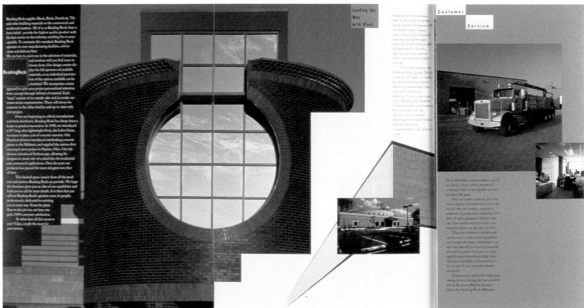

COMAIR ANNUAL REPORT

DESIGNER MIKE ZENDER

DESIGN FIRM ZENDER + ASSOCIATES, INC.

SOFTWARE QUARK, PHOTOSHOP

HARDWARE MAC II, IICX, IIFX

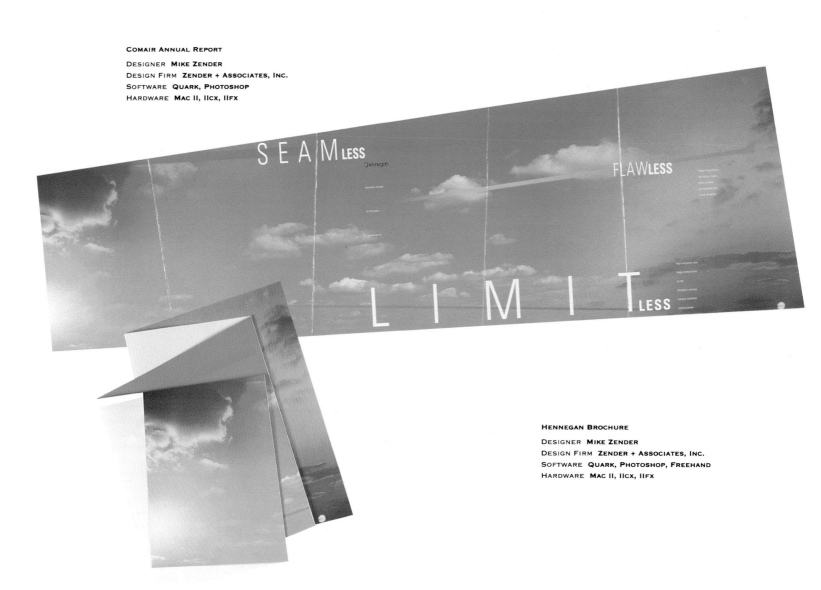

HENNEGAN BROCHURE

DESIGNER MIKE ZENDER

DESIGN FIRM ZENDER + ASSOCIATES, INC.

SOFTWARE QUARK, PHOTOSHOP, FREEHAND

HARDWARE MAC II, IICX, IIFX

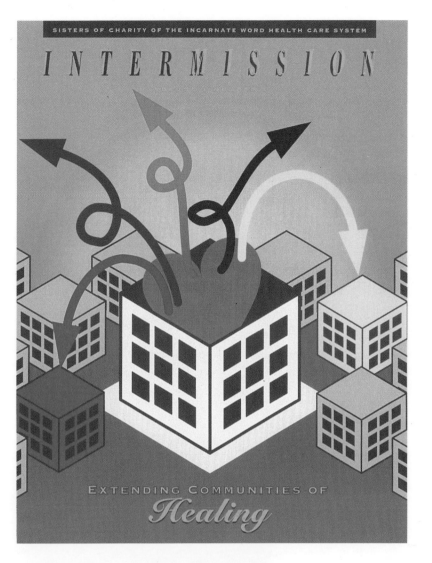

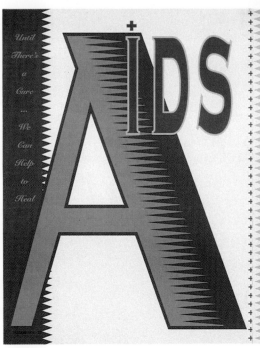

SISTERS OF CHARITY OF THE INCARNATE WORD -
HOUSTON MAGAZINE

DESIGNER ROBERT COOK
DESIGN FIRM ROBERT COOK DESIGN
SOFTWARE PAGEMAKER 4.0, ILLUSTRATOR
HARDWARE MAC IICX

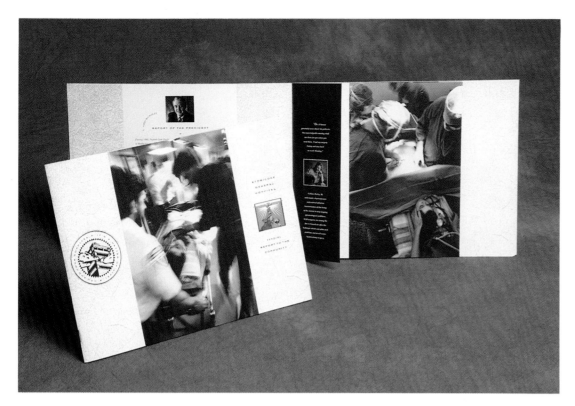

ETOBICOKE GENERAL HOSPITAL ANNUAL REPORT

DESIGNERS RIC RIORDON, SHIRLEY RIORDON, DAN WHEATON
DESIGN FIRM THE RIORDON DESIGN GROUP, INC.
SOFTWARE QUARK 3.0, ILLUSTRATOR 3.0
HARDWARE MAC IICI, IKEGAMI 19" COLOR MONITOR, SYQUEST

DEPELCHIN'S CHILDREN CENTER BROCHURE

DESIGN FIRM PEAT JARIYA DESIGN
DESIGNER PEAT JARIYA
SOFTWARE PAGEMAKER, ILLUSTRATOR, FREEHAND
HARDWARE MAC

Results for the year were disappointing, to say the least. As substantial shareholders, your management and employees are likewise dissatisfied. During the fourth quarter, sales were sluggish and we took charges against inventories and bad debts that were higher than anticipated. The year-end inventory devaluation was caused by lower prices among commodity items (primarily copper, PVC, and aluminum) which in many instances were 20%-25% below the prior year. Bad debt charges are the result of the joint problems of an increasingly competitive market place and tightening credit practices among lending institutions. ■ Our managers acted aggressively to meet these problems by taking additional charges against fourth quarter earnings. It has always been our policy to take a conservative approach toward providing for adverse market conditions. Accordingly, the bad debt provision was increased by $1.2 million, bringing our provision to 1/2% of sales. We believe the current provision to be sufficient to cover the risk in this area. We continue to maintain centralized control over this part of our business. ■ The additional inventory provision which showed up in the fourth quarter amounted to $850,000. This write-down was the result of declining prices during the fourth quarter for many commodity items purchased throughout the year. These products include plastic and copper pipe, valves, and fittings; wire and cable; refrigeration tubing; and other products which in total account for 20% of our sales. When commodity prices decline, the end-user market immediately reflects the lower cost of production. Thus, inventories purchased at the higher prices are subject to declining value. In addition to the year-end write-down, we estimate that declining commodity pricing cost us approximately $3 million which showed up throughout the year as lower gross margins. We are cautiously encouraged that pricing among at least two commodity groups (PVC and copper) has strengthened since year-end. ■ Computers are becoming an increasingly important part of our business and during 1989 we made the decision to upgrade our capability in this area. Installation of a new system is currently underway and we are convinced its full implementation will help our sales and service personnel respond to customer needs while improving asset management. ■ We continue to maintain control of expenses while trying to be certain that we don't discourage the individual growth of our people. Selling, general and administrative expenses from existing operations were up just 7% and yet we increased spending on training and recruiting by $960,000. ■ Depreciation and amortization increased $400,000 to $9.1 million. ■ In our 60 years of serving construction markets, we have never failed to make a profit. Efforts toward diversification taken in recent years have rendered us, not immune, but less exposed to cyclical markets. We are taking a long-term view by controlling expenses, improving our purchasing and pricing capabilities, while making major investments in people and systems. ■ Florida and the entire Southeast remain highly attractive growth markets which should continue to out perform other areas of the country. Sincerely,

David H. Hughes, *President & Chairman of the Board*

Dramatic second and fourth quarter declines in copper and PVC commodity prices resulted in devaluation of inventory. Management is, however, cautiously optimistic that future upswings in these two commodity groups will once again make sales in these categories solid performers, and that large process piping installations like the one shown on the opposite page will continue to account for approximately 6% of Hughes Supply, Inc.'s sales.

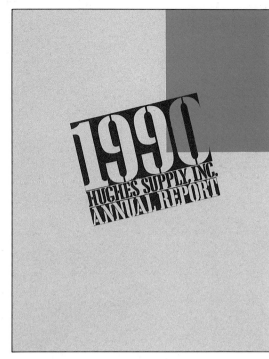

HUGHES SUPPLY, INC. ANNUAL REPORT

DESIGNER ALAN URBAN
DESIGN FIRM URBAN TAYLOR + ASSOCIATES
SOFTWARE PAGEMAKER, PHOTOSHOP, FREEHAND
HARDWARE MAC IICX (20MB), 80MB QUANTUM HD, SUPERMAC
COLOR MONITOR, MICROTEK 300Z SCANNER

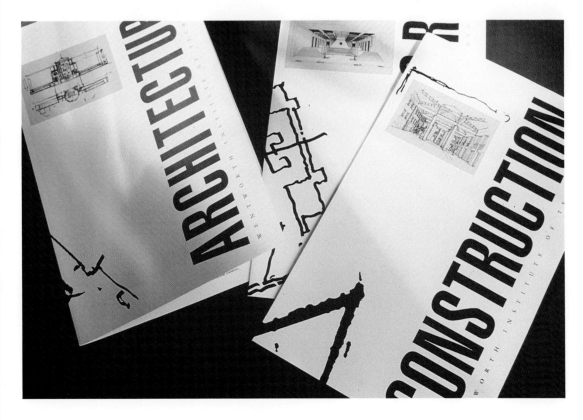

WENTWORTH INSTITUTE OF TECHNOLOGY BROCHURE

DESIGNER ROBIN PERKINS
DESIGN FIRM CLIFFORD SELBERT DESIGN
SOFTWARE PAGEMAKER, FREEHAND
HARDWARE MAC IICX

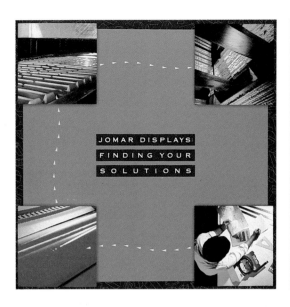

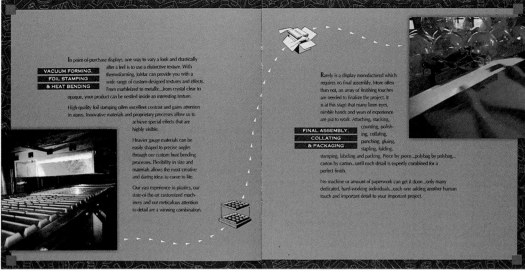

JOMAR DISPLAYS BROCHURE

DESIGNER GIL LIVNE

DESIGN FIRM NOTOVITZ DESIGN, INC.

SOFTWARE PAGEMAKER, ILLUSTRATOR, ADOBE STREAMLINE

HARDWARE MAC IIX, QMS 810 PRINTER, APPLE SCANNER, PLI

REMOVABLE DRIVE

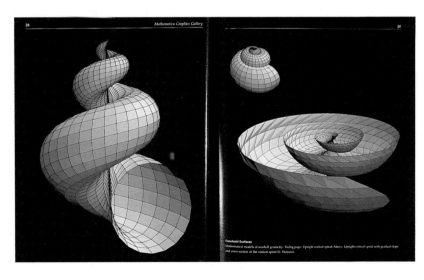

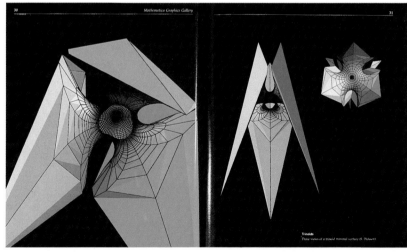

MATHEMATICA GRAPHICS GALLERY

DESIGNER JOHN BONADIES, ANDRE KUZNIAREK, FRANCES BRODT

SOFTWARE MATHEMATICA, ILLUSTRATOR, FRAMEMAKER, PHOTOSHOP

HARDWARE MAC IICX, NEXT

INSTITUTE OF CONTEMPORARY ART CATALOG

ART DIRECTOR PAUL KRONER
DESIGNERS PAUL KRONER, MARTY LAPHAM
ILLUSTRATOR ADRIENNE EPSTEIN
DESIGN FIRM LAPHAM/MILLER ASSOCIATES
SOFTWARE QUANTEL GRAPHICS PAINTBOX

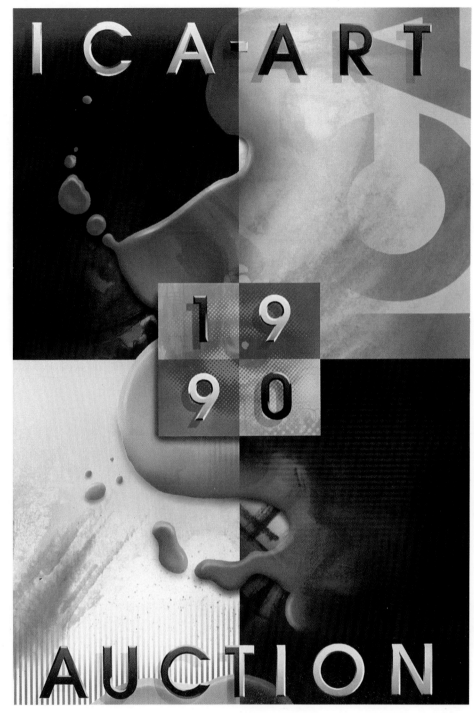

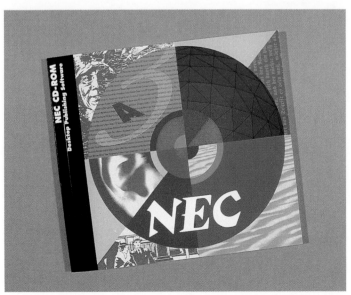

NEC TECHNOLOGIES, INC. BROCHURE

DESIGNERS STEVE LISKA, BROCK HALDEMAN, RICHARD TAYLOR
DESIGN FIRM LISKA AND ASSOCIATES, INC.
SOFTWARE QUARK, ALDUS FREEHAND, ILLUSTRATOR
HARDWARE MAC IICI, NEC CDR-73

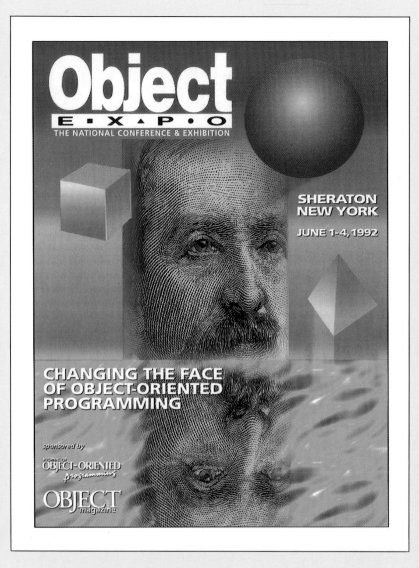

OBJECT EXPO ADVERTISER PROMO

DESIGNER SARAH HAMILTON
DESIGN FIRM S.I.G. PUBLICATION
SOFTWARE PHOTOSHOP
HARDWARE MAC IICX (32MB), DAYSTAR 50MB, POWERCARD

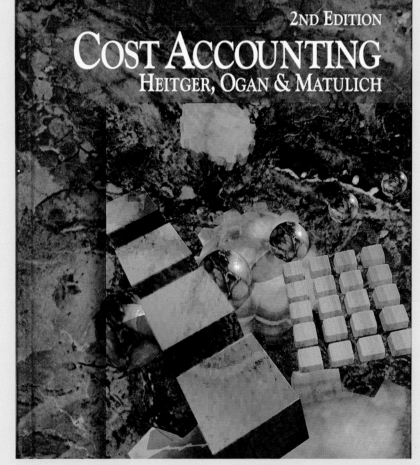

COST ACCOUNTING BOOK COVER

DESIGNER ALAN BROWN
DESIGN FIRM PHOTONICS GRAPHICS, INC.
SOFTWARE STRATAVISION, PHOTOSHOP, QUARK
HARDWARE MAC IIFX (20MB)

HENNEGAN BOOK

DESIGNER MIKE ZENDER, PRISCILLA FISHER, DAVID
STEINBRUNNER, MARY BETH MCSWIGAN, MOLLY SCHOENHOFF
DESIGN FIRM ZENDER + ASSOCIATES, INC.
SOFTWARE QUARK, FREEHAND, PHOTOSHOP
HARDWARE MAC II, IICX, IIFX

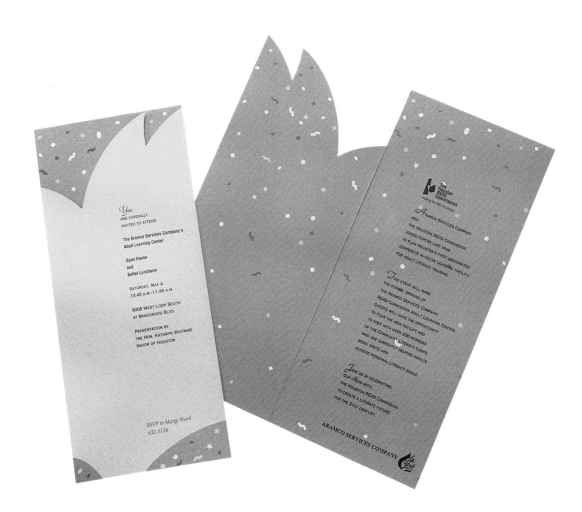

ARAMCO SERVICES COMPANY INVITATION

DESIGN FIRM PEAT JARIYA DESIGN
DESIGNER PEAT JARIYA
SOFTWARE PAGEMAKER, ILLUSTRATOR, FREEHAND
HARDWARE MAC

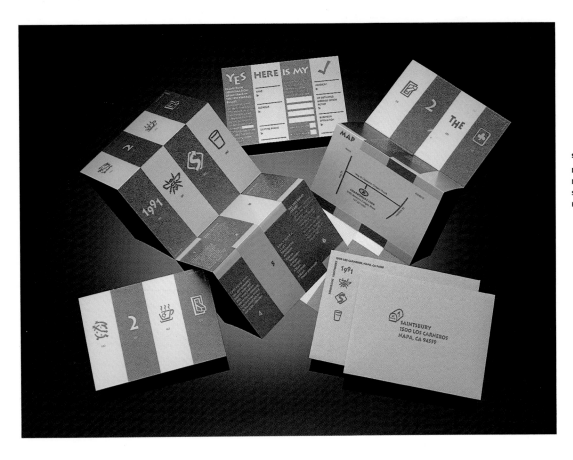

SAINTSBURY + BOUCHAINE VINEYARDS PAMPHLET

DESIGNERS JIM WALCOTT-AYERS, LIZ POLLINA
DESIGN FIRM THE WALCOTT-AYERS GROUP
SOFTWARE ILLUSTRATOR
HARDWARE MAC IICI, RADIUS 19" MONITOR

San Francisco AIGA Poster

Designer Jennifer Morla, Jeanette Aramburu
Design Firm Morla Design
Software PageMaker, Photoshop
Hardware Mac IIcx

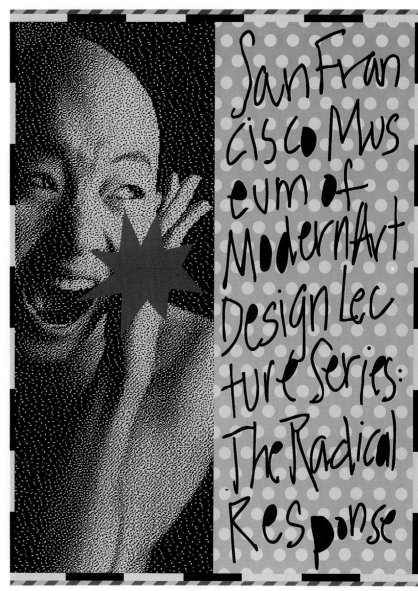

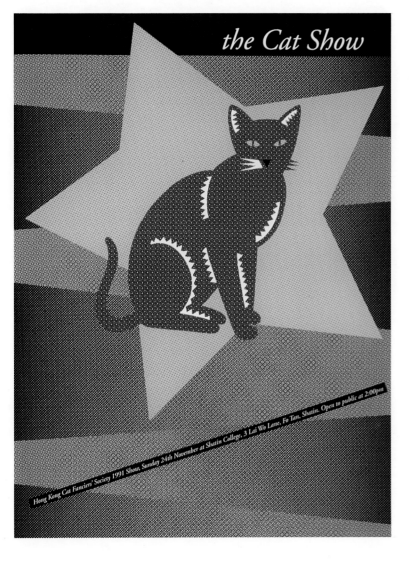

Hong Kong Cat Fanciers' Society Poster

Designer Victor Cheong
Design Firm Victor Cheong & Associates
Software Aldus Freehand 3.0
Hardware Mac IIci

PERCUSSION GROUP POSTER

DESIGN FIRM ZENDER + ASSOC. INC.
DESIGNER MIKE ZENDER
SOFTWARE LIGHTSPEED, PIXEL PAINT, FREEHAND
HARDWARE MAC II, IICX, IIFX

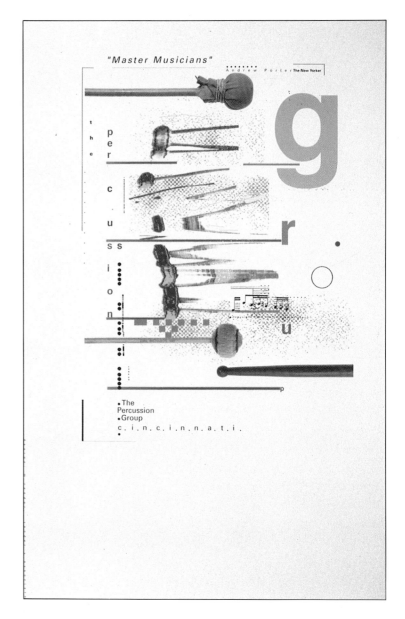

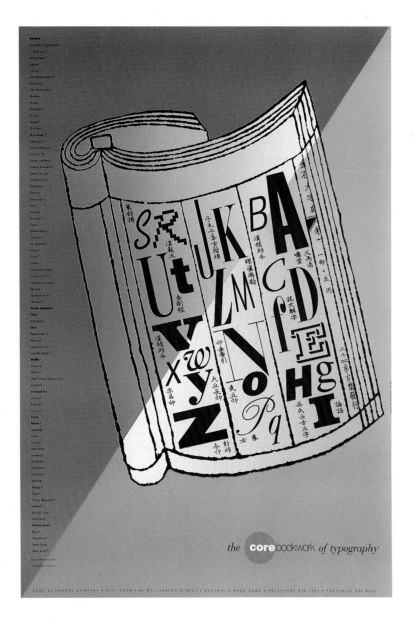

CORE BOOKWORK TYPESETTING CO. POSTER

DESIGN FIRM VICTOR CHEONG & ASSOC.
DESIGNER VICTOR CHEONG
SOFTWARE FREEHAND
HARDWARE MAC IICI

METRO THEATER COMPANY MAILER/POSTER

DESIGN FIRM **DESIGN II**
DESIGNER **ROBB SPRINGFIELD**
SOFTWARE **FREEHAND**
HARDWARE **MAC IICX, MICROTEK SCANNER 600ZS**

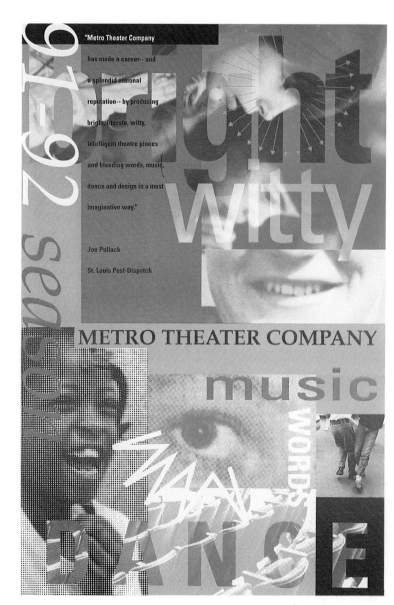

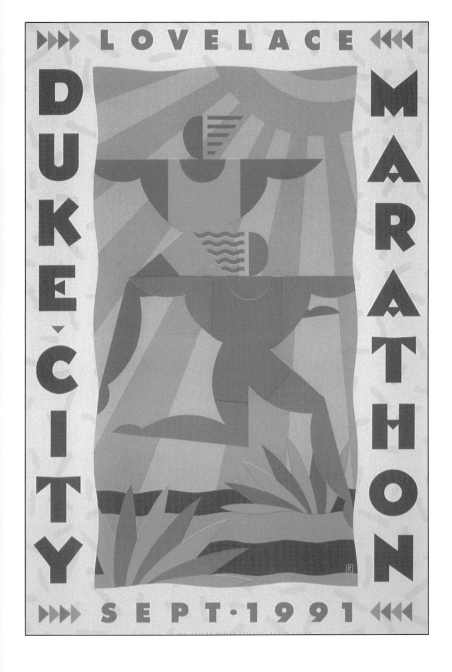

DUKE CITY MARATHON POSTER

DESIGN FIRM **VAUGHN/WEDEEN CREATIVE**
DESIGNER **RICK VAUGHN**
SOFTWARE **ILLUSTRATOR**
HARDWARE **MAC IICX**

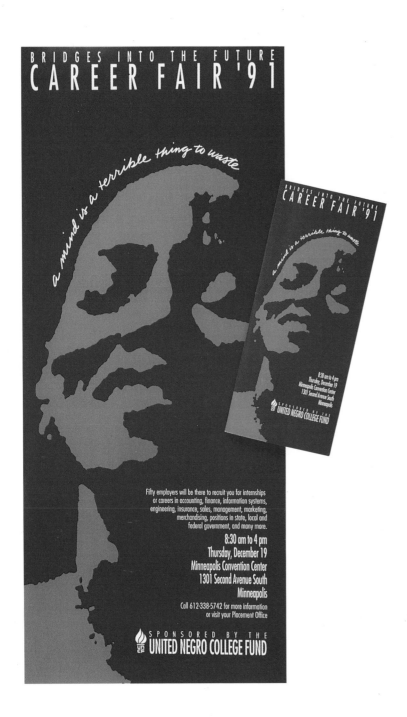

UNITED NEGRO COLLEGE FUND POSTER AND BROCHURE

DESIGNER LESLIE HACKING
DESIGN FIRM CREATIVE RESOURCE CENTER
SOFTWARE ILLUSTRATOR
HARDWARE MAC IICI

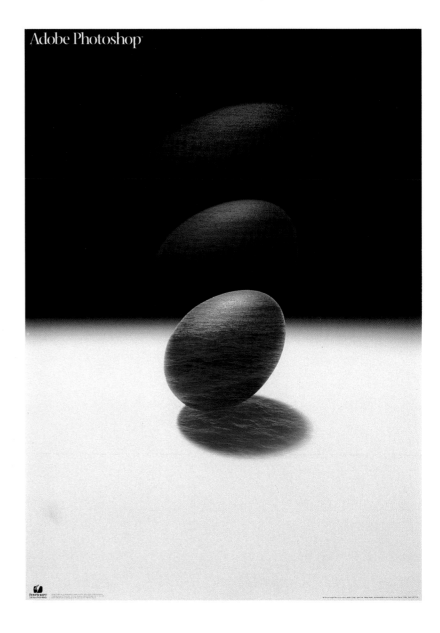

ADOBE SYSTEMS INC. POSTER

DESIGNER SUSUMU ENDO
SOFTWARE PHOTOSHOP
HARDWARE MAC IIFX

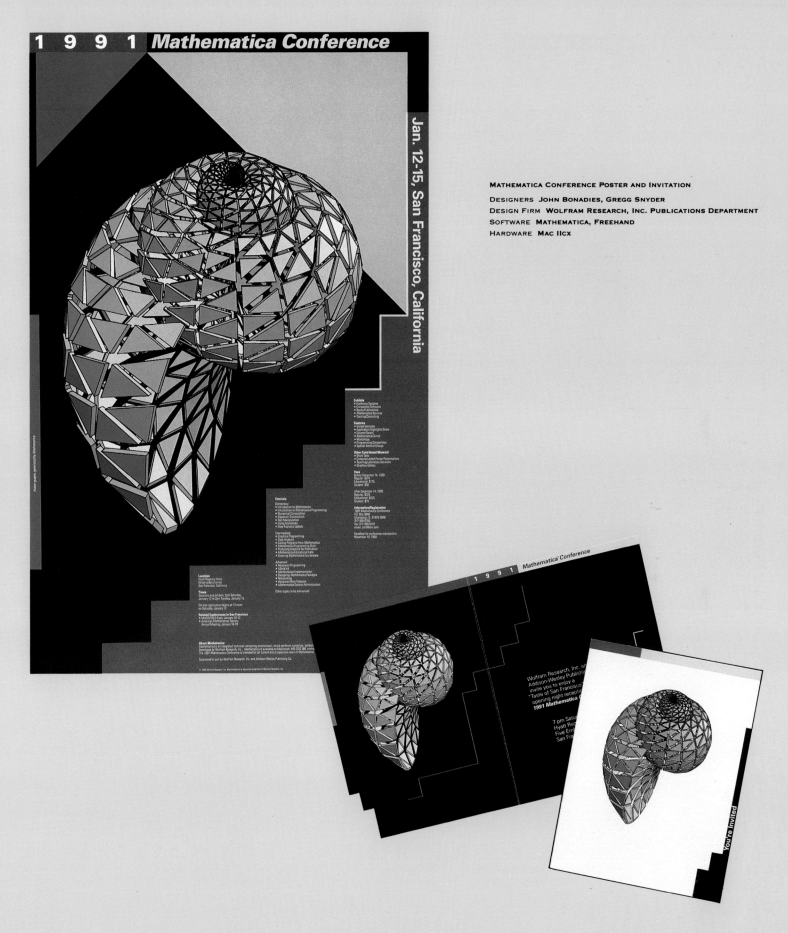

MATHEMATICA CONFERENCE POSTER AND INVITATION

DESIGNERS JOHN BONADIES, GREGG SNYDER

DESIGN FIRM WOLFRAM RESEARCH, INC. PUBLICATIONS DEPARTMENT

SOFTWARE MATHEMATICA, FREEHAND

HARDWARE MAC IICX

GRAPHIC DESIGN

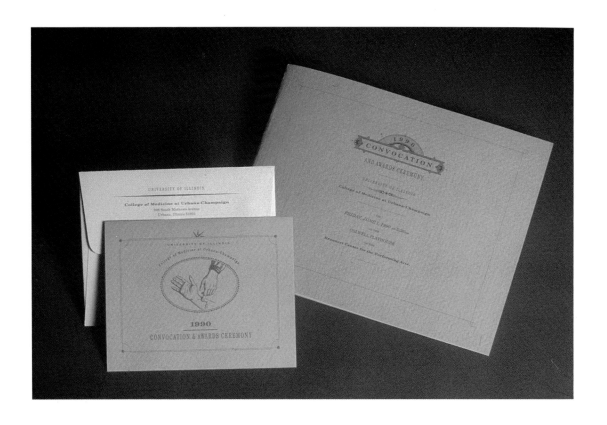

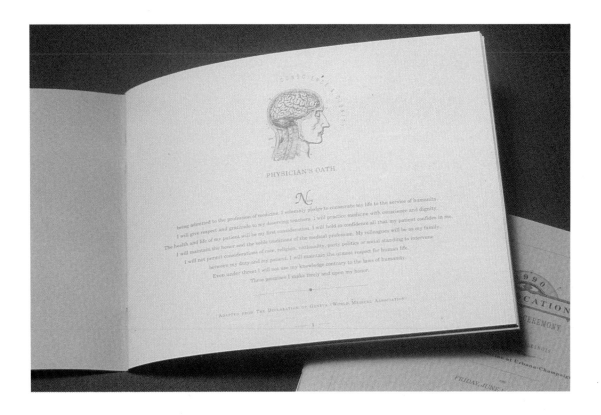

UNIVERSITY OF ILLINOIS AT URBANA-CHAMPAIGN COLLEGE OF
MEDICINE COMMENCEMENT PROGRAM AND INVITATION

DESIGNER KATHLEEN CHMELEWSKI
SOFTWARE PAGEMAKER, ALDUS FREEHAND
HARDWARE MAC SE, ABATON SCANNER

Fall Dance Season

at the Herbst Theater San Francisco

September 1987

5 th Cheryl Chaddick Dance Group
16th The Martha Graham Company
24th The New York Ballet
29th Merce Cunningham and Friends

all events at 8 p.m.

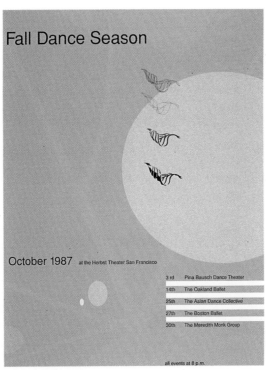

Fall Dance Season

October 1987 at the Herbst Theater San Francisco

3 rd Pina Bausch Dance Theater
14th The Oakland Ballet
25th The Asian Dance Collective
27th The Boston Ballet
30th The Meredith Monk Group

all events at 8 p.m.

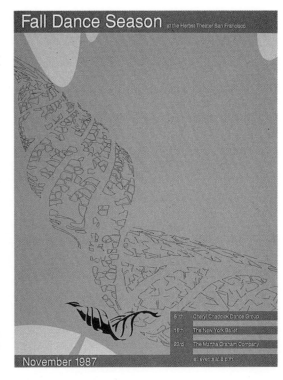

Fall Dance Season at the Herbst Theater San Francisco

5 th Cheryl Chaddick Dance Group
16th The New York Ballet
23rd The Martha Graham Company

November 1987 all events at 8 p.m.

APPLE COMPUTER POSTERS

DESIGNER MICHAEL RENNER
DESIGN FIRM APPLE COMPUTER CREATIVE SERVICES
SOFTWARE ILLUSTRATOR (BETA)
HARDWARE MAC PLUS

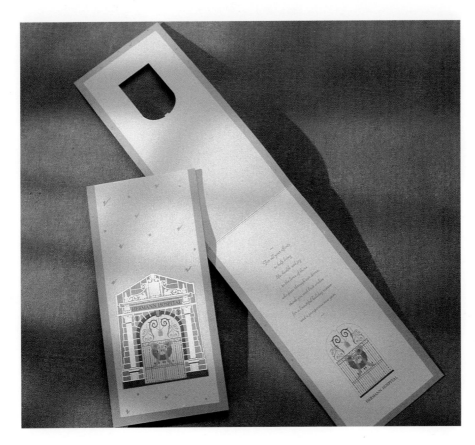

HERMANN HOSPITAL CARD

DESIGN FIRM PEAT JARIYA DESIGN
DESIGNER PEAT JARIYA
SOFTWARE PAGEMAKER, ILLUSTRATOR, FREEHAND
HARDWARE MAC

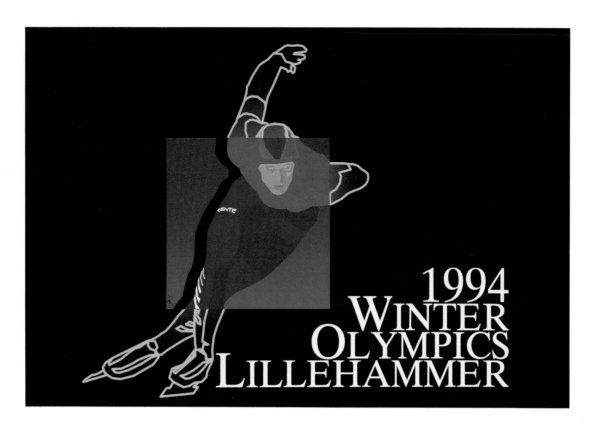

DANIEL BORIS SELF-PROMO POSTER

DESIGNER **DANIEL BORIS**
SOFTWARE **GENIGRAPHICS**
HARDWARE **GENIGRAPHICS**

DANIEL BORIS SELF-PROMO POSTER

DESIGNER **DANIEL BORIS**
SOFTWARE **GENIGRAPHICS**
HARDWARE **GENIGRAPHICS**

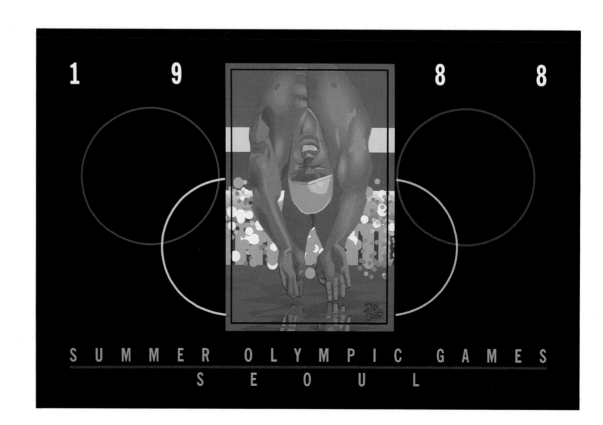

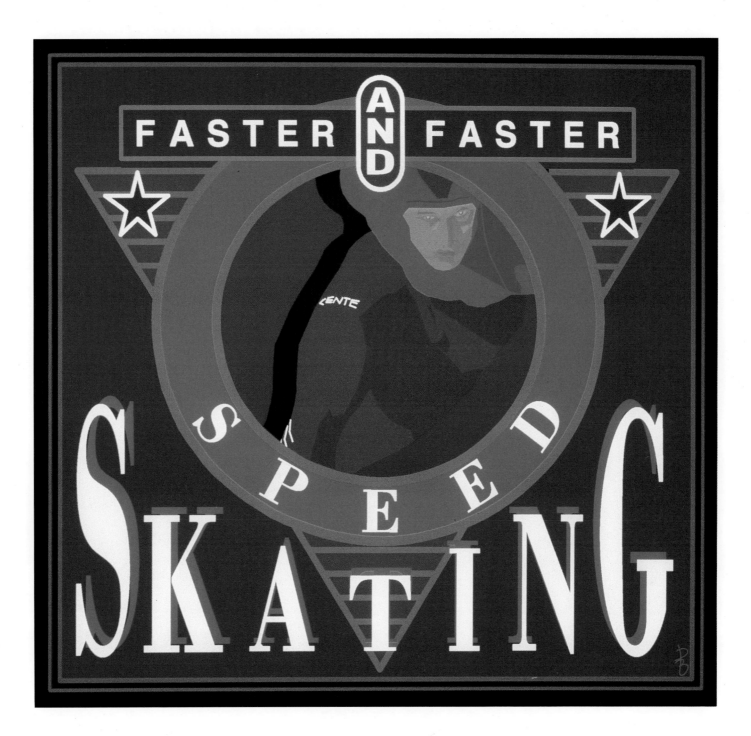

Daniel Boris Self-Promo Poster

Designer Daniel Boris
Software Genigraphics
Hardware Genigraphics

BASEL SCHOOL OF DESIGN POSTERS

DESIGNER MICHAEL RENNER
DESIGN FIRM MICHAEL RENNER DESIGN
SOFTWARE PHOTOSHOP 1.0, ILLUSTRATOR 3.0, SEPARATOR 2.0
HARDWARE MAC IICI (4MB), 80MB HD

BASEL SCHOOL OF DESIGN POSTER

DESIGNER MICHAEL RENNER
DESIGN FIRM MICHAEL RENNER DESIGN
SOFTWARE ILLUSTRATOR 3.0, PHOTOSHOP 1.17/2.0
HARDWARE MAC II, SYQUEST DRIVE

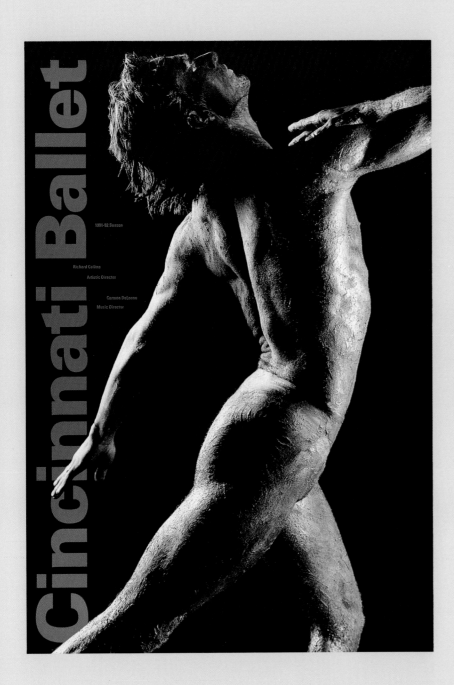

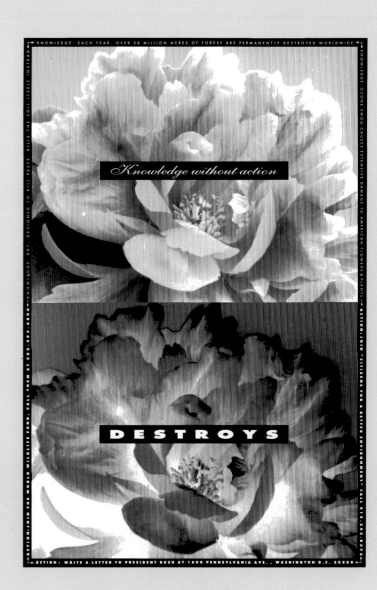

AMERICAN INSTITUTE OF GRAPHIC ARTS POSTER

DESIGNERS JENNIFER MORLA, SHARRIE BROOKS
DESIGN FIRM MORLA DESIGN
SOFTWARE PAGEMAKER, ILLUSTRATOR
HARDWARE MAC IICX

CINCINNATI BALLET POSTER

DESIGNER CHARLEEN CATT LYON
ILLUSTRATOR/PHOTOGRAPHER ALAN BROWN, PHOTONICS GRAPHICS
DESIGN FIRM CATT LYON DESIGN
SOFTWARE PHOTOSHOP
HARDWARE MAC IIFX

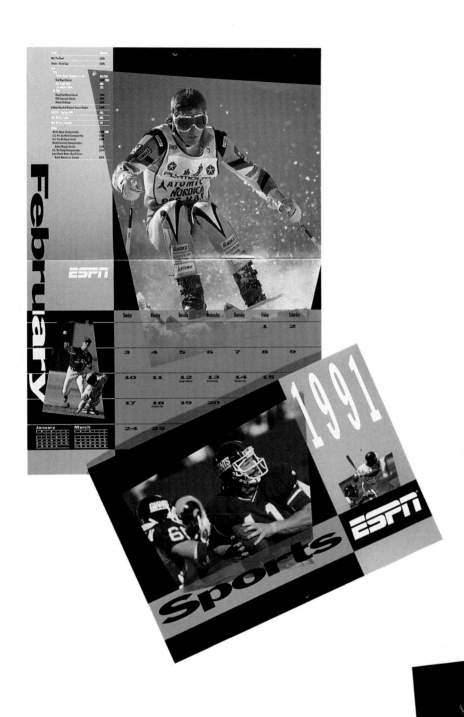

ESPN Calendar

Design Firm Handler Group, Inc.
Designer Tom Dolle
Software Quark
Hardware Mac IIcx

Special Olympics Invitation

Designers Marc Kundmann, Nancy Whittlesey
Design Firm Larsen Design Office, Inc.
Software Freehand 2.02, DeskPaint
Hardware Mac IIci, Microtek Color Scanner

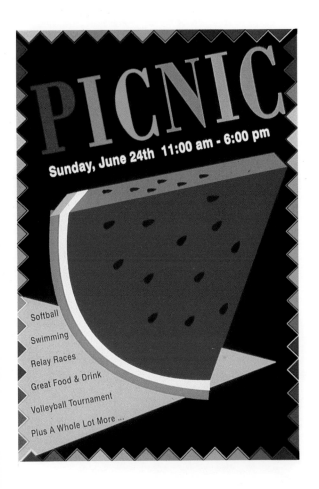

TOWERS PERRIN POSTER

ART DIRECTOR JIM KOHLER
DESIGNER ERIC JOHNSON
DESIGN FIRM TOWERS PERRIN
SOFTWARE ZENOGRAPHIC MIRAGE
HARDWARE COMPAQ 486

ADVERTISING FEDERATION OF GREATER MIAMI POSTER

DESIGNER ALAN URBAN
DESIGN FIRM URBAN TAYLOR + ASSOCIATES
SOFTWARE PHOTOSHOP 1.0.7, FREEHAND
HARDWARE MAC IICX (20MB), 80MB QUANTUM HD, SUPERMAC
COLOR MONITOR, MICROTEK 300Z SCANNER

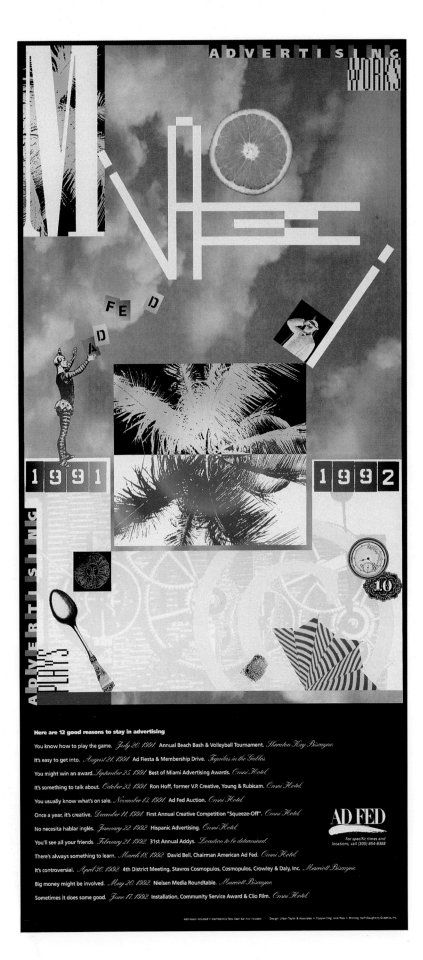

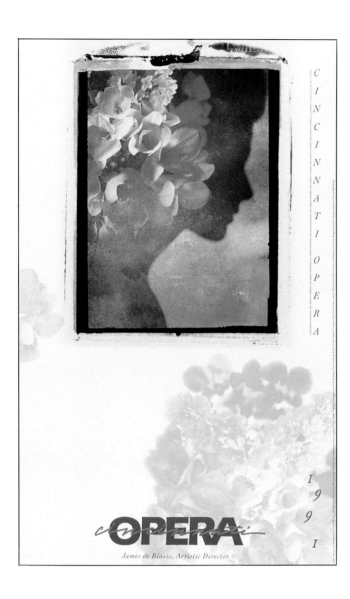

CINCINNATI OPERA POSTER

DESIGNER **LIZ KATHMAN GRUBOW**
ILLUSTRATOR **ALAN BROWN, PHOTONICS GRAPHICS**
SOFTWARE **PHOTOSHOP, COLOR STUDIO**
HARDWARE **MAC IIFX**

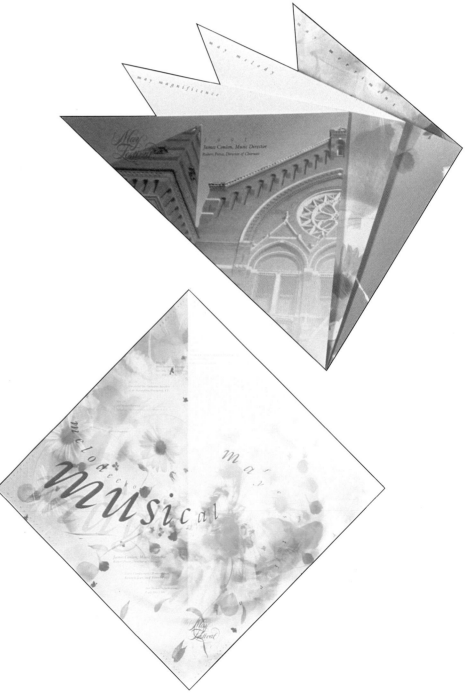

MAY FESTIVAL POSTER/BROCHURE

DESIGNER **MOLLY SCHOENHOFF**
DESIGN FIRM **ZENDER + ASSOCIATES, INC.**
SOFTWARE **FREEHAND, PHOTOSHOP**
HARDWARE **MAC II, IICX, IIFX**

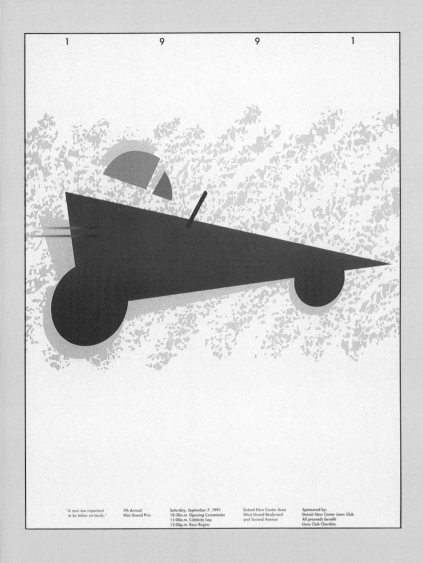

1 9 9 1

"A race too important 7th Annual Saturday, September 7, 1991 Detroit New Center Area Sponsored by:
to be taken seriously." Mini Grand Prix 10:30a.m. Opening Ceremonies West Grand Boulevard Detroit New Center Lions Club
 11:00a.m. Celebrity Lap and Second Avenue All proceeds benefit
 12:00p.m. Race Begins Lions Club Charities.

NEW CENTER LIONS CLUB POSTER

DESIGNER BETH ANN KNISELY
DESIGN FIRM COLORPOINTE DESIGN, INC.
SOFTWARE ILLUSTRATOR
HARDWARE MAC

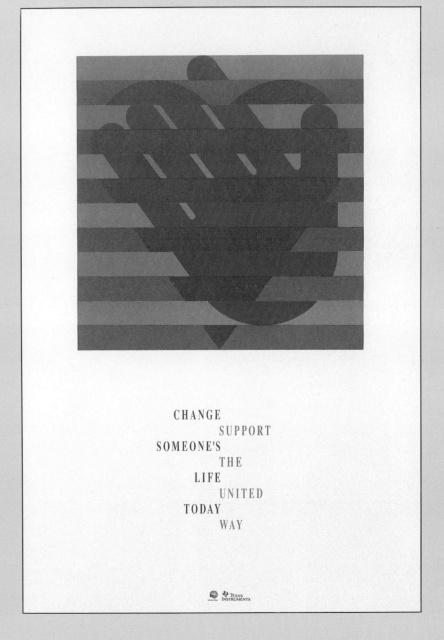

CHANGE
 SUPPORT
SOMEONE'S
 THE
 LIFE
 UNITED
TODAY
 WAY

TEXAS INSTRUMENTS

TEXAS INSTRUMENTS FOR UNITED WAY OF TEXAS POSTER

DESIGNER JOE RATTAN
COMPUTER LORI WALLS
DESIGN FIRM JOSEPH RATTAN DESIGN
SOFTWARE QUARK, ILLUSTRATOR
HARDWARE MAC IIFX

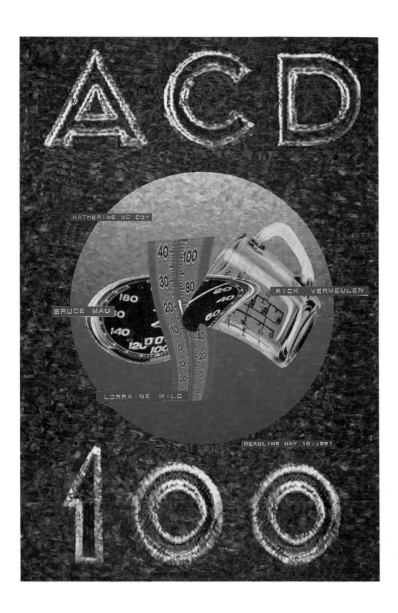

American Center for Design Poster

Designer Timothy O'Keeffe
Design Firm Cranbrook Academy of Art Design Department
Software Quark, Photoshop
Hardware Mac IIfx, Canon Video Visualizer, Mac Flatbed Scanner, PLI Infinity 40

Duke City Marathon Poster

Designer Rick Vaughn
Design Firm Vaughn/Wedeen Creative
Software Illustrator 3.0
Hardware Mac IIci, Radius 19" Color Monitor

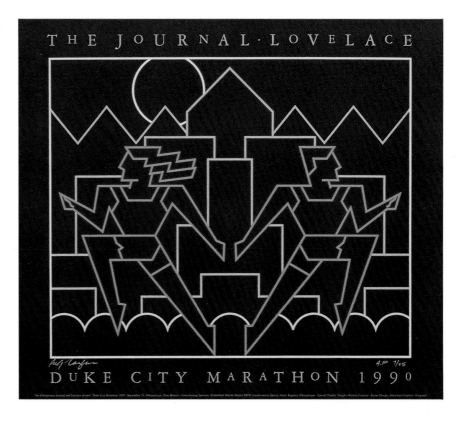

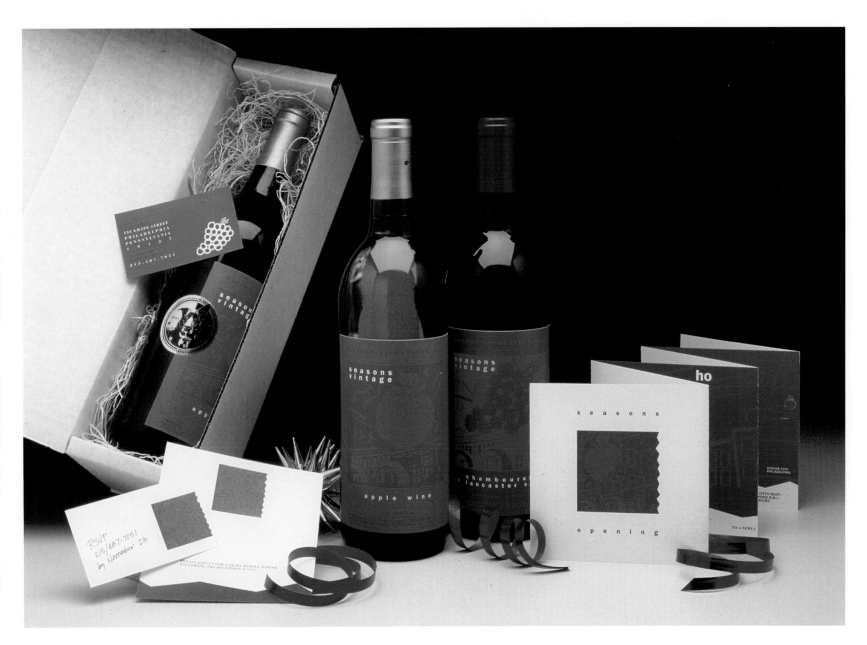

HANSON ASSOCIATES SELF-PROMO

DESIGNERS GIL HANSON, DEBORAH MCSORLEY
DESIGN FIRM HANSON ASSOCIATES, INC.
SOFTWARE ILLUSTRATOR 3.01
HARDWARE MAC IICI

SELF PROMO & COMPTON PRESS POSTER

DESIGNER GIL LIVNE

DESIGN FIRM NOTOVITZ DESIGN, INC.

SOFTWARE ILLUSTRATOR 3.0, ADOBE STREAMLINE

HARDWARE MAC IICI, QMS 810, APPLE SCANNER, PLI REMOVABLE
40MB DRIVE

VIKING GRAPHICS POSTER

DESIGNERS ROBERT QUALLY, KARLA WALUSIAK
DESIGN FIRM QUALLY & COMPANY, INC.
SOFTWARE SCITEX
HARDWARE HEWLETT-PACKARD, INTEL

JONES LANG WOOTTON MAP/POSTER

DESIGNER GAIL WIGGIN
ILLUSTRATOR MARTIN HAGGLAND/MICROCOLOR, INC.
DESIGN FIRM WIGGIN DESIGN
SOFTWARE ILLUSTRATOR
HARDWARE MAC IIX

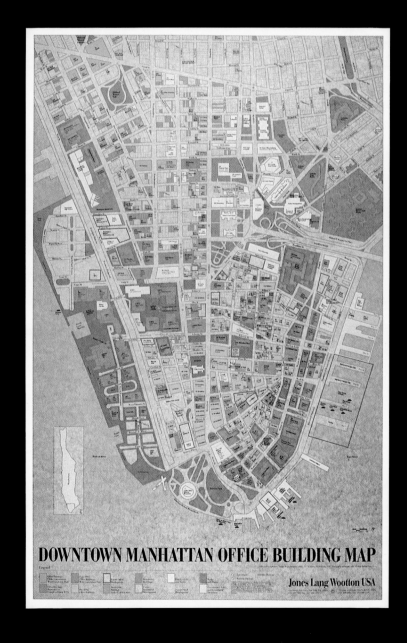

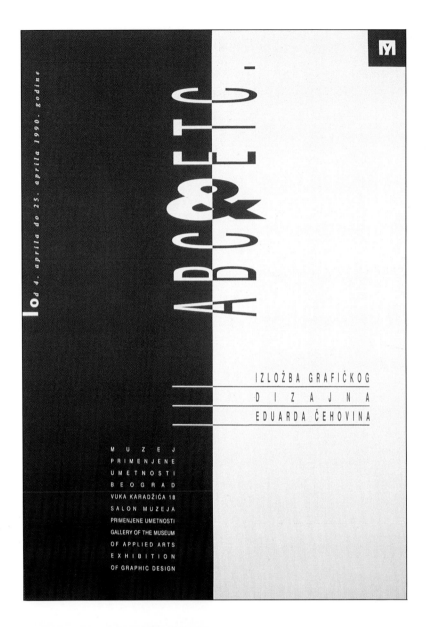

EDUARD CEHOVIN SELF-PROMO POSTER AND INVITATION FOR
PERSONAL EXHIBITION

DESIGNER EDUARD CEHOVIN
DESIGN FIRM A±B (ART MORE OR LESS BUSINESS)
SOFTWARE FREEHAND
HARDWARE MAC IICI

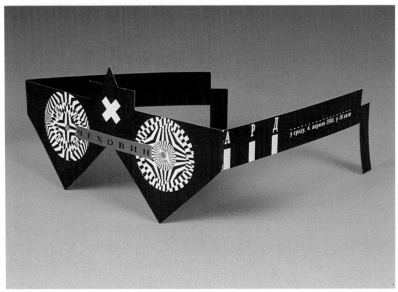

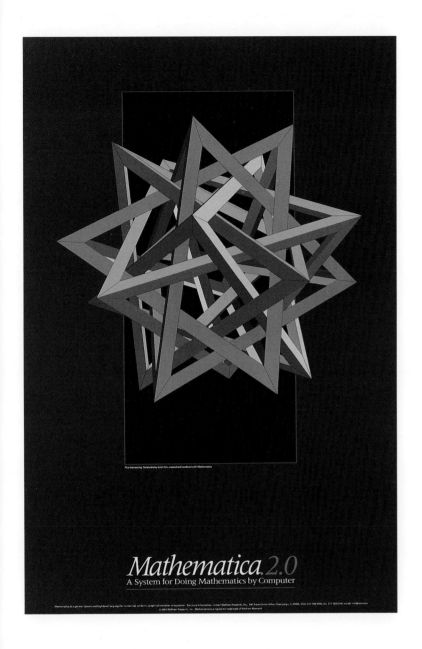

MATHEMATICA POSTER

DESIGNER **JOHN BONADIES**
SOFTWARE **MATHEMATICA, ILLUSTRATOR**
HARDWARE **MAC IICX**

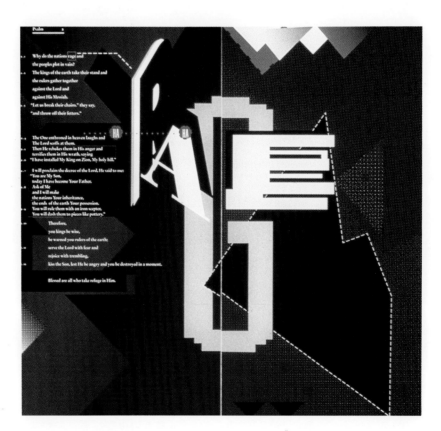

Z+ POSTER

DESIGNER **MIKE ZENDER**
DESIGN FIRM **ZENDER + ASSOCIATES, INC.**
SOFTWARE **FREEHAND**
HARDWARE **MAC II, IICX, IIFX**

GRAPHIC DESIGN

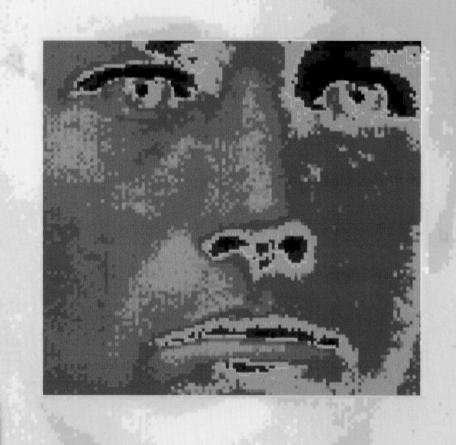

ILLUSTRATION

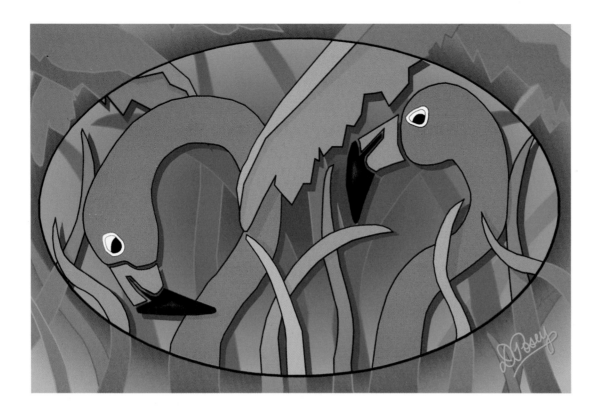

INTERLUDE

DESIGNER DAVID POSEY
SOFTWARE GENIGRAPHICS
HARDWARE GENIGRAPHICS 100D+

AV VIDEO MAGAZINE COVER
INDEXING

DESIGNER STEVE HARLAN
SOFTWARE PAINT
HARDWARE MANAGEMENT GRAPHICS VISTAR

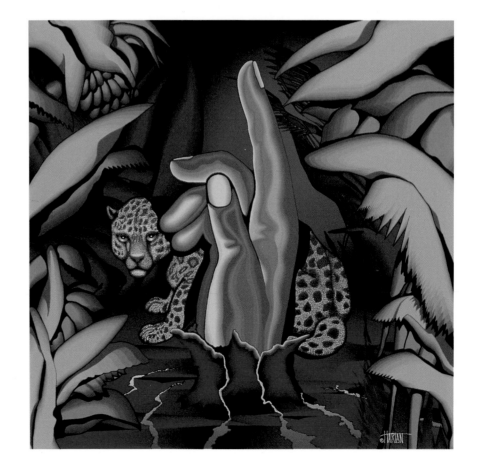

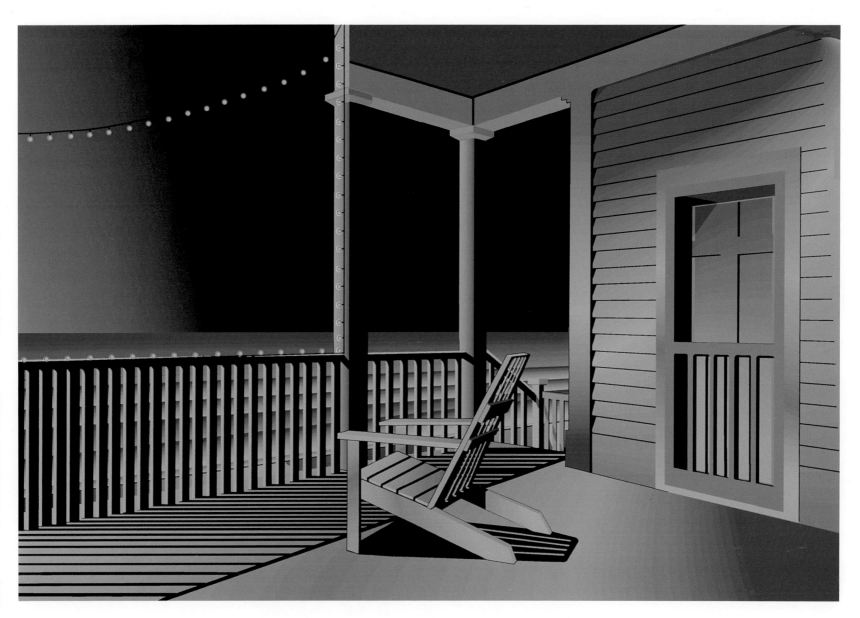

COMPUTER GRAPHICS WORLD MAGAZINE COVER
COOL PORCH

DESIGNER STEVE HARLAN
SOFTWARE PAINT
HARDWARE MANAGEMENT GRAPHICS VISTAR

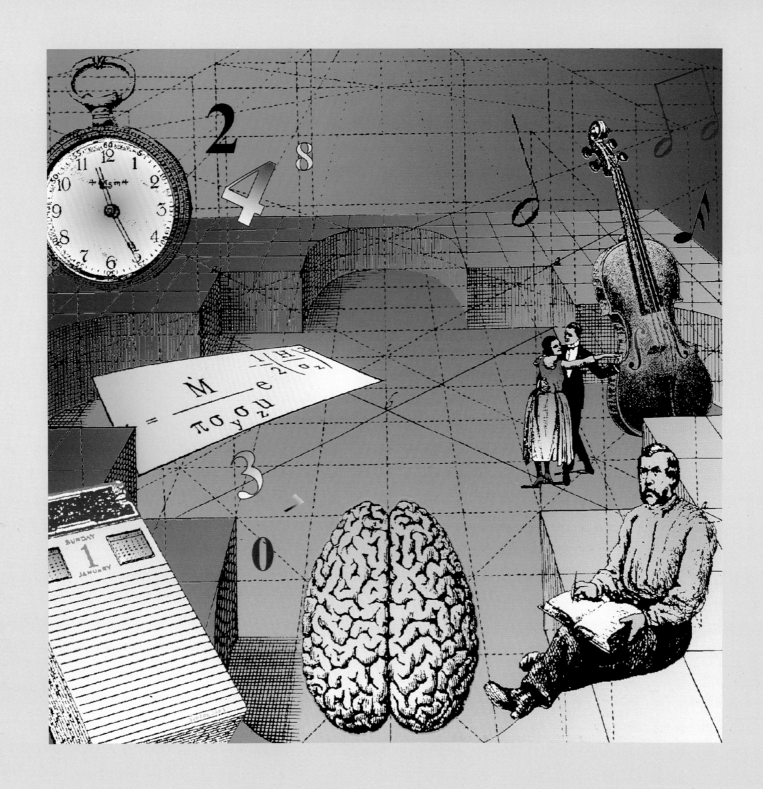

VIKING PENGUIN BOOK COVER

ILLUSTRATOR MARC YANKUS
SOFTWARE PHOTOSHOP
HARDWARE MAC IICX (32MB), SUPERMAC 19" MONITOR

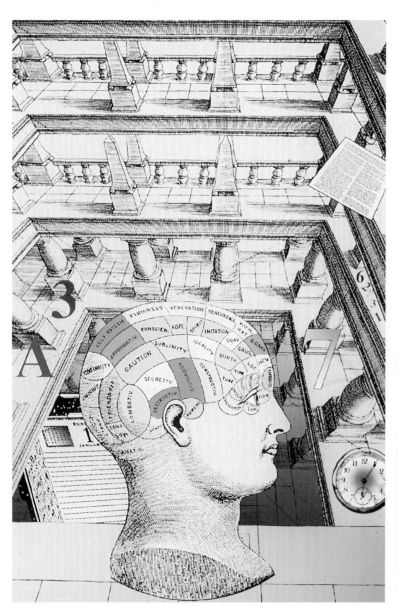

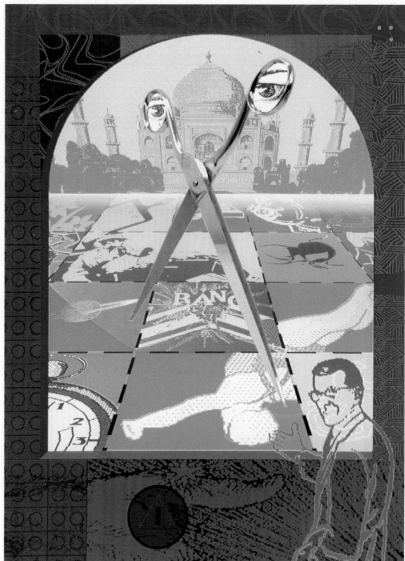

VIKING PENGUIN BOOK COVER

ILLUSTRATOR MARC YANKUS
SOFTWARE PHOTOSHOP
HARDWARE MAC IICX (32MB), SUPERMAC 19" MONITOR

MACWORLD MAGAZINE ILLUSTRATION

DESIGNERS ERIK ADIGARD, PATRICIA McSHANE
DESIGN FIRM M.A.D.
SOFTWARE PHOTOSHOP, ILLUSTRATOR
HARDWARE MAC IIFX, MICROTEK COLOR/GRAY SCANNER

ILLUSTRATION

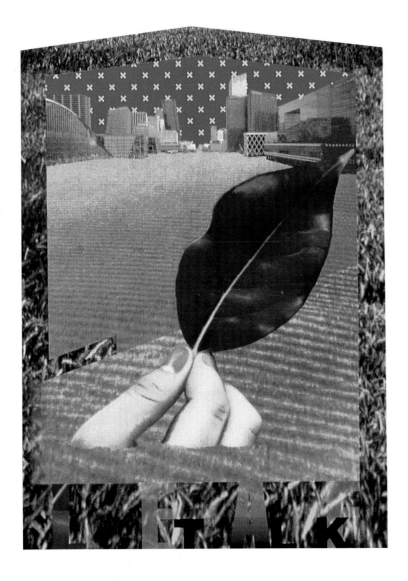

ADOBE SYSTEMS PROMO

DESIGNERS **ERIK ADIGARD, PATRICIA MCSHANE**
DESIGN FIRM **M.A.D.**
SOFTWARE **PHOTOSHOP**
HARDWARE **MAC IIFX, MICROTEK COLOR/GRAY SCANNER**

DESIGNER **DAVID CROSSLEY**
DESIGN FIRM **LIQUID PIXEL**
SOFTWARE **PHOTOSHOP, MONET, PAINTER, COLOR STUDIO**
HARDWARE **MAC IICX (8/330)**

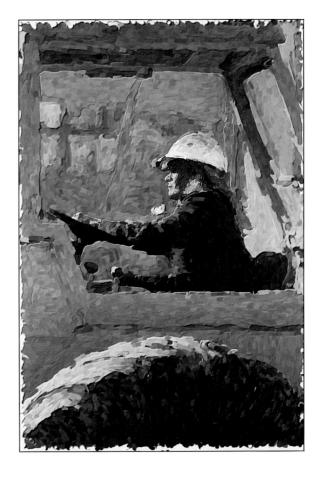

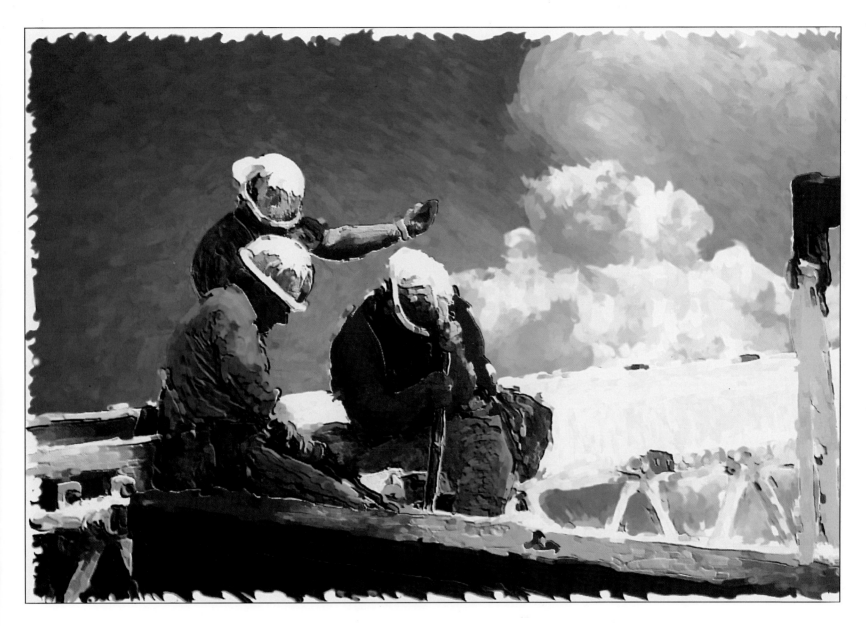

DESIGNER DAVID CROSSLEY
DESIGN FIRM LIQUID PIXEL
SOFTWARE PHOTOSHOP, MONET, PAINTER, COLOR STUDIO
HARDWARE MAC IICX, (8/330)

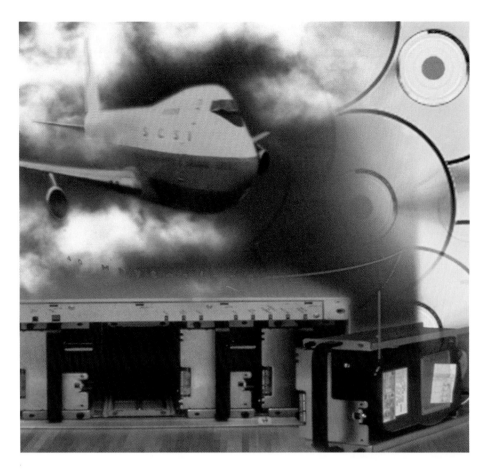

LAN Technology Magazine Illustration

Designers Erik Adigard, Patricia McShane
Design Firm M.A.D.
Software Photoshop
Hardware Mac IIfx, Microtek Color/Gray Scanner

Your Money Magazine Illustration

Illustrator Marc Yankus
Designer Beth Ceisel
Software Photoshop
Hardware Mac IIcx (32MB), Daystar 50-MB Power Card

MILL HOLLOW MAGAZINE ILLUSTRATION

ILLUSTRATOR MARC YANKUS
SOFTWARE PHOTOSHOP
HARDWARE MAC IICX (32MB), SUPERMAC 19" MONITOR

VIEWPOINT SELF-PROMO MAGAZINE AD

DESIGNER MATTHEW HAUSMAN
DESIGN FIRM VIEWPOINT COMPUTER ANIMATION
SOFTWARE ALIAS SOFTWARE
HARDWARE SILICON GRAPHICS 4D WORKSTATION

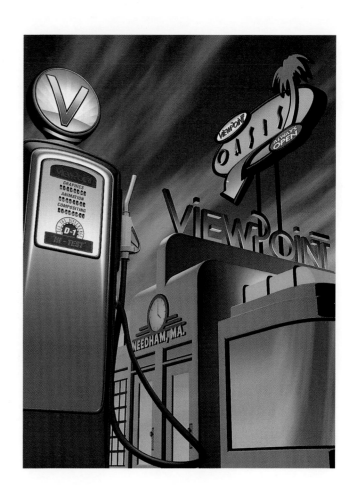

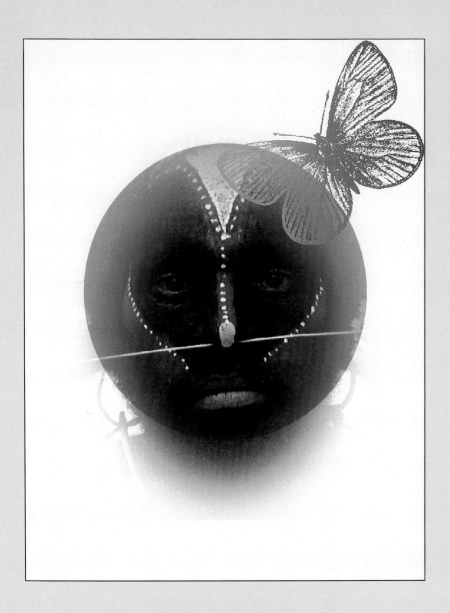

TRAVEL LIFE MAGAZINE ILLUSTRATION

ILLUSTRATOR MARC YANKUS
SOFTWARE PHOTOSHOP
HARDWARE MAC IICX (32MB), DAYSTAR 50-MB POWERCARD

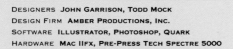

DESIGNERS JOHN GARRISON, TODD MOCK
DESIGN FIRM AMBER PRODUCTIONS, INC.
SOFTWARE ILLUSTRATOR, PHOTOSHOP, QUARK
HARDWARE MAC IIFX, PRE-PRESS TECH SPECTRE 5000

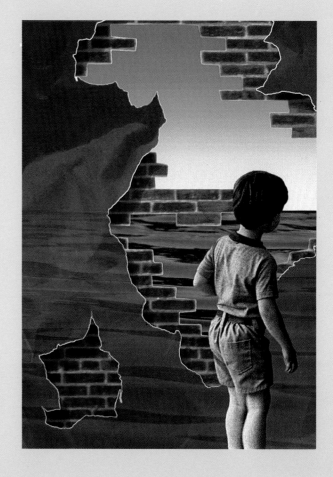

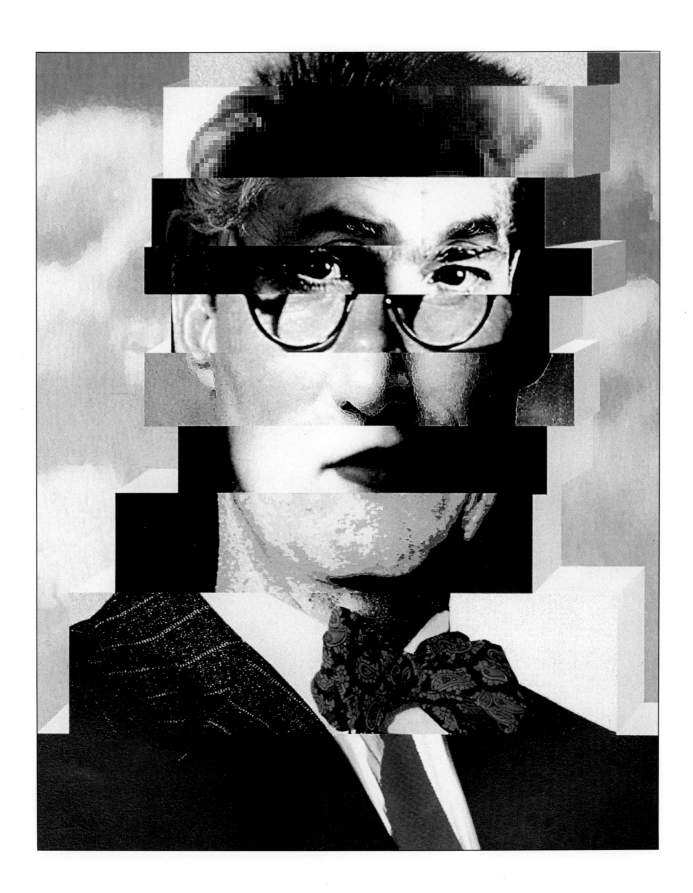

HOW MAGAZINE

ILLUSTRATOR ALAN BROWN/PHOTONICS GRAPHICS
SOFTWARE PHOTOSHOP
HARDWARE MAC IIFX

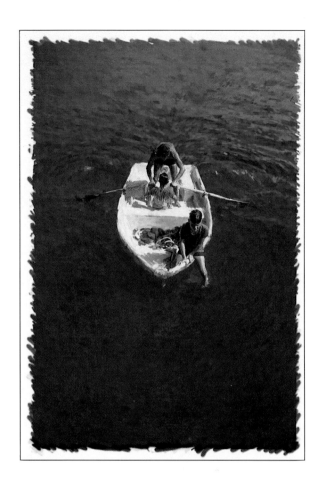

DESIGNER DAVID CROSSLEY
DESIGN FIRM LIQUID PIXEL
SOFTWARE PHOTOSHOP, MONET, PAINTER, COLOR STUDIO
HARDWARE MAC IICX (8/330)

PRICE WATERHOUSE BROCHURE

ILLUSTRATOR MARC YANKUS
DESIGNER REA ACKERMAN
SOFTWARE PHOTOSHOP
HARDWARE MAC IICX (32MB), DAYSTAR 50-MB POWER CARD

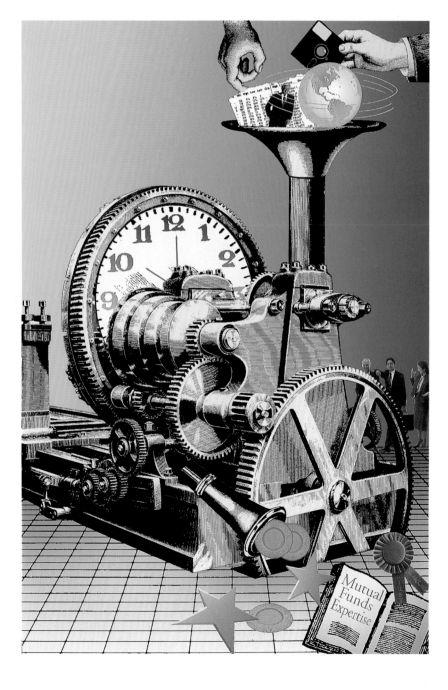

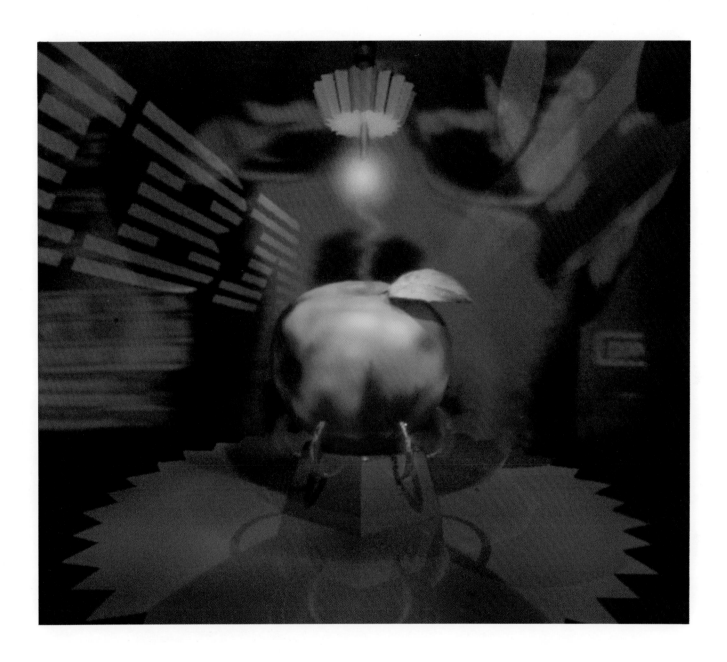

MACWORLD MAGAZINE ILLUSTRATION

DESIGNERS ERIK ADIGARD, PATRICIA MCSHANE
DESIGN FIRM M.A.D.
SOFTWARE PHOTOSHOP, ILLUSTRATOR
HARDWARE MAC IIFX, MICROTEK COLOR/GRAY SCANNER

DESIGNER DAVID CROSSLEY
DESIGN FIRM LIQUID PIXEL
SOFTWARE PHOTOSHOP, MONET, PAINTER, COLOR STUDIO
HARDWARE MAC IICX (8/330)

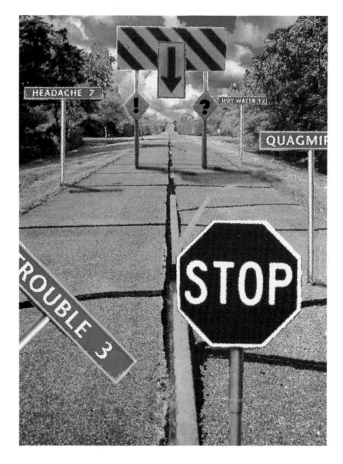

CALIFORNIA TRUCLEAR

DESIGNER DON WOO
DESIGN FIRM ELECTRONIC ARTS
SOFTWARE STUDIO 32
HARDWARE MAC IIFX

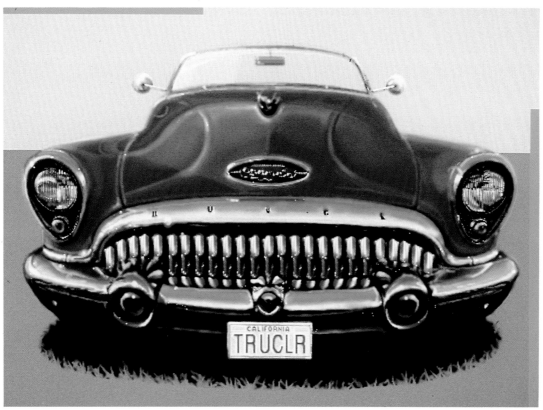

THE COMPLETE MIDI STUDIO

ILLUSTRATOR ADAM COHEN
DESIGNER MARC NEEDLEMAN
SOFTWARE PHOTOSHOP
HARDWARE MAC IIFX

THE COLORADO PROGRESSIVE AUTO INSURANCE CO.

ILLUSTRATOR ADAM COHEN
ART DIRECTOR SARA BURRIS
SOFTWARE PHOTOSHOP
HARDWARE MAC IIFX

VIKING PENGUIN BOOK COVER

ILLUSTRATOR MARC YANKUS
SOFTWARE PHOTOSHOP
HARDWARE MAC IICX (32MB), SUPERMAC 19" MONITOR

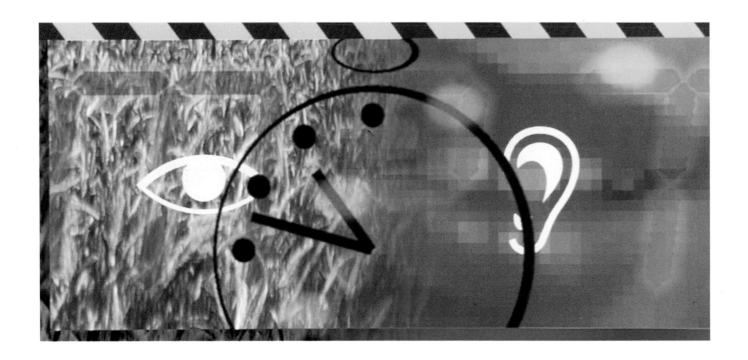

ELECTRONIC MUSICIAN MAGAZINE ILLUSTRATION

DESIGNERS ERIK ADIGARD, PATRICIA MCSHANE
DESIGN FIRM M.A.D.
SOFTWARE PHOTOSHOP, ILLUSTRATOR
HARDWARE MAC IIFX, MICROTEK COLOR/GRAY SCANNER

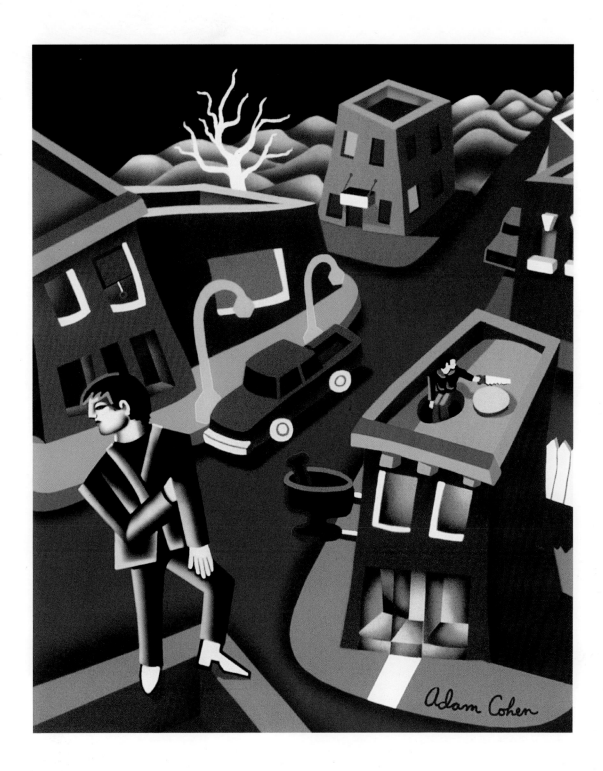

DRUGSTORE COWBOY

ILLUSTRATOR ADAM COHEN
DESIGNER VICTOR WEAVER
SOFTWARE PHOTOSHOP
HARDWARE MAC IIFX

DESIGNER DAVID CROSSLEY
DESIGN FIRM LIQUID PIXEL
SOFTWARE PHOTOSHOP, MONET, PAINTER, COLOR STUDIO
HARDWARE MAC IICX/8/330

We Deliver

ILLUSTRATOR **ADAM COHEN**
DESIGNER **MARC NEEDLEMAN**
SOFTWARE **PHOTOSHOP**
HARDWARE **MAC IIFX**

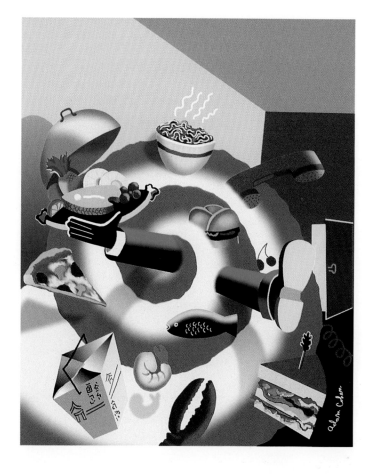

ELECTRONIC ARTS ILLUSTRATION

DESIGNER **DON WOO**
DESIGN FIRM **ELECTRONIC ARTS**
SOFTWARE **STUDIO/32**
HARDWARE **MAC IIFX**

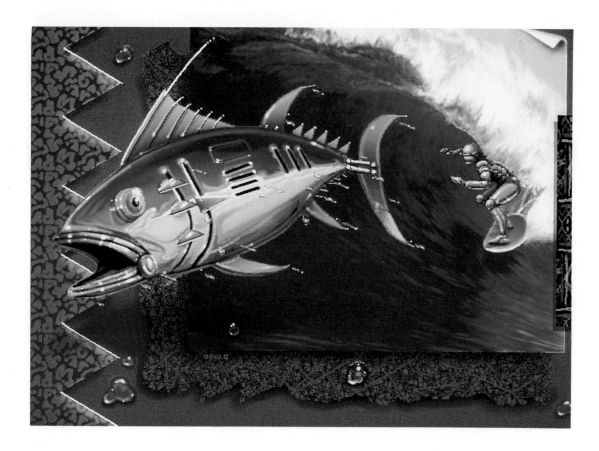

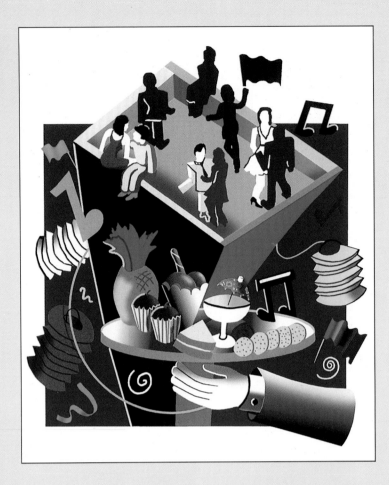

McGraw-Hill Party Invitation

ILLUSTRATOR ADAM COHEN
DESIGNER JANET MILLSTEIN
SOFTWARE PHOTOSHOP
HARDWARE MAC IIFX

Blacklight Book Cover

ILLUSTRATOR ADAM COHEN
DESIGNER VICTOR WEAVER
SOFTWARE PHOTOSHOP
HARDWARE MAC IIFX

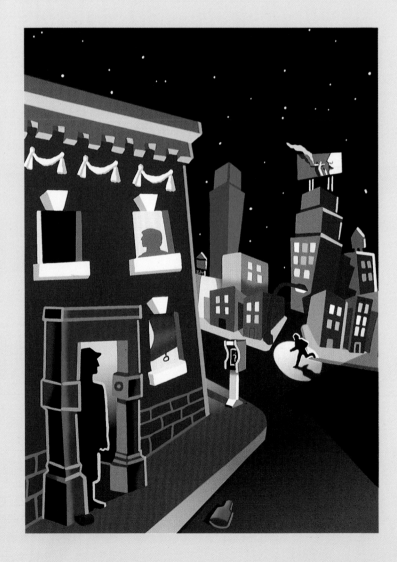

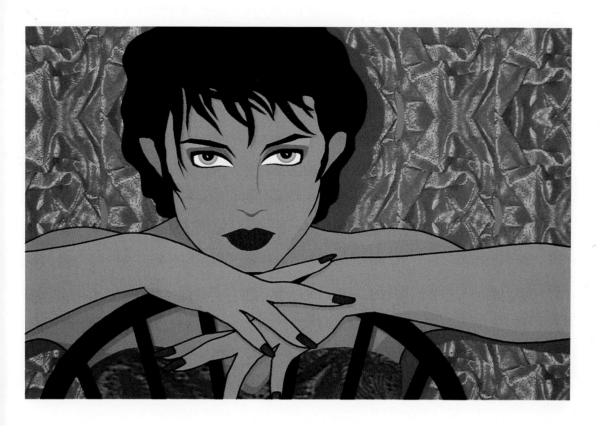

GREEN-EYED LADY

DESIGNER DAVID POSEY
SOFTWARE PAINT, FRAME GRAB
HARDWARE GENIGRAPHICS 100D+

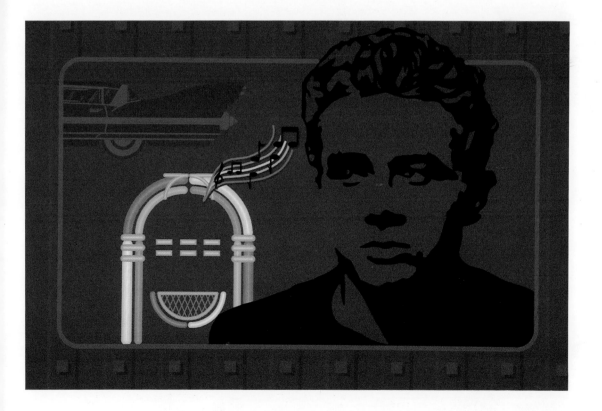

JAMES

DESIGNER LISA WAGNER
SOFTWARE GENIGRAPHICS
HARDWARE GENIGRAPHICS SGI

ILLUSTRATION

A Rose at any Other Size

DESIGNERS Erik Adigard, Patricia McShane
DESIGN FIRM M.A.D.
SOFTWARE Photoshop, Illustrator
HARDWARE Mac IIfx, Microtek Color/Gray Scanner

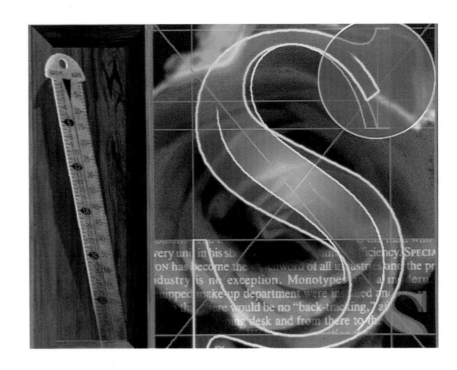

Get the Point

DESIGNER Lisa Wagner
SOFTWARE Genigraphics Paint, Frame Grab
HARDWARE Genigraphics 100D+/Sony video camera

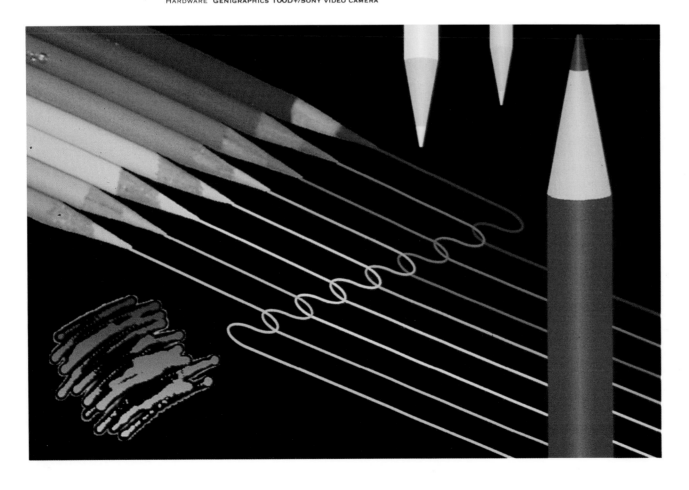

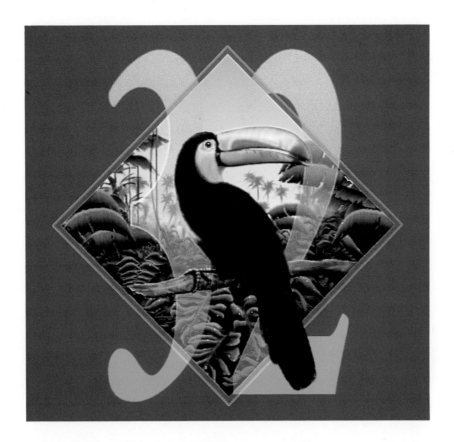

ELECTRONIC ARTS ILLUSTRATION

DESIGNER DON WOO
DESIGN FIRM ELECTRONIC ARTS
SOFTWARE PHOTOSHOP
HARDWARE MAC IIFX

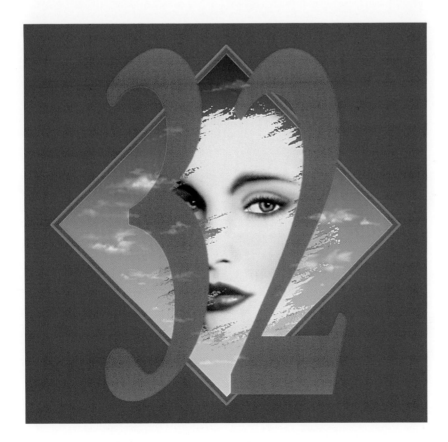

ELECTRONIC ARTS ILLUSTRATION

DESIGNER DON WOO
DESIGN FIRM ELECTRONIC ARTS
SOFTWARE PHOTOSHOP
HARDWARE MAC IIFX

ILLUSTRATION

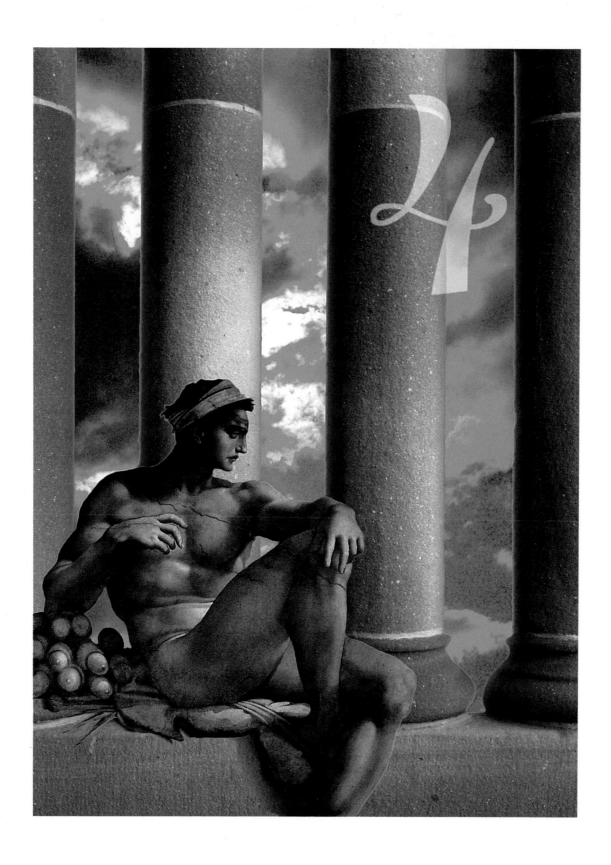

D'PIX ILLUSTRATION

DESIGNERS JOHN GARRISON, TODD MOCK
DESIGN FIRM AMBER PRODUCTIONS, INC.
SOFTWARE QUARK, ILLUSTRATOR, PHOTOSHOP
HARDWARE MAC IIFX, PRE-PRESS TECH SPECTRE 5000

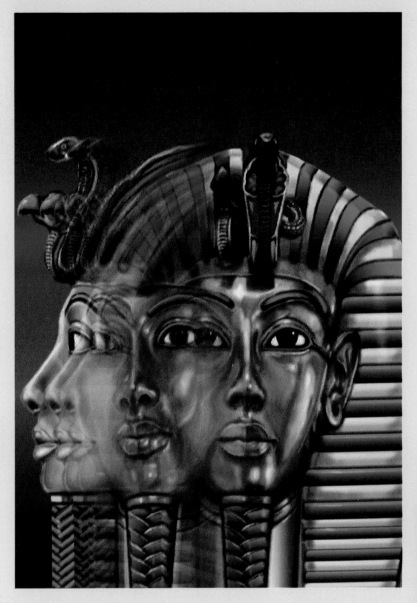

ELECTRONIC ARTS ILLUSTRATION

DESIGNER DON WOO
DESIGN FIRM ELECTRONIC ARTS
SOFTWARE STUDIO/32
HARDWARE MAC IIFX

JUST VISITING

DESIGNER DON WOO
DESIGN FIRM ELECTRONIC ARTS
SOFTWARE STUDIO/32
HARDWARE MAC IIFX

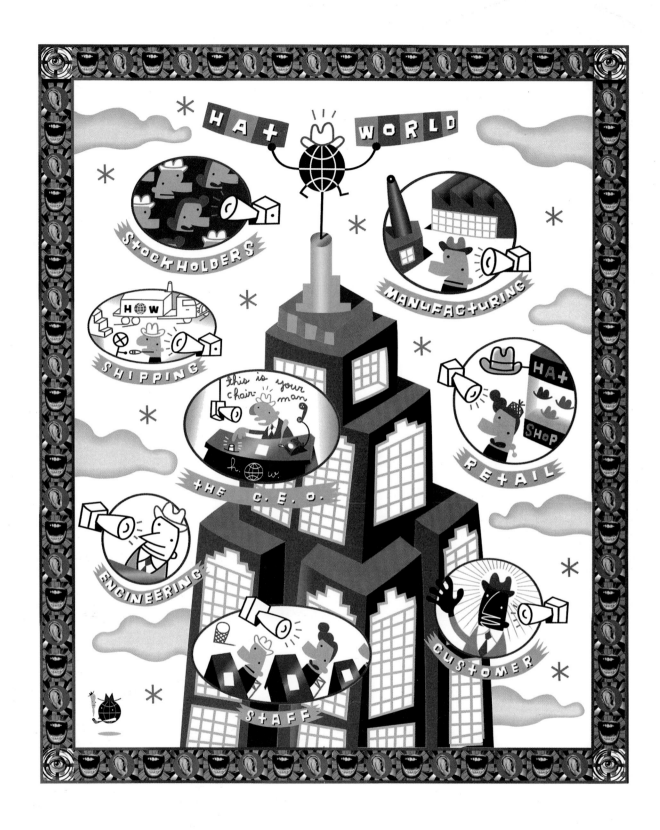

WYATT COMMUNICATIONS CORPORATE QUARTERLY
HAT WORLD

DESIGN FIRM PRESSLEY JACOBS
ILLUSTRATOR J. OTTO SIEBOLD
SOFTWARE ILLUSTRATOR, PHOTOSHOP
HARDWARE MAC IICI, RADIUS 21" COLOR MONITOR, UMAX COLOR
SCANNER

ATARI MAGAZINE

ILLUSTRATOR ADAM COHEN
DESIGNER MARC NEEDLEMAN
SOFTWARE PHOTOSHOP
HARDWARE MAC IIFX

SCORES ON SCREEN

DESIGNER MARK YANKUS
DESIGNER MARC NEEDLEMA
SOFTWARE PHOTOSHOP
HARDWARE MAC IIFX

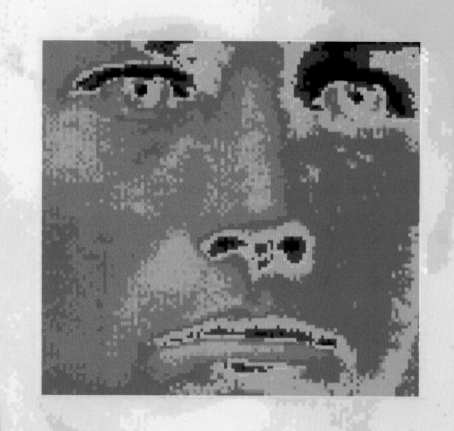

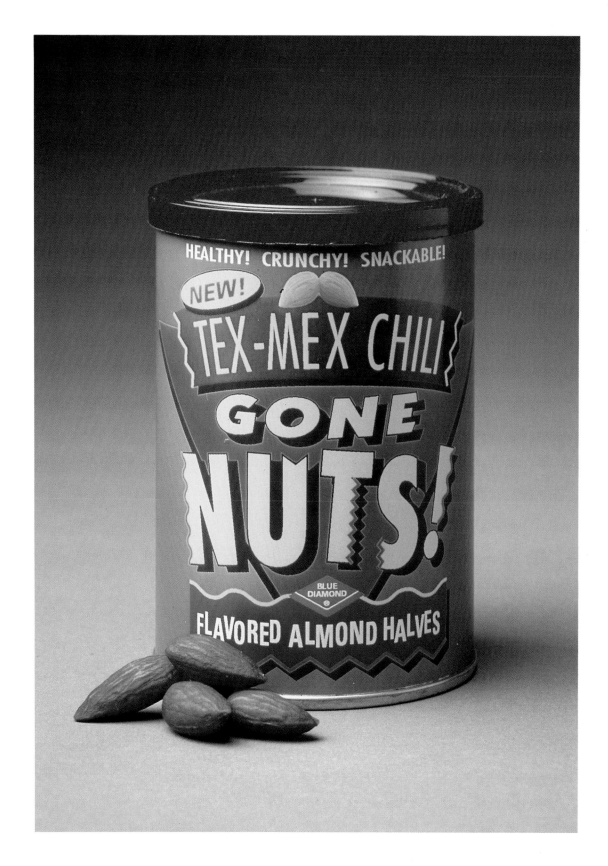

HALLBERG, SCHIRESON & COMPANY PACKAGING

DESIGNERS JIM WALCOTT-AYERS, LIZ POLLINA
DESIGN FIRM THE WALCOTT-AYERS GROUP
SOFTWARE ILLUSTRATOR
HARDWARE MAC IIFX, RADIUS 19" MONITOR

NORWEST BANKS PROMO GIFT BOX

DESIGNER JAMES STRANGE
DESIGN FIRM CULVER + ASSOCIATES
SOFTWARE ALDUS FREEHAND 2.0

CASA DE ROSAS SALSA LABEL

DESIGNERS MARK VERLANDER, KEITH BRIGHT
DESIGN FIRM BRIGHT + ASSOCIATES
SOFTWARE ALDUS FREEHAND

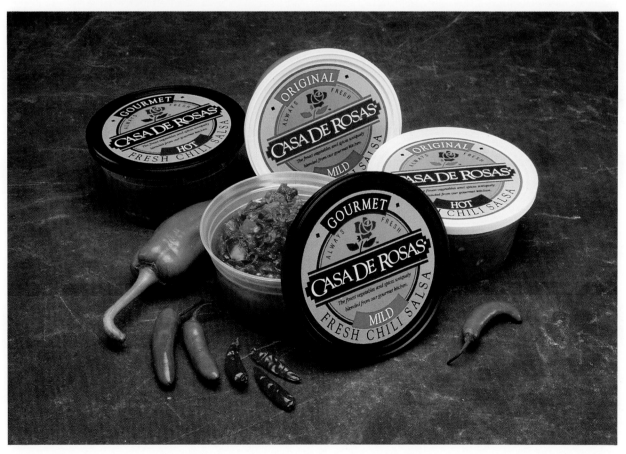

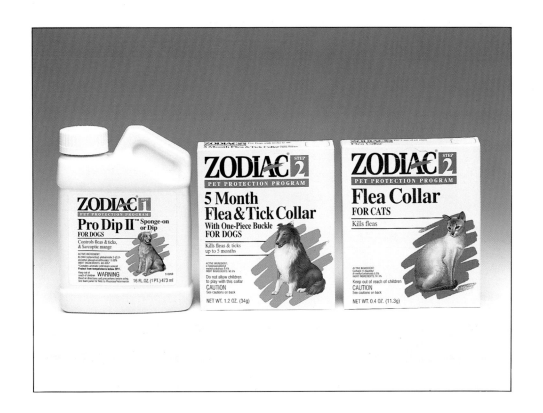

ZOECON CORP. PACKAGING

DESIGNERS EDWARD MORRILL, RICHARD C. ROTH, WILLIAM LEE,
LORRAINE FIERRO, SARAH ALLEN
DESIGN FIRM COLEMAN, LIPUMA, SEGAL & MORRILL, INC.
SOFTWARE QUARK, ILLUSTRATOR, PHOTOSHOP
HARDWARE MACII FX (8MB), 80MB

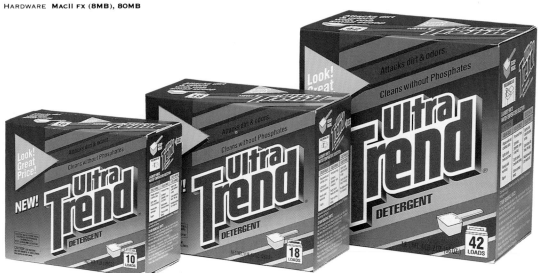

THE DIAL CORP. PACKAGING

DESIGNERS OWEN W. COLEMAN, ABE SEGAL, WILLIAM LEE
DESIGN FIRM COLEMAN, LIPUMA, SEGAL & MORRILL, INC.
SOFTWARE ILLUSTRATOR
HARDWARE MAC IIFX (8MB), 100MB

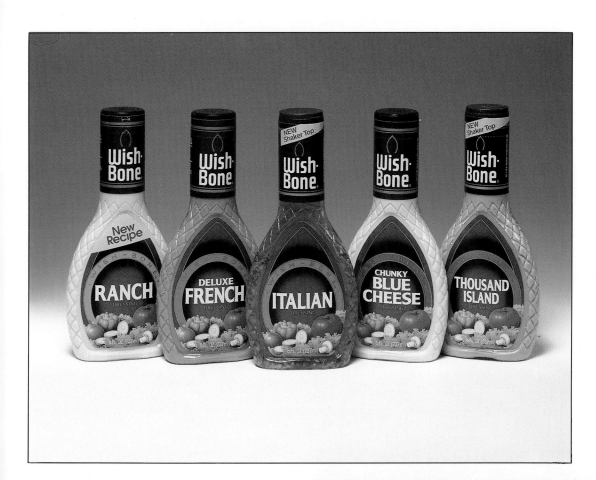

THOMAS J. LIPTON, INC. LABEL

DESIGNERS EDWARD MORRILL, OWEN W. COLEMAN, ABE SEGAL, JOHN RUTIG

DESIGN FIRM COLEMAN, LIPUMA, SEGAL & MORRILL, INC.

SOFTWARE ILLUSTRATOR

HARDWARE MAC IIFX (8MB), 80MB

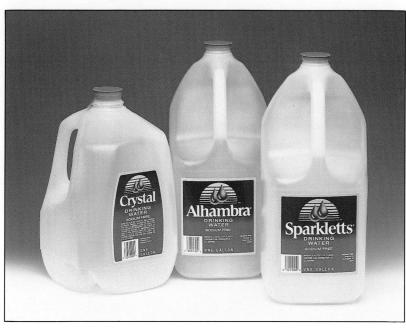

MCKESSON WATER PRODUCTS COMPANY LABEL

DESIGNERS OWEN W. COLEMAN, ABE SEGAL, WILLIAM LEE, JOHN RUTIG

DESIGN FIRM COLEMAN, LIPUMA, SEGAL & MORRILL, INC.

SOFTWARE ILLUSTRATOR

HARDWARE MAC IIX (8MB), 100MB

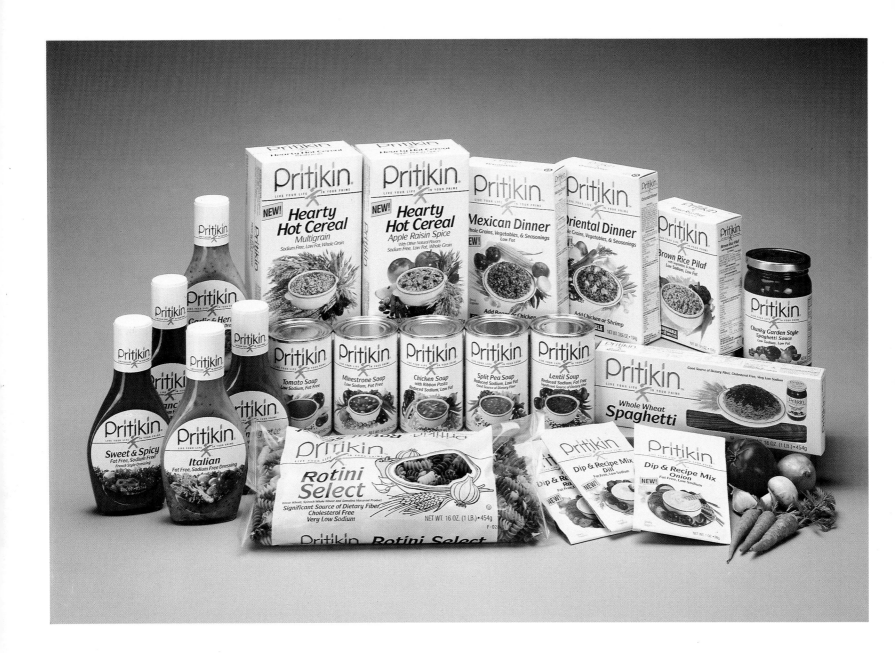

QUAKER OATS COMPANY PACKAGING

DESIGNERS EDWARD MORRILL, OWEN W. COLEMAN, WILLIAM LEE,
SARAH ALLEN
DESIGN FIRM COLEMAN, LIPUMA, SEGAL & MORRILL, INC.
SOFTWARE QUARK, ILLUSTRATOR, PHOTOSHOP
HARDWARE MAC IIFX (8MB), 80MB

DINKELACKER BRAUEREI STUTTGART BEER LABEL

DESIGNERS MARTIN DOBLER, STEFANI MERZ
DESIGN FIRM MCI DESIGN GMBH
HARDWARE AESTHEDES 2 DESIGN SYSTEM, BARCO GRAPHICS

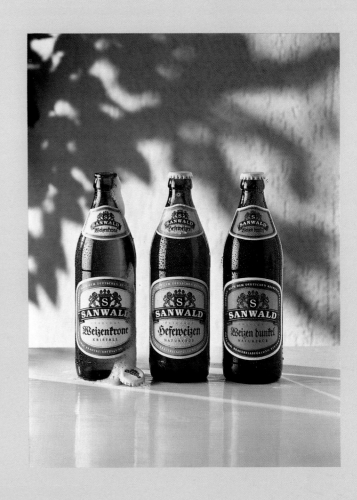

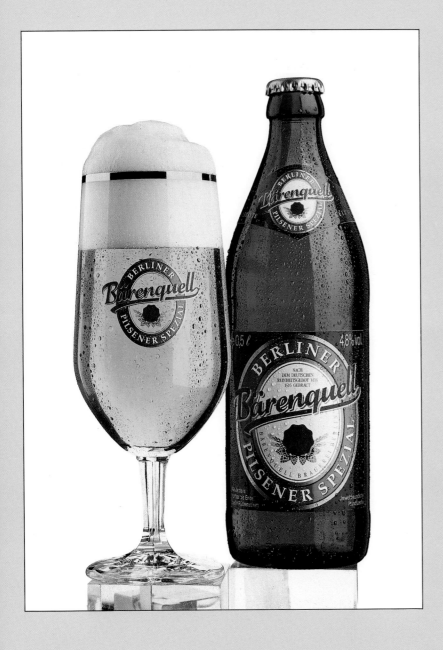

BARENQUELL BERLIN BEER LABEL

DESIGNERS MARTIN DOBLER
DESIGN FIRM MCI DESIGN GMBH
HARDWARE AESTHEDES 2 DESIGN SYSTEM, BARCO GRAPHICS

THE DIAL CORP. PACKAGING

DESIGNERS OWEN W. COLEMAN, ABE SEGAL, WILLIAM LEE
DESIGN FIRM COLEMAN, LIPUMA, SEGAL & MORRILL, INC.
SOFTWARE QUARK, ILLUSTRATOR, PHOTOSHOP
HARDWARE MAC IIFX (8MB), 80MB

DOW PACKAGE DESIGN

DESIGNER RUSSEL ANG
DESIGN FIRM CREATIVE RESOURCE CENTER
SOFTWARE ILLUSTRATOR
HARDWARE MAC IICI

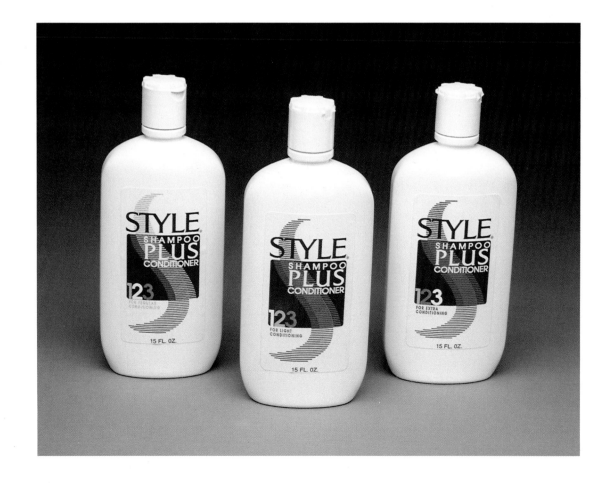

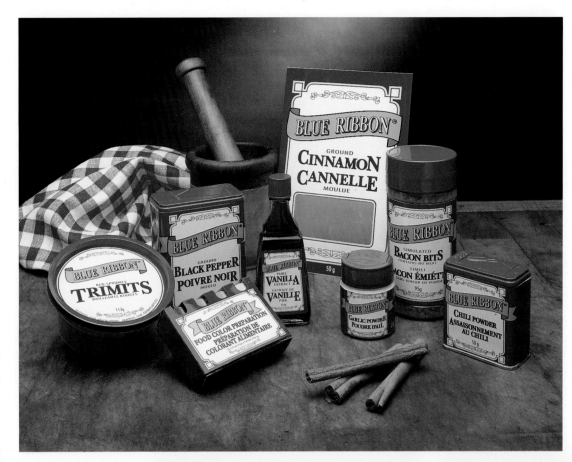

SPECIALTY BRANDS, LTD. PACKAGING

DESIGNERS JIM WALCOTT-AYERS, LIZ POLLINA
DESIGN FIRM THE WALCOTT-AYERS GROUP
SOFTWARE ILLUSTRATOR
HARDWARE MAC IIFX, MAC IICI, RADIUS 19" MONITOR

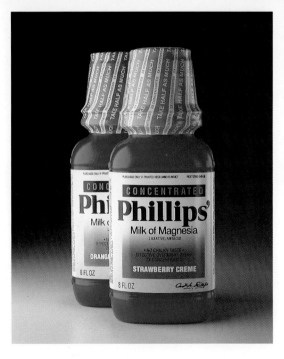

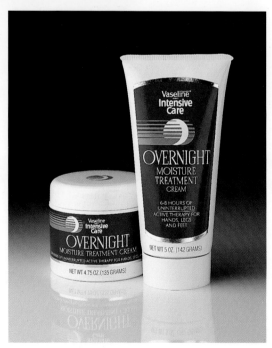

STERLING HEALTH PACKAGING

DESIGNERS STEPHEN HOOPER, STEPHANIE SIMPSON
DESIGN FIRM HANS FLINK DESIGN, INC.
SOFTWARE ALDUS FREEHAND, ILLUSTRATOR
HARDWARE MAC IIFX (8MB), 210MB

CHESEBROUGH-PONDS USA PACKAGING

DESIGNERS STEPHEN HOOPER, STEPHANIE SIMPSON
DESIGN FIRM HANS FLINK DESIGN, INC.
SOFTWARE ALDUS FREEHAND, ILLUSTRATOR
HARDWARE MAC IIFX (8MB), 210MB

CREATIVE RESOURCE CENTER SELF-PROMO PACKAGE

DESIGNER KEITH ANDERSON
DESIGN FIRM CREATIVE RESOURCE CENTER
SOFTWARE ILLUSTRATOR
HARDWARE MAC IICI

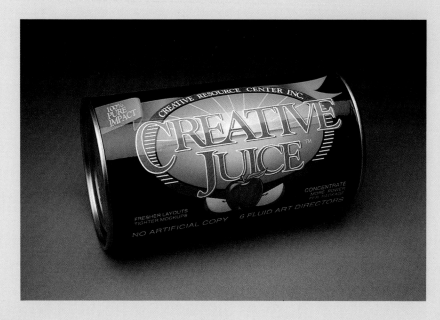

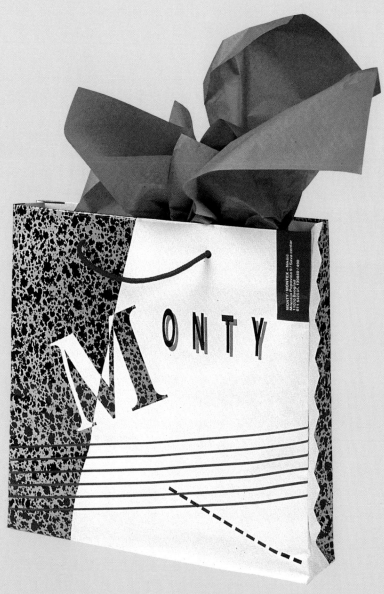

MONTY-MONTEX SHOPPING BAG

DESIGNER EDUARD CEHOVIN
DESIGN FIRM A±B (ART MORE OR LESS BUSINESS)
SOFTWARE FREEHAND
HARDWARE MAC IICI

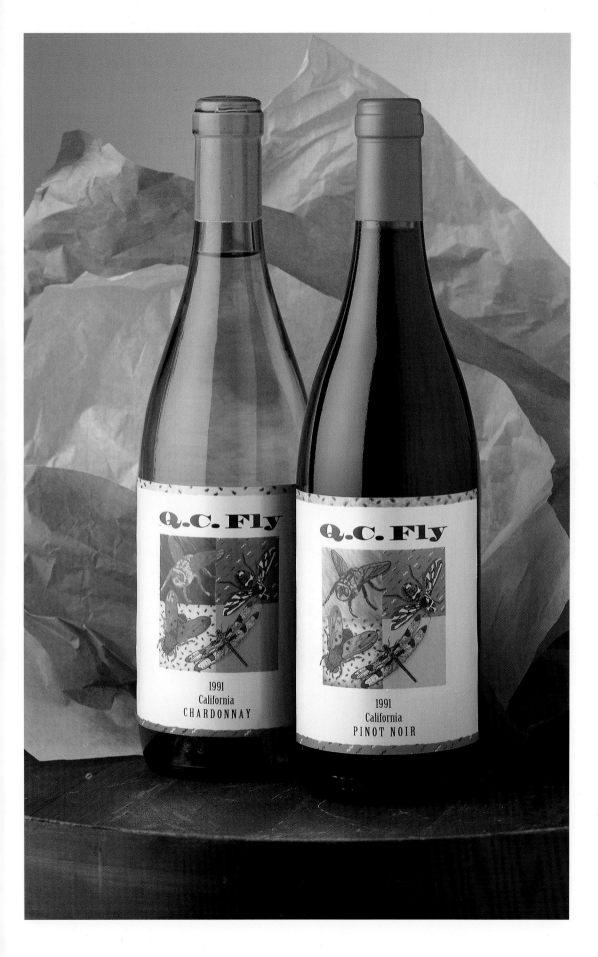

BOUCHAINE VINEYARDS LABELS

DESIGNERS JIM WALCOTT-AYERS, LIZ POLLINA
DESIGN FIRM THE WALCOTT-AYERS GROUP
SOFTWARE PHOTOSHOP, ILLUSTRATOR
HARDWARE MAC IICI, 19" RADIUS

PACKAGING

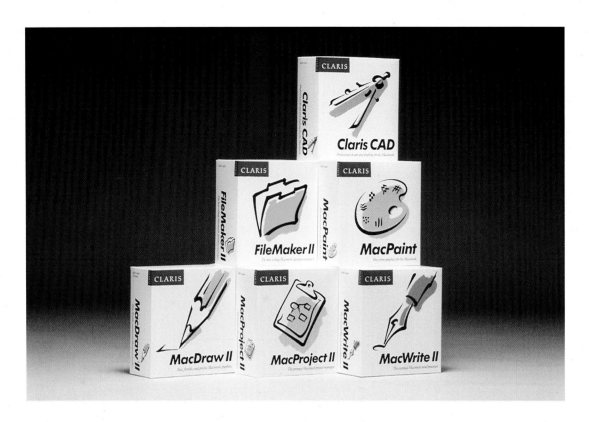

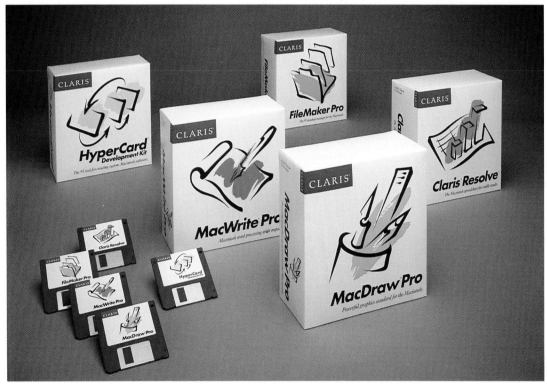

CLARIS CORP. PACKAGING

DESIGNER MARTY NEUMEIER, CHRISTOPHER CHU, CURTIS WONG
DESIGN FIRM NEUMEIER DESIGN TEAM
SOFTWARE QUARK, ALDUS FREEHAND, ILLUSTRATOR
HARDWARE MAC IICI

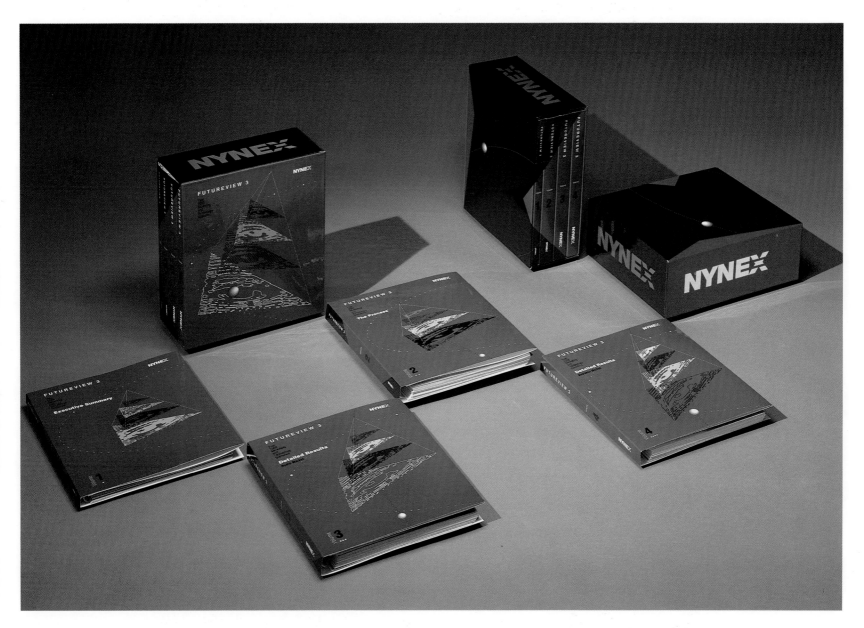

Nynex Boxed Brochures

Designers **Andrew Jablonski, Andrzej Olejniczak**
Design Firm **O&J Design, Inc.**
Software **Illustrator**
Hardware **Mac IIfx**

RIKUYO-SHA PUBLISHING BOOK COVER

ART DIRECTOR/DESIGNER/PHOTOGRAPHER SUSUMU ENDO
ELECTRONIC DESIGN ETSURO ENDO
SOFTWARE PHOTOSHOP
HARDWARE MAC IIFX

NIKKEI SHINBUN-SHA (JAPAN ECONOMIC JOURNAL) BOOK COVER

CREATIVE DIRECTOR HIDEO MUKAI
ART DIRECTOR/DESIGNER/PHOTOGRAPHER SUSUMU ENDO
ELECTRONIC DESIGN ETSURO ENDO
SOFTWARE PHOTOSHOP
HARDWARE MAC IIFX

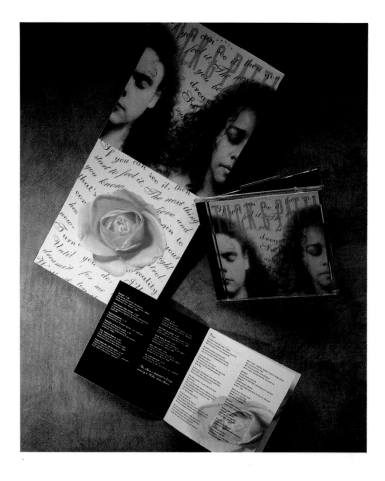

TUCK & PATTI ALBUM PACKAGING

DESIGNER JENNIFER MORLA, JEANETTE ARAMBURU
DESIGN FIRM MORLA DESIGN
SOFTWARE ILLUSTRATOR, PHOTOSHOP
HARDWARE MAC IICX

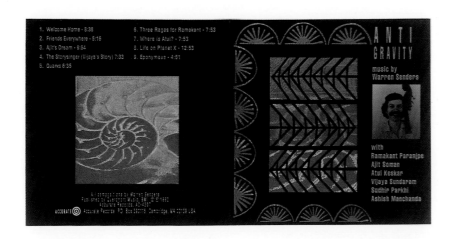

WARREN SENDERS' ANTIGRAVITY CD
DESIGN FIRM KARYL KLOPP DESIGN
DESIGNER KARYL KLOPP
SOFTWARE PHOTOSHOP, FREEHAND
HARDWARE MAC IIFX

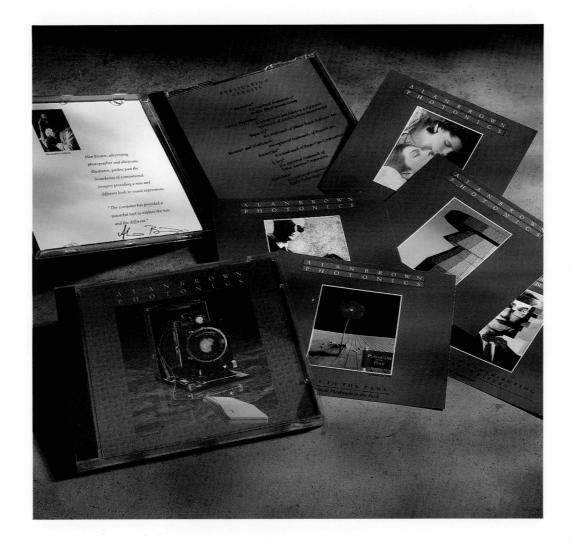

PACKAGING

PHOTONICS GRAPHICS SELF-PROMO PACKAGING

DESIGNER LLOYD HOWELL
ILLUSTRATOR ALAN BROWN/PHOTONICS GRAPHICS
DESIGN FIRM PLUM STREET GROUP
SOFTWARE PHOTOSHOP, MACVISION, PHOTOMAC, COLOR STUDIO
HARDWARE MAC IIFX (20MB)

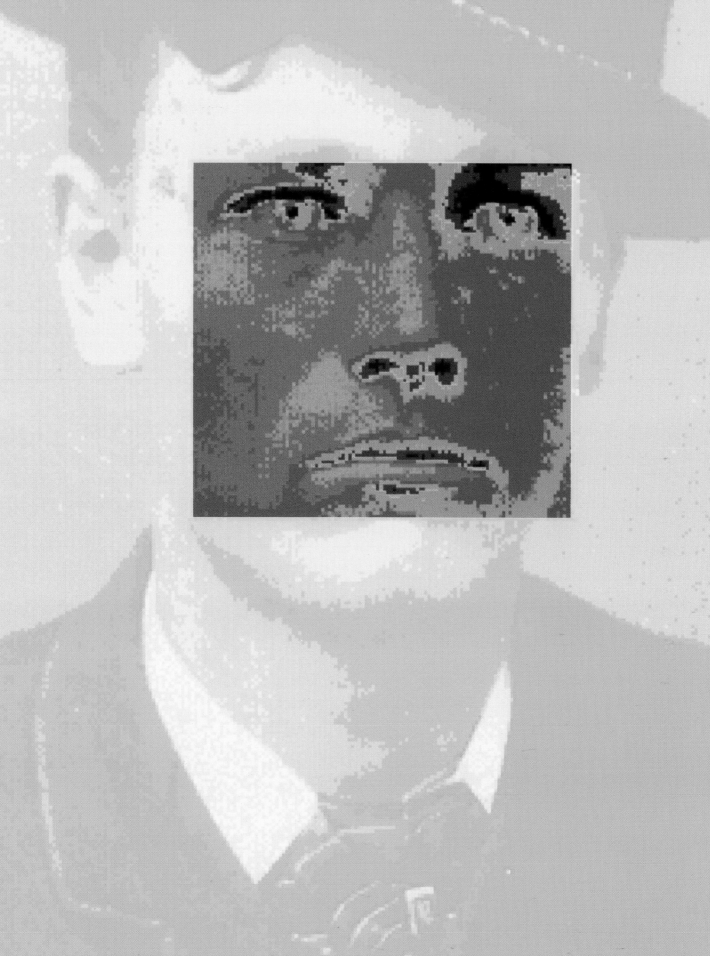

PHOTONICS

PHOTONICS GRAPHICS LOGO

DESIGNER LISA BALLARD/SIEBERT DESIGN, ALAN BROWN/
PHOTONICS GRAPHICS, INC.
SOFTWARE DESIGN STUDIO, MC SCAN-IT, PHOTOMAC, MACVISION
HARDWARE MAC IIFX (20MB)

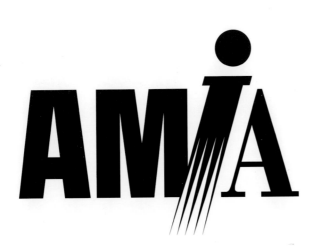

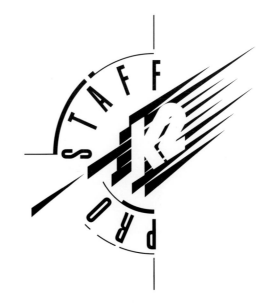

American Medical Informatics Association Logo

Designers William Hafeman, Mark Oldach, Nils Bunde
Design Firm Hafeman Design Group, Oldach Design
Software Illustrator
Hardware Mac IICI

K2 Pro Staff Logo

Designers Jack Anderson, Brian O'Neill, Denise Weir
Design Firm Hornall Anderson Design Works
Software Freehand 3.0
Hardware Mac IICI

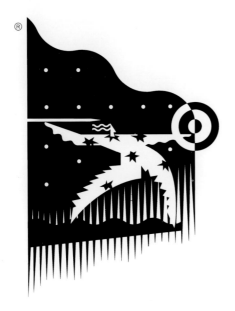

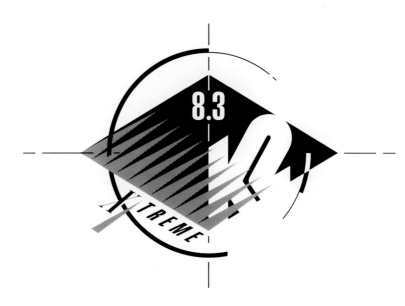

The Riordan Design Group, Inc. Logo

Designers Dan Wheaton, Bill Frampton, Ric Riordan
Design Firm The Riordan Design Group, Inc.
Software Quark, Illustrator
Hardware Mac II and Mac IICI

K2 8.3 Xtreme Logo

Designers Jack Anderson, Julia LaPine, Denise Weir,
Brian O'Neill
Design Firm Hornall Anderson Design Works
Software Freehand 3.0
Hardware Mac IICI

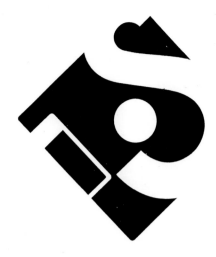

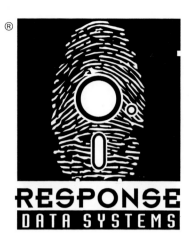

SWIP Trading Co. Logo

Designer **Michael Renner**
Design Firm **M. Renner Design**
Software **Illustrator, Adobe Separator**
Hardware **Mac II (4MB), 80-MB HD**

Response Data Systems Logo

Designer **Dan Wheaton, Ric Riordan**
Design Firm **The Riordan Design Group, Inc.**
Software **Quark, Illustrator**
Hardware **Mac IICI, Ikegami 19" color monitor, Syquest**

A. Conrad Logo

Designers **Liz Rotter, Clifford Selbert**
Design Firm **Clifford Selbert Design, Inc.**
Software **Freehand**
Hardware **Mac IICI**

Belgrade Cultural Center Logo

Designer **Eduard Cehovin**
Design Firm **A±B (Art More or Less Business)**
Software **Freehand**
Hardware **Mac IICI**

Rocky Mountain Inventors and Entrepreneurs Congress

Rocky Mountain Inventors and Entrepreneurs Logo

Design Firm **Pollman Marketing Arts, Inc.**
Designer **Jennifer Pollman, Jennifer Davis**
Software **Illustrator**
Hardware **Mac IICX**

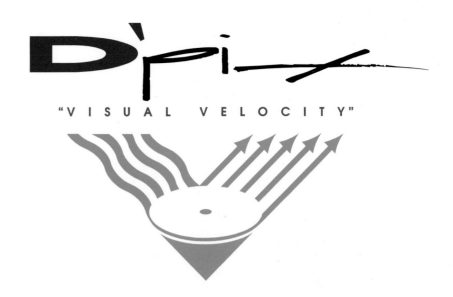

ROBERT COOK DESIGN LOGO

DESIGNER **ROBERT COOK**
DESIGN FIRM **ROBERT COOK DESIGN**
SOFTWARE **PAGEMAKER 4.0, ILLUSTRATOR**
HARDWARE **MAC IICX**

CHARTERED
ACCOUNTANTS

M&M CHARTERED ACCOUNTANTS LOGO

DESIGNER **DAN WHEATON**
DESIGN FIRM **THE RIORDAN DESIGN GROUP, INC.**
SOFTWARE **QUARK, ILLUSTRATOR**
HARDWARE **MAC IICI, SYQUEST, IKEGAMI 19" COLOR MONITOR**

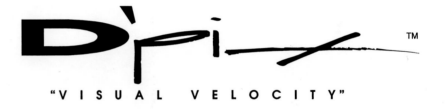

D'PIX - FOLIO 1 LOGO

DESIGNER **JOHN GARRISON, TODD MOCK**
DESIGN FIRM **AMBER PRODUCTIONS, INC.**
SOFTWARE **ILLUSTRATOR**
HARDWARE **MAC IIFX**

INTERNATIONAL

BUSINESS AND PROFESSIONAL WOMEN LOGO

DESIGNER JENNIFER POLLMAN, JENNIFER DAVIS
DESIGN FIRM POLLMAN MARKETING ARTS, INC.
SOFTWARE ILLUSTRATOR
HARDWARE MAC IICX

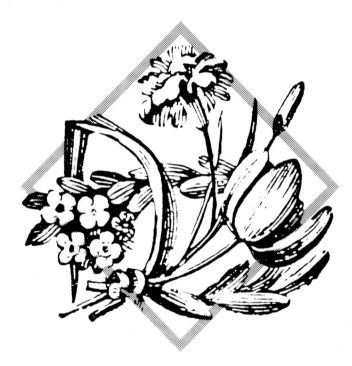

CAROLINE BENSON LANDSCAPE & DESIGN LOGO

DESIGNER BARBI CHRISTOPHER
DESIGN FIRM WHITNEY•EDWARDS DESIGN
SOFTWARE QUARK, C-SCAN
HARDWARE MAC IICI, ABATON SCANNER, LINO 300

CAROLINE T. BENSON
LANDSCAPE AND DESIGN

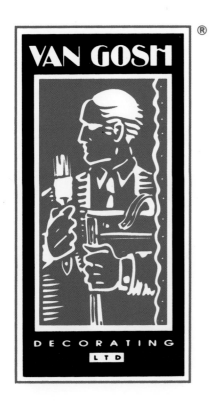

ARBOR
SYSTEMS
GROUP

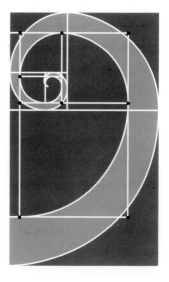

NIXON · JOHNSON

ARCHITECTURAL

ASSOCIATES, P.C.

VAN GOSH DECORATING LOGO

DESIGNER RIC RIORDAN
DESIGN FIRM THE RIORDAN DESIGN GROUP, INC.
SOFTWARE QUARK, ILLUSTRATOR
HARDWARE MAC II

ARBOR SYSTEMS GROUP LOGO

DESIGNERS STEVE ATKINSON, JANINE THIELK
DESIGN FIRM PERICH + PARTNERS, LTD.
SOFTWARE ALDUS FREEHAND
HARDWARE MAC IIX

NIXON JOHNSON ARCHITECTURAL ASSOC. LOGO

DESIGN FIRM POLLMAN MARKETING ARTS, INC.
DESIGNER JENNIFER POLLMAN, JENNIFER DAVIS
SOFTWARE ILLUSTRATOR
HARDWARE MAC IICX

ONTRACK LOGO

DESIGNER LESLIE HACKING
DESIGN FIRM CREATIVE RESOURCE CENTER
SOFTWARE ILLUSTRATOR
HARDWARE MAC IICI

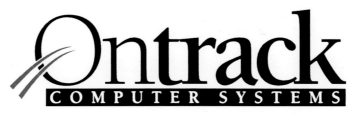

For Maximum Drive

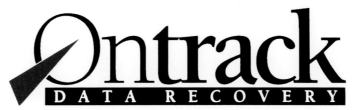

For that critical moment when only the best will do

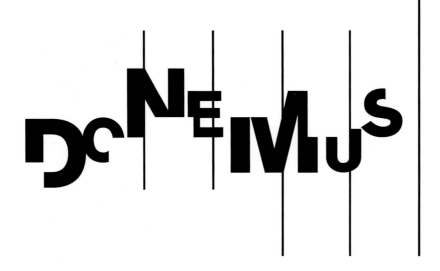

DONEMUS LOGO

DESIGNER HANS MEIBOOM
DESIGN FIRM SAMENWERKENDE ONTWERPERS
SOFTWARE ILLUSTRATOR
HARDWARE MAC II

BRADLEY GROUP LOGO

DESIGNER MARGO CHASE
DESIGN FIRM MARGO CHASE DESIGN
SOFTWARE ILLUSTRATOR
HARDWARE MAC IICI

MERCURY SERVICES LOGO

DESIGNER CHARLENE WHITNEY•EDWARDS
DESIGN FIRM WHITNEY•EDWARDS DESIGN
SOFTWARE ILLUSTRATOR
HARDWARE MAC IICI, LINO 300

JAMES STRANGE DESIGN LOGO

DESIGNER JAMES STRANGE
DESIGN FIRM JAMES STRANGE DESIGN
SOFTWARE FREEHAND 2.02

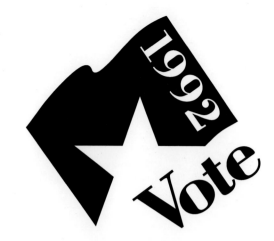

OASIS RADIO STATION LOGO

DESIGNER DICK MITCHELL
DESIGN FIRM RBMM/THE RICHARDS GROUP
SOFTWARE ILLUSTRATOR
HARDWARE MAC IIFX, HOWTEK SCANNER

WCVB-TV LOGO

DESIGNER THOMAS NIELSEN
SOFTWARE QUANTEL PAINTBOX

GENERAL INFORMATION, INC. HOTLINE LOGO

DESIGNERS JACK ANDERSON, JULIA LAPINE, BRIAN O'NEILL
DESIGN FIRM HORNALL ANDERSON DESIGN WORKS
SOFTWARE FREEHAND 3.0
HARDWARE MAC IICI (8/80)

PINKERTON SECURITY

DESIGNERS MARK VERLANDER, KEITH BRIGHT
DESIGN FIRM BRIGHT & ASSOCIATES
SOFTWARE FREEHAND

ART CAFFE LOGO

DESIGNER EDUARD CEHOVIN
DESIGN FIRM A±B (ART MORE OR LESS BUSINESS)
SOFTWARE FREEHAND
HARDWARE MAC IICI

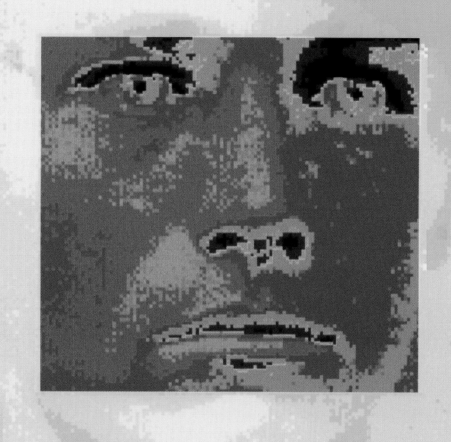

BROADCAST DESIGN

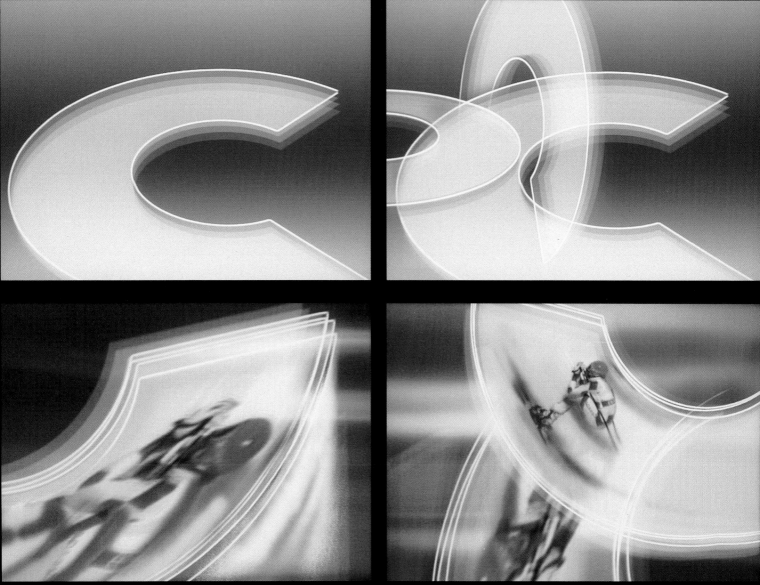

ESPN Skiing Open

Designers Janet Scabrini, Judy Rosenfeld
Design Firm Janet + Judy Design Associates, Inc.
Software Quantel (Proprietary)
Hardware Quantel Paintbox

 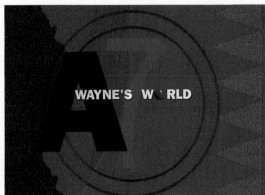 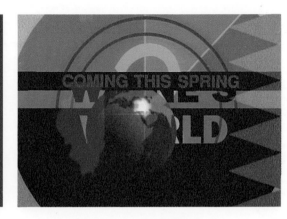

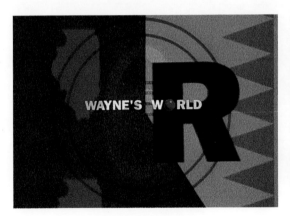 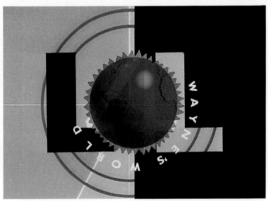 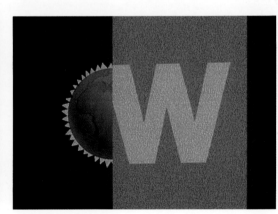

ASPECT RATIO, PARAMOUNT PICTURES *WAYNE'S WORLD*
PROMO GRAPHICS

DESIGNER JEFF BOORTZ
DESIGN FIRM PITTARD/SULLIVAN DESIGN

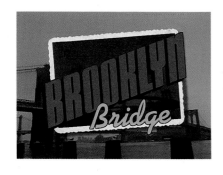 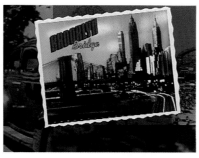 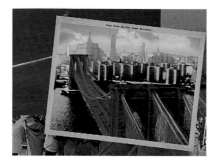

PARAMOUNT DOMESTIC TELEVISION/UBU PRODUCTIONS MAIN TITLE
FOR "BROOKLYN BRIDGE"
DESIGNER JUDY KORIN
DESIGN FIRM PITTARD/SULLIVAN DESIGN

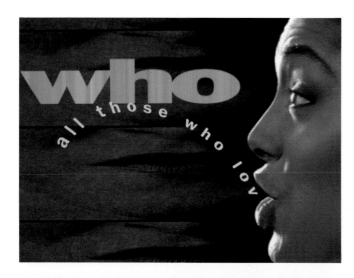 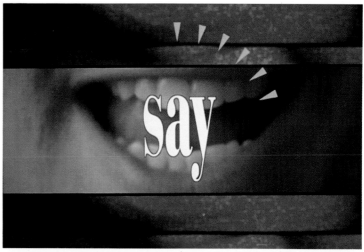

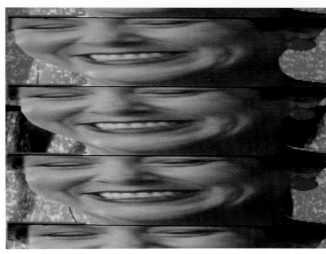 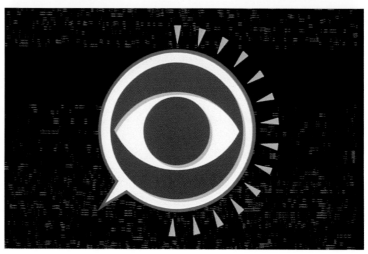

CBS "SAY EYE" NETWORK PROMO

DESIGNER BILL DAWSON
DESIGN FIRM PITTARD/SULLIVAN DESIGN
SOFTWARE QUANTEL PAINTBOX, ILLUSTRATOR

Yonchenko Communications Program Open

DESIGNERS JANET SCABRINI, JUDY ROSENFELD
DESIGN FIRM JANET + JUDY DESIGN ASSOCIATES, INC.
SOFTWARE QUANTEL (PROPRIETARY)
HARDWARE QUANTEL PAINTBOX, HARRY

BROADCAST DESIGN

127

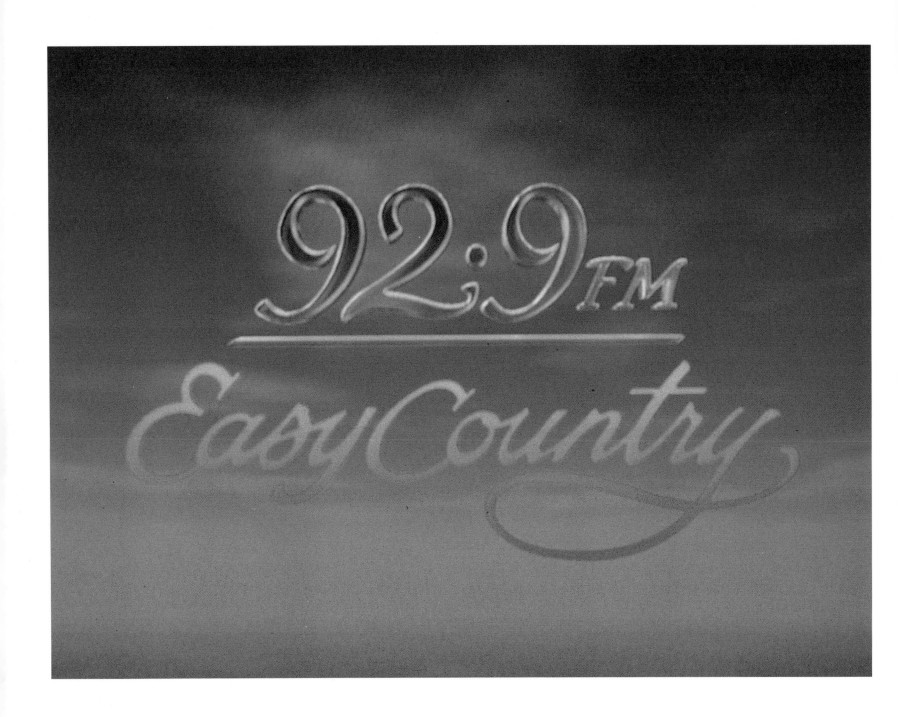

CUSTOM PRODUCTIONS, INC. TV STATION ID

DESIGNER BRIAN BRAM, MATTHEW HAUSMAN
DESIGN FIRM VIEWPOINT COMPUTER ANIMATION
SOFTWARE ALIAS/3, QUANTEL PBX

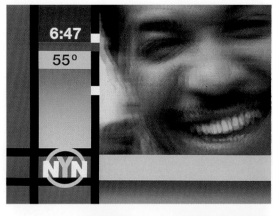
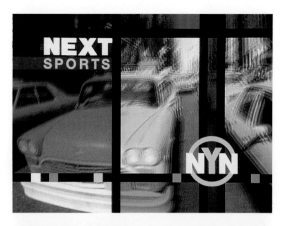
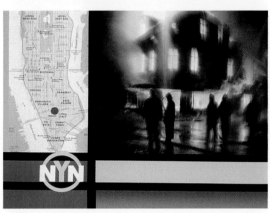
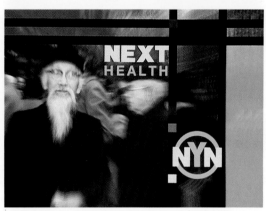

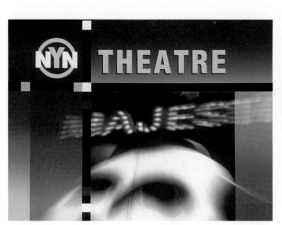
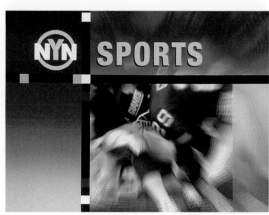
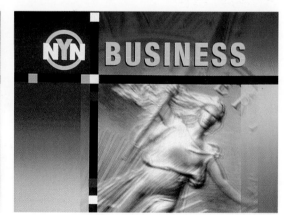

TIME WARNER NYC NEWS CHANNEL NETWORK ID

DESIGNER JANET SCABRINI, JUDY ROSENFELD
DESIGN FIRM JANET + JUDY DESIGN ASSOCIATES, INC.
SOFTWARE QUANTEL (PROPRIETARY)
HARDWARE QUANTEL PAINTBOX

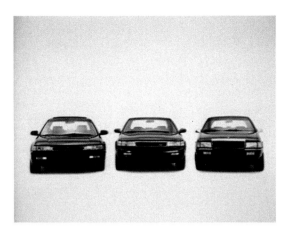 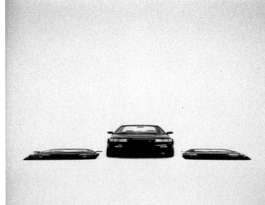

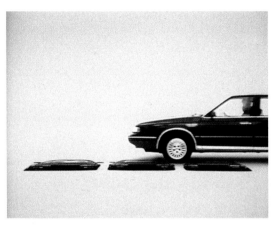 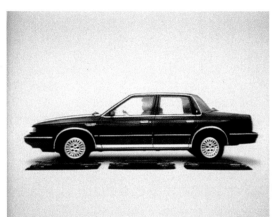

LAWNER REINGOLD BRITTON FOR NEW ENGLAND OLDSMOBILE

DESIGNERS BRIAN BRAM, MATTHEW HAUSMAN
DESIGN FIRM VIEWPOINT COMPUTER ANIMATION
SOFTWARE ALIAS/3, QUANTEL PBX

BIOMEDICAL VIDEO PROGRAM

DESIGNER GLENN ROBBINS
DESIGN FIRM VIEWPOINT COMPUTER ANIMATION
SOFTWARE ALIAS/3, QUANTEL PBX

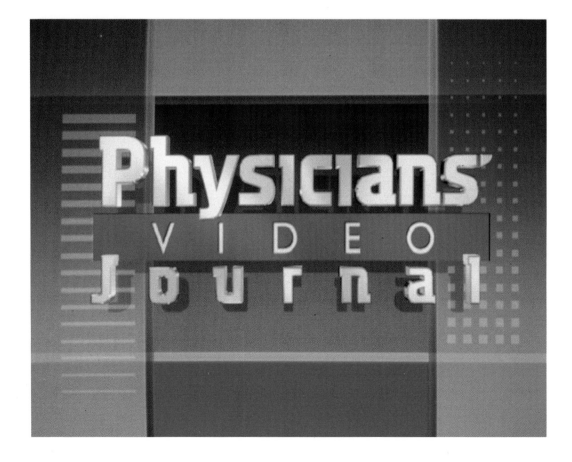

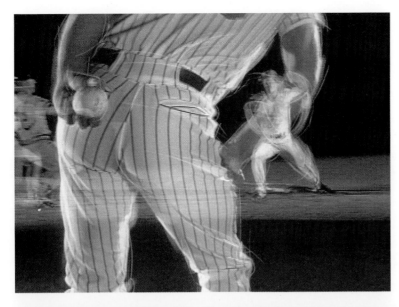

WOR TV Channel 9 Program Open

DESIGNER JANET SCABRINI
DESIGN FIRM JANET + JUDY DESIGN ASSOCIATES, INC.
SOFTWARE QUANTEL (PROPRIETARY)
HARDWARE QUANTEL PAINTBOX, HARRY

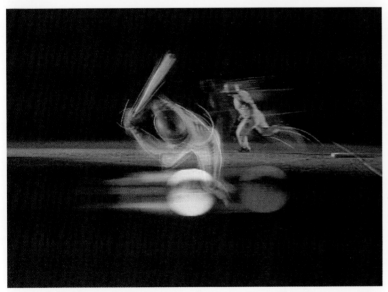

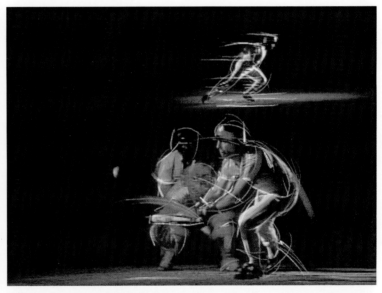

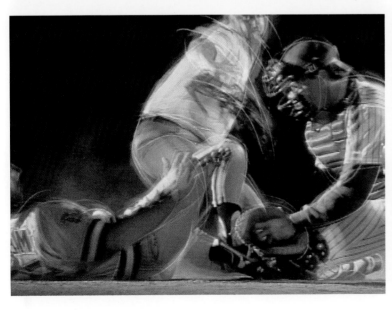

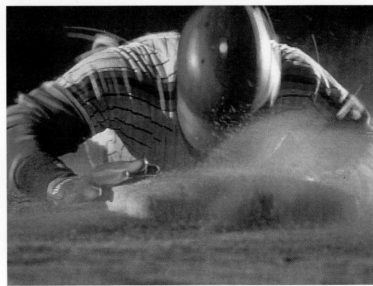

BROADCAST DESIGN

WCVB TV HOLIDAY ID

DESIGNER CHRISTINE FINN
DESIGN FIRM WCVB TV 5
SOFTWARE QUANTEL PAINTBOX

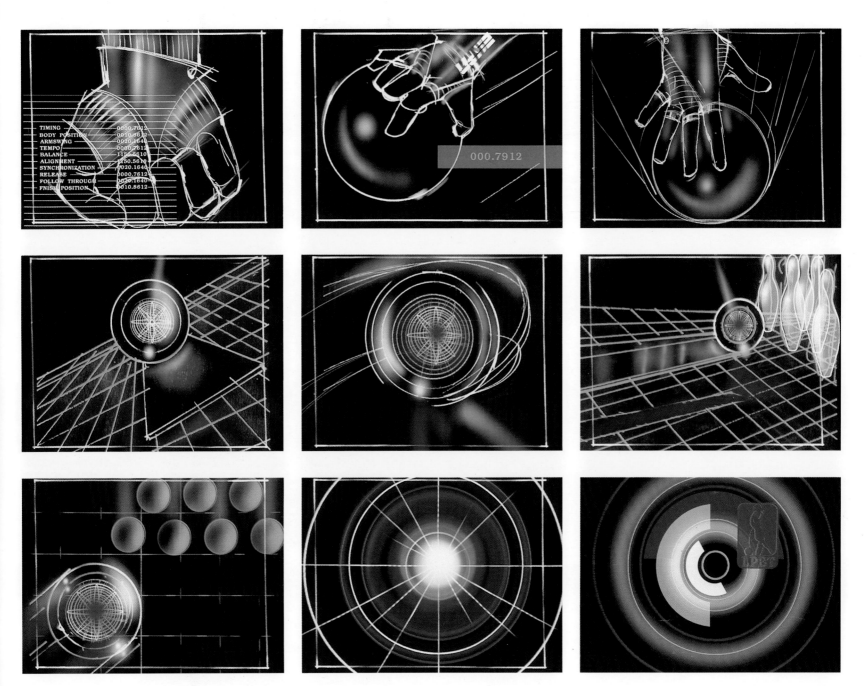

ESPN BOWLING OPEN

DESIGNERS JANET SCABRINI, JUDY ROSENFELD
DESIGN FIRM JANET + JUDY DESIGN ASSOCIATES, INC.
SOFTWARE QUANTEL (PROPRIETARY)
HARDWARE QUANTEL PAINTBOX

WCVB TV Election Logo

Designers Michael Tiedemann, Chris Finn
Design Firm WCVB TV 5
Software Quark, Aldus Freehand
Hardware Mac IIci, Supermac 19" Monitor, Quantel Paintbox

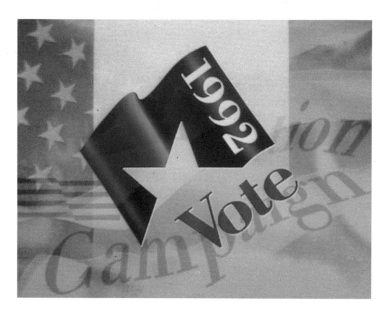

WCVB TV News Logo

Designer Marcelle Watkins
Design Firm WCVB TV 5
Hardware Quantel Paintbox

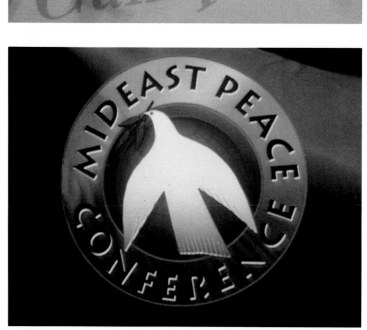

WCVB TV Logo Animation

Designer Tom Nielsen
Design Firm WCVB TV 5
Software Quantel Paintbox

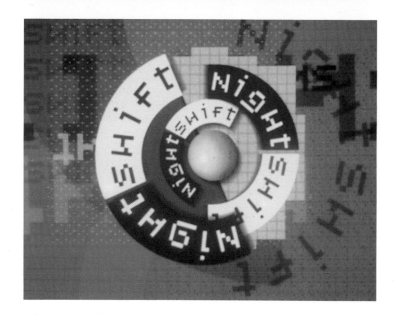

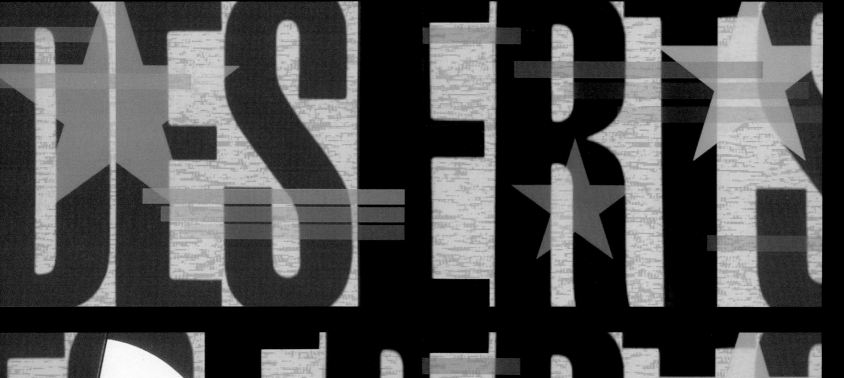

OPERATION
DESERT STORM

BROADCAST DESIGN

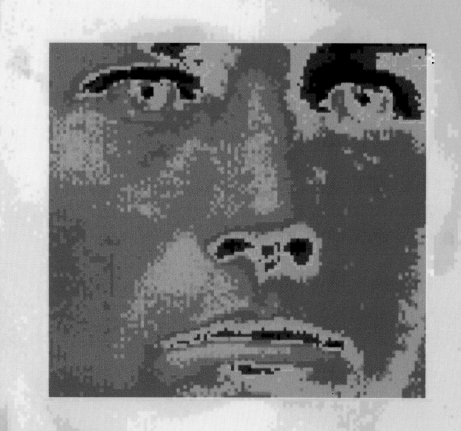

FINE ART

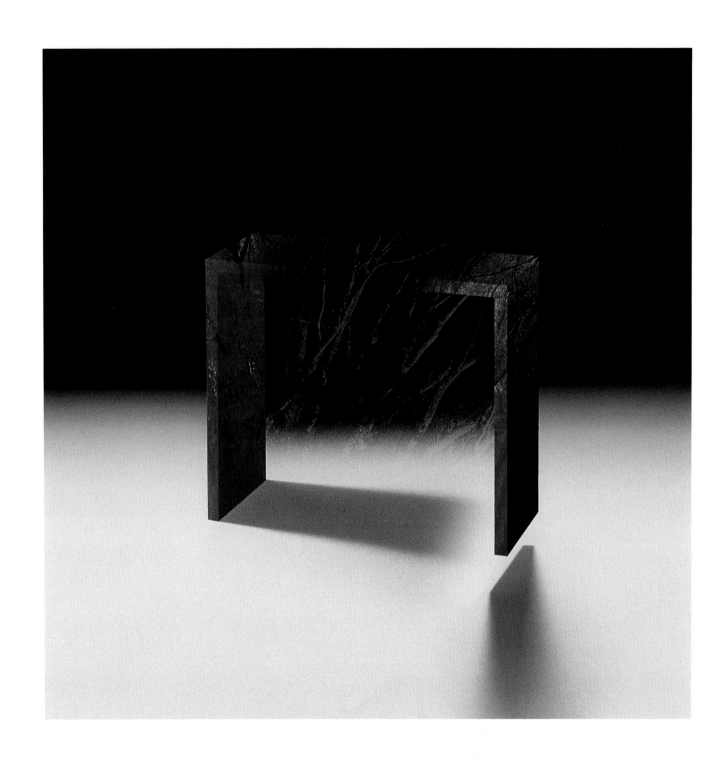

SPACE & SPACE/WOOD 3

DESIGNER **SUSUMU ENDO**

ELECTRONIC DESIGN **ETSURO END**

SOFTWARE **PHOTOSHOP**

HARDWARE **MAC IIFX**

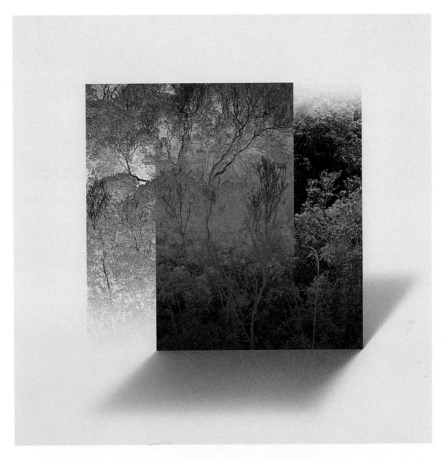

SPACE & SPACE/FOREST 91E

DESIGNER **SUSUMU ENDO**
ELECTRONIC DESIGN **ETSURO END**
SOFTWARE **PHOTOSHOP**
HARDWARE **MAC IIFX**

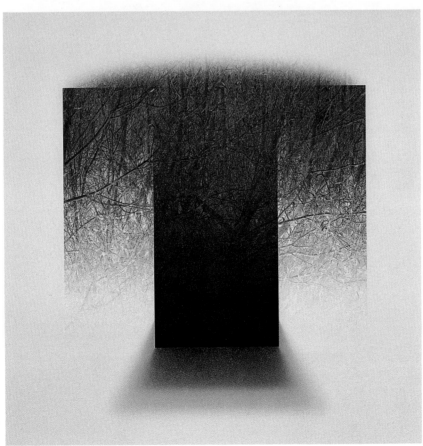

SPACE & SPACE/FOREST 91A

DESIGNER **SUSUMU ENDO**
ELECTRONIC DESIGN **ETSURO END**
SOFTWARE **PHOTOSHOP**
HARDWARE **MAC IIFX**

FINE ART

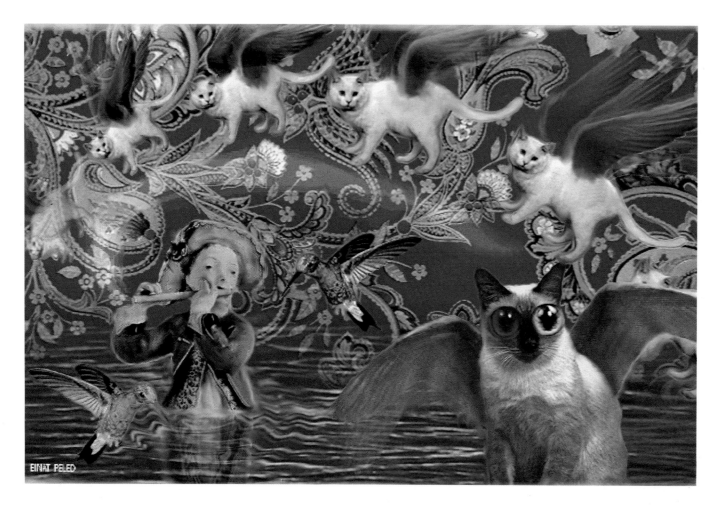

MAKE THE UNBELIEVABLE BELIEVABLE

DESIGNER **EINAT PELED**
SOFTWARE **PHOTOSHOP**

BACKYARD RIDE

DESIGNER **EROL OTUS**
SOFTWARE GIANT **PAINT, TIPS, VISTATIPS**
HARDWARE **IBM AT, TARGA 32, SUMMAGRAPHICS TABLET, VISTABOARD**

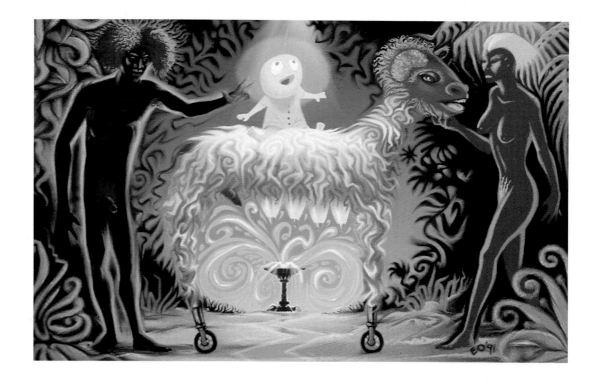

140

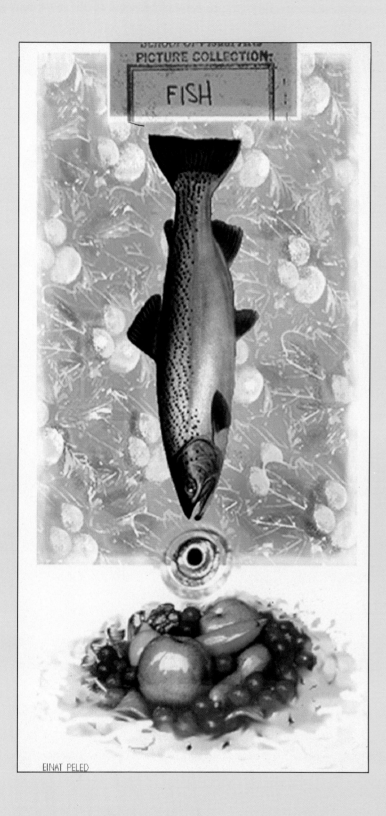

Falling Fish

Designer Einat Peled
Software Photoshop

Designer Jack Cliggett
Design Firm Cliggett Design Group, Inc.
Software Photoshop
Hardware Mac IIfx (20MB), Wacom Tablet, Microtek 300Z

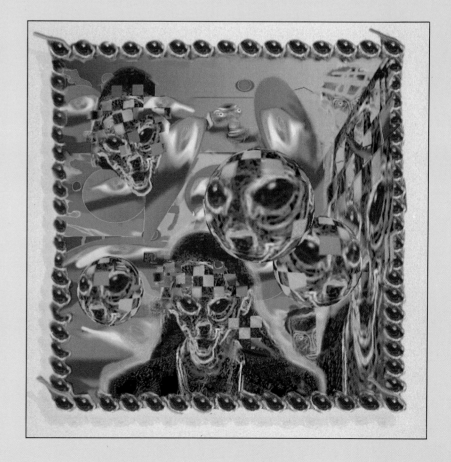

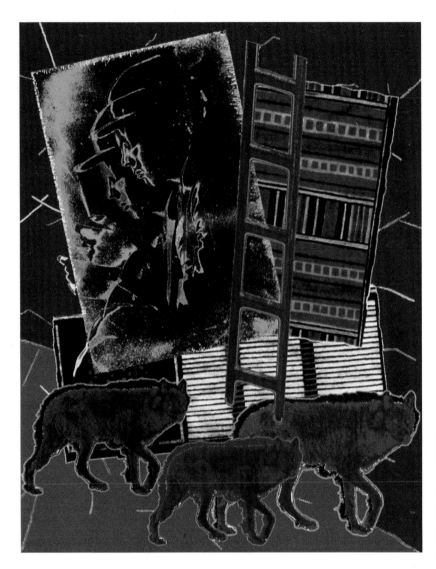

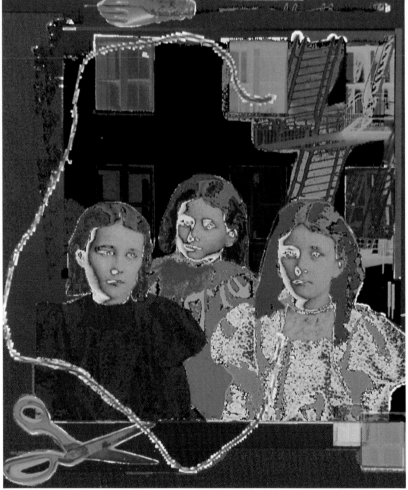

THE SHAPESHIFTER

DESIGNER DIANE FENSTER
DESIGN FIRM DIANE FENSTER COMPUTER ART & DESIGN
SOFTWARE IMAGE STUDIO, COLOR STUDIO
HARDWARE MAC IIx, APPLE 13" RGB MONITOR, SUPERMAC
SPECTRUM 24-COLOR CARD, APPLE SCANNER WITH ABATON
GRAYSCALE UPGRADE, WREN 337-MB HD, RODIME 140- MB HD

THE THREE FATES

DESIGNER DIANE FENSTER
DESIGN FIRM DIANE FENSTER COMPUTER ART & DESIGN
SOFTWARE IMAGE STUDIO, COLOR STUDIO
HARDWARE MAC IIx, APPLE 13" RGB MONITOR, SUPERMAC
SPECTRUM 24-COLOR CARD, APPLE SCANNER WITH ABATON
GRAYSCALE UPGRADE, WREN 337-MB HD, RODIME 140- MB HD

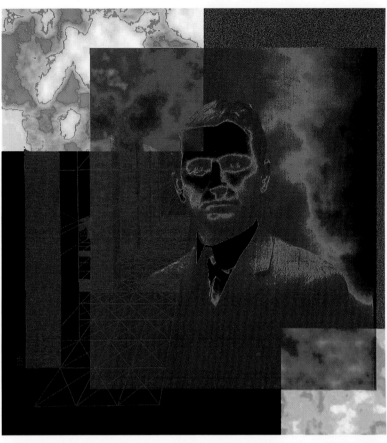

THE DOPPELGANGER

DESIGNER DIANE FENSTER
DESIGN FIRM DIANE FENSTER COMPUTER ART & DESIGN
SOFTWARE IMAGE STUDIO, COLOR STUDIO
HARDWARE MAC IIx, APPLE 13" RGB MONITOR, SUPERMAC
SPECTRUM 24-COLOR CARD, APPLE SCANNER WITH ABATON
GRAYSCALE UPGRADE, WREN 337-MB HD, RODIME 140-MB HD

ACUPUNCTURE ANESTHESIA (WITH ONE NEEDLE)

DESIGNER PAUL DEAN
DESIGN FIRM PAUL DEAN GRAPHIC DESIGN
SOFTWARE DIGIVIEW 4.0, DELUXEPAINT 4.0
HARDWARE AMIGA 2000

 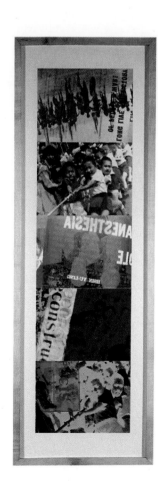 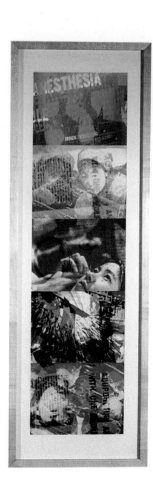

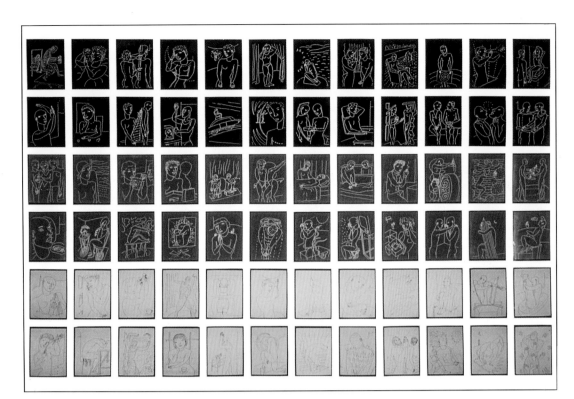

GERMAN LIVES

DESIGNER **BARBARA NESSIM**
DESIGN FIRM **NESSIM & ASSOCIATES**
SOFTWARE **DELUXE PAINT PROGRAM/LIQUID LIGHT**
HARDWARE **COMMODORE AMIGA 1000, POLAROID PALLETTE**

FLOWERS IN THE WIND

DESIGNER **BARBARA NESSIM**
DESIGN FIRM **NESSIM & ASSOCIATES**
SOFTWARE **BASIC PAINT PROGRAMS**
HARDWARE **NEC PC 100**

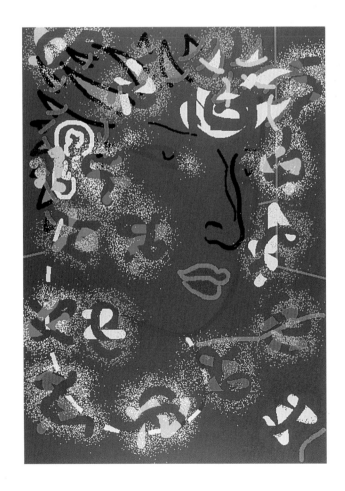

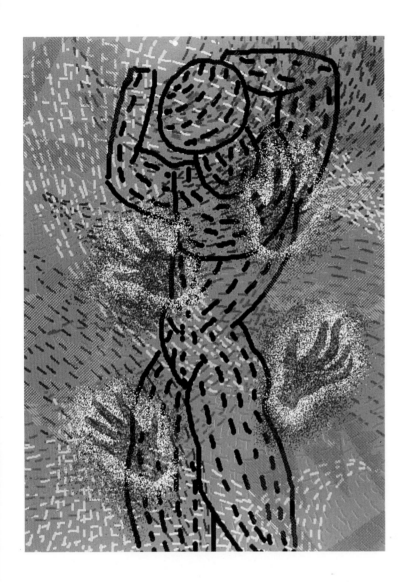

HAND MEMORY

DESIGNER **BARBARA NESSIM**
DESIGN FIRM **NESSIM & ASSOCIATES**
SOFTWARE **BASIC PAINT PROGRAMS**
HARDWARE **NEC PC 100**

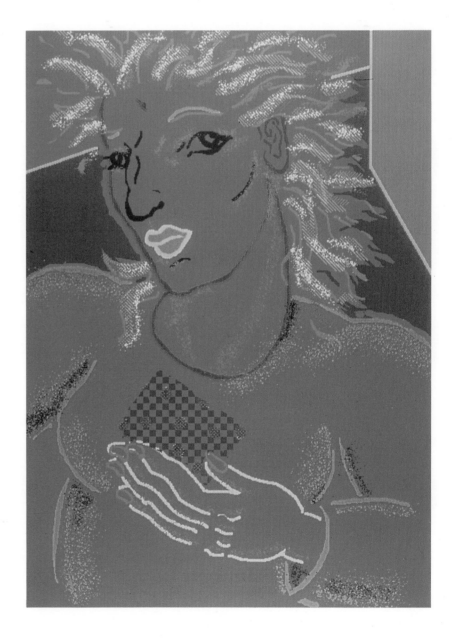

THE GIFT

DESIGNER **BARBARA NESSIM**
DESIGN FIRM **NESSIM & ASSOCIATES**
SOFTWARE **BASIC PAINT PROGRAMS**
HARDWARE **NEC PC 100**

FINE ART

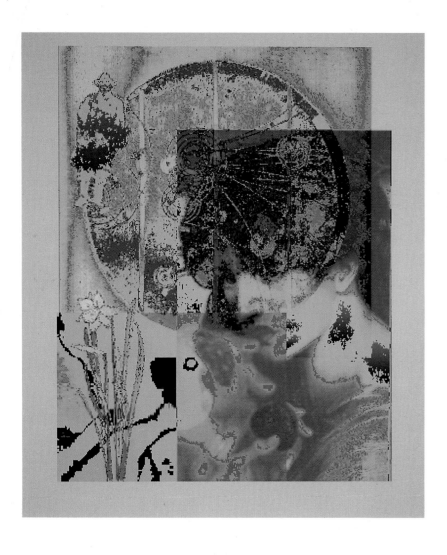

PERSEPHONE

DESIGNER DIANE FENSTER
DESIGN FIRM DIANE FENSTER COMPUTER ART & DESIGN
SOFTWARE IMAGE STUDIO, PIXELPAINT PROFESSIONAL
HARDWARE MAC IIX, APPLE 13" RGB MONITOR, SUPERMAC
SPECTRUM 24-COLOR CARD, APPLE SCANNER WITH ABATON
GRAYSCALE UPGRADE, RODIME 140-MB HD

ROCKAWAY

DESIGNER DIANE MARGOLIN
SOFTWARE COLOR STUDIO, PHOTOSHOP
HARDWARE MAC IIX, APPLE RGB MONITOR, WACOM TABLET

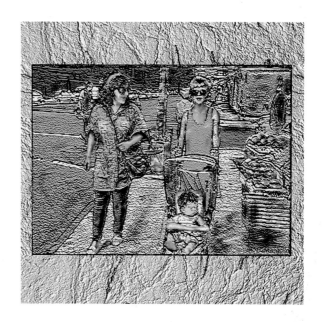

SLOAN

DESIGNER DIANE MARGOLIN
SOFTWARE COLOR STUDIO, PHOTOSHOP
HARDWARE MAC IIX, APPLE RGB MONITOR, WACOM TABLET

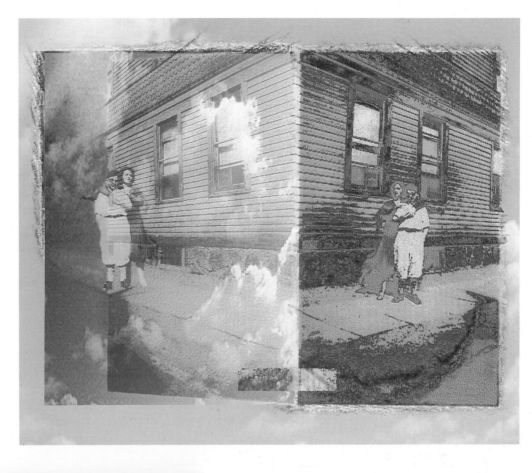

THE BURDEN OF UNIMAGINED TIME

DESIGNER DIANE FENSTER
DESIGN FIRM DIANE FENSTER COMPUTER ART & DESIGN
SOFTWARE IMAGE STUDIO, COLOR STUDIO, PHOTOSHOP, PAINTER
HARDWARE MAC IIX, APPLE 13" RGB MONITOR, SUPERMAC
SPECTRUM 24-COLOR CARD, APPLE SCANNER WITH ABATON
GRAYSCALE UPGRADE, WREN 337-MB HD, RODIME 140- MB HD,
SYQUEST 45-MB REMOVABLE DRIVE, CANON XAPSHOT STILL VIDEO
CAMERA, MASSMICRO QUICKIMAGE 24-FRAME GRABBER

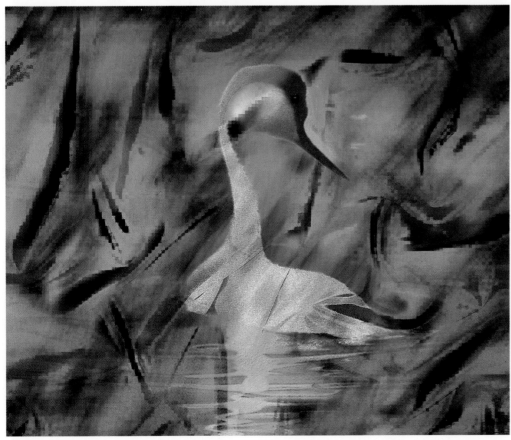

UNTITLED

DESIGNER TITO SAUBIDET
SOFTWARE QUANTEL GRAPHIC PAINTBOX
HARDWARE QUANTEL

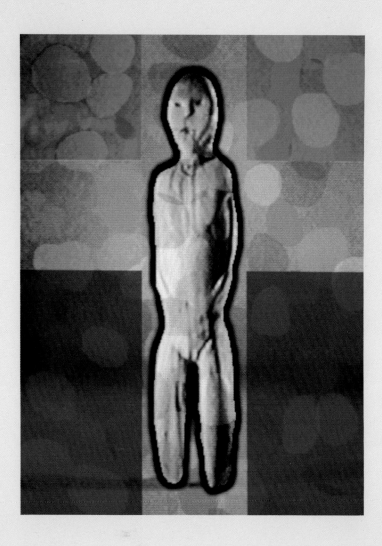

FRIEND WITH BLACK AURA

DESIGNER KATHLEEN CHMELEWSKI
SOFTWARE TIPS
HARDWARE IBM VIDEO GROUP

DESIGNER DIANE MARGOLIN
SOFTWARE COLOR STUDIO, PHOTOSHOP
HARDWARE MAC IIX, APPLE RGB MONITOR, WACOM TABLET

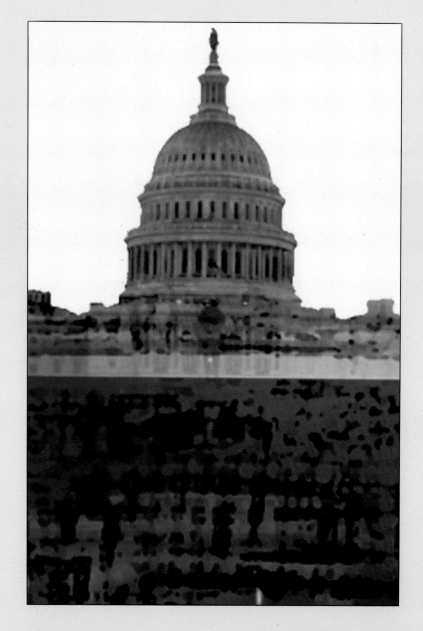

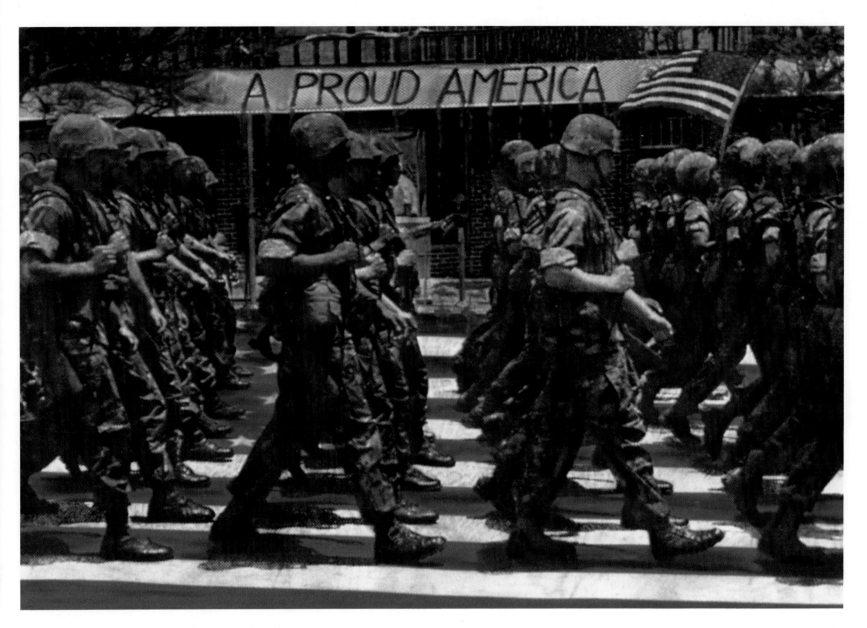

A Proud America

Designer Maureen Nappi
Design Firm Maureen Nappi, Inc.
Software Quantel Version 4.07
Hardware Quantel Graphic Paintbox XL

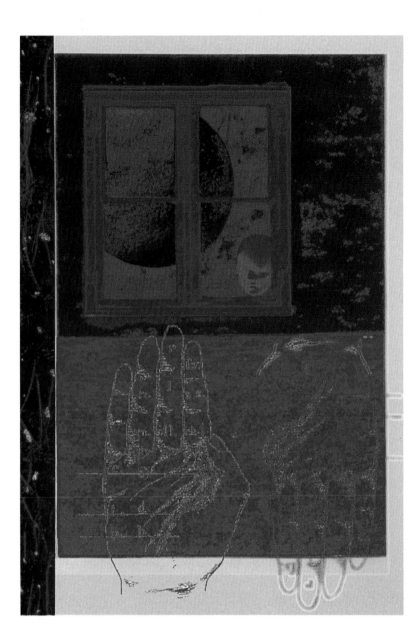

SELF-PORTRAIT REVISITED

DESIGNER DIANE FENSTER
DESIGN FIRM DIANE FENSTER COMPUTER ART & DESIGN
SOFTWARE IMAGE STUDIO, COLOR STUDIO
HARDWARE MAC IIX, APPLE 13" RGB MONITOR, SUPERMAC
SPECTRUM 24 COLOR CARD, APPLE B&W SCANNER WITH ABATON
GRAYSCALE UPGRADE, RODIME 140-MB HARD DISK

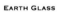

EARTH GLASS

DESIGNER MAUREEN NAPPI
DESIGN FIRM MAUREEN NAPPI, INC.
SOFTWARE QUANTEL VERSION 4.07
HARDWARE QUANTEL GRAPHIC PAINTBOX XL

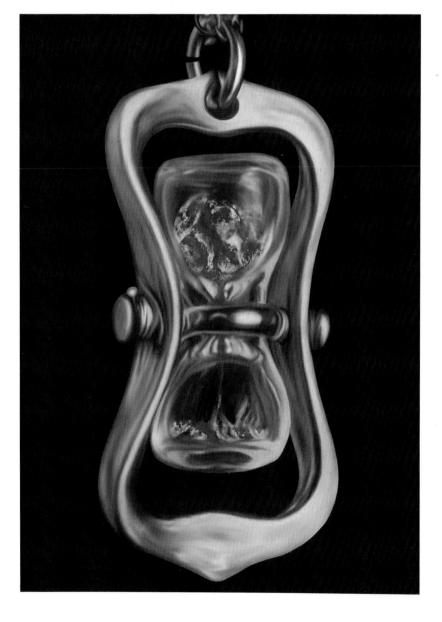

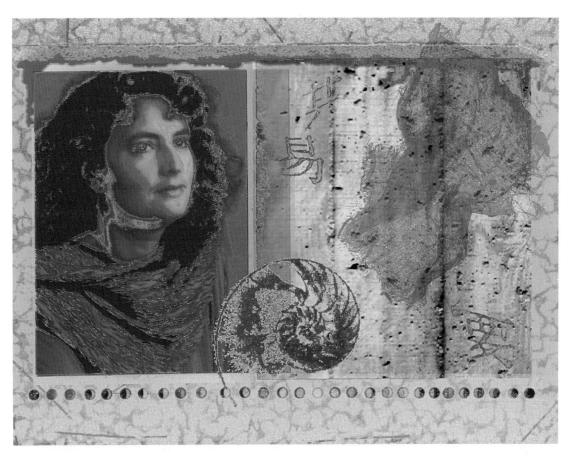

A MONTH OF MOONS

DESIGNER DIANE FENSTER
DESIGN FIRM DIANE FENSTER COMPUTER ART & DESIGN
SOFTWARE IMAGE STUDIO, COLOR STUDIO, PHOTOSHOP
HARDWARE MAC IIX, APPLE 13" RGB MONITOR, SUPERMAC
SPECTRUM 24-COLOR CARD, APPLE SCANNER WITH ABATON
GRAYSCALE UPGRADE, WREN 337-MB HD, RODIME 140- MB HD,
SYQUEST 45-MB REMOVABLE DRIVE, CANON XAPSHOT STILL VIDEO
CAMERA, MASSMICRO QUICKIMAGE 24-FRAME GRABBER

UNTITLED

DESIGNER EROL OTUS
SOFTWARE GIANT PAINT, TIPS, VISTATIPS
HARDWARE IBM AT, TARGA 32, SUMMAGRAPHICS TABLET,
VISTABOARD

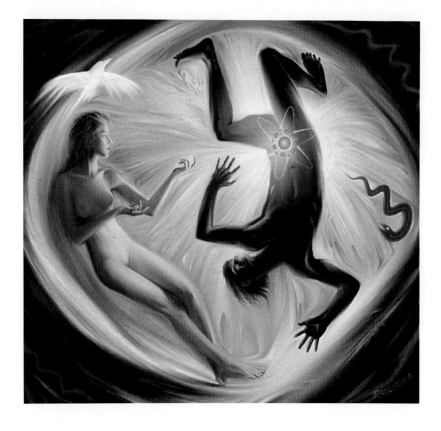

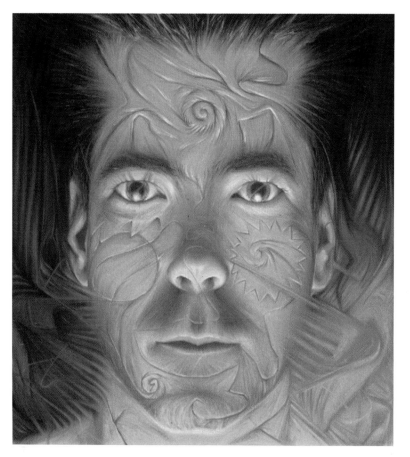

SELF PORTRAIT

DESIGNER EROL OTUS
SOFTWARE GIANT PAINT, TIPS, VISTATIPS
HARDWARE IBM AT, TARGA 32, SUMMAGRAPHICS TABLET,
VISTABOARD

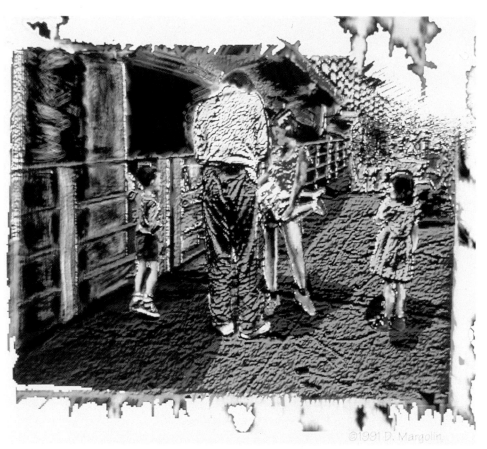

BEACH DRINK

DESIGNER DIANE MARGOLIN
SOFTWARE COLOR STUDIO, PHOTOSHOP
HARDWARE MAC IIX, APPLE RGB MONITOR, WACOM TABLET

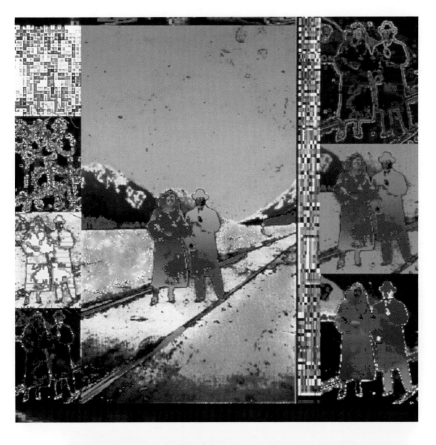

To See Your Face in the Snow

DESIGNER DIANE FENSTER
DESIGN FIRM DIANE FENSTER COMPUTER ART & DESIGN
SOFTWARE IMAGE STUDIO, PIXELPAINT PROFESSIONAL
HARDWARE MAC IIX, APPLE 13" RGB MONITOR, SUPERMAC
SPECTRUM 24-COLOR CARD, APPLE SCANNER WITH ABATON
GRAYSCALE UPGRADE, RODIME 140-MB HD

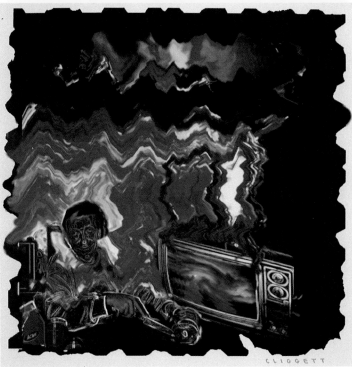

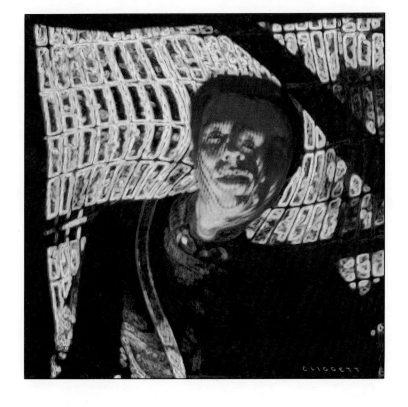

DESIGNER JACK CLIGGETT
DESIGN FIRM CLIGGETT DESIGN GROUP, INC.
SOFTWARE PHOTOSHOP
HARDWARE MAC IIFX (20MB), WACOM TABLET, MICROTEK 300Z

DESIGNER JACK CLIGGETT
DESIGN FIRM CLIGGETT DESIGN GROUP, INC.
SOFTWARE PHOTOSHOP
HARDWARE MAC IIFX (20MB), WACOM TABLET, MICROTEK 300Z

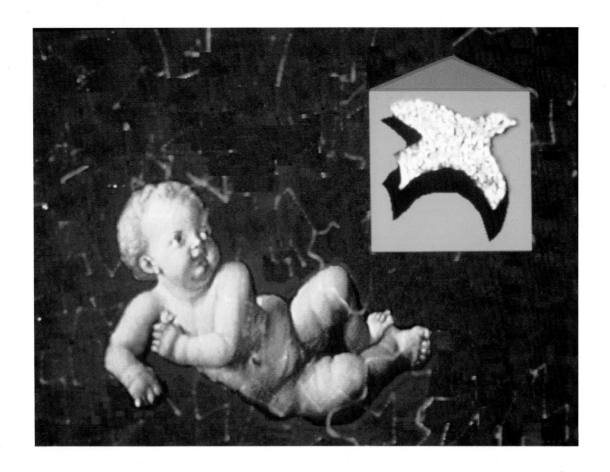

CHILD AFTER DURER

DESIGNER KATHLEEN CHMELEWSKI
SOFTWARE TIPS
HARDWARE IBM, VIDEO GRAB

LIFE FORMS

DESIGNER MAUREEN NAPPI
DESIGN FIRM MAUREEN NAPPI, INC.
SOFTWARE QUANTEL VERSION 4.07
HARDWARE QUANTEL GRAPHIC PAINTBOX XL

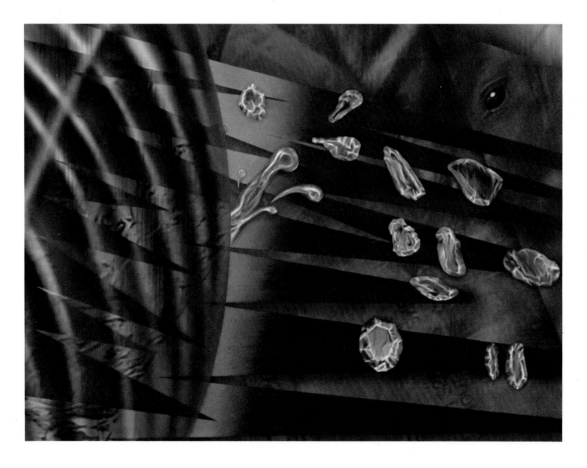

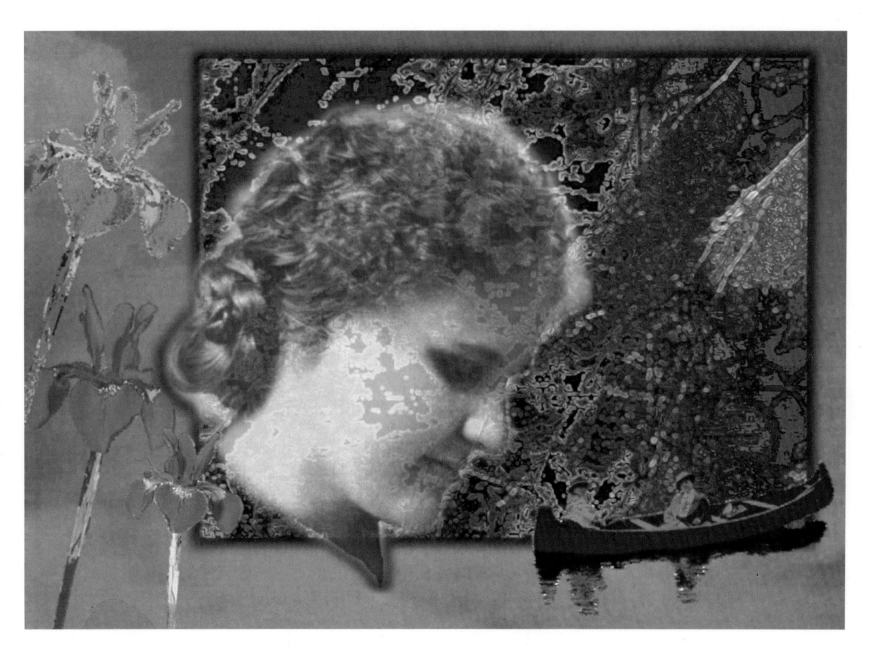

ROADMAP OF THE SOUL

DESIGNER DIANE FENSTER
DESIGN FIRM DIANE FENSTER COMPUTER ART & DESIGN
SOFTWARE PHOTOSHOP, IMAGE STUDIO
HARDWARE MAC IIX, APPLE 13" RGB MONITOR, SUPERMAC
SPECTRUM 24-COLOR CARD, APPLE SCANNER WITH ABATON
GRAYSCALE UPGRADE, WREN 337-MB HD, RODIME 140- MB HD

(E)N.2

DESIGNER **STEWART ZIFF**
DESIGN FIRM **GEOSTAR IMAGING STUDIO**
SOFTWARE **PHOTOSHOP**
HARDWARE **MAC IIFX**

TRANSITION FILTER

DESIGNER **STEWART ZIFF**
DESIGN FIRM **GEOSTAR IMAGING STUDIO**
SOFTWARE **PHOTOSHOP, TURBO C**
HARDWARE **MAC IIFX, PC CLONE**

WINTER WATCH

DESIGNER **CHRISTOPHER PALLOTTA**
SOFTWARE **ALDUS FREEHAND 2.0**
HARDWARE **MAC IIFX**

COLLIDEOSCOPE QUILT

DESIGNER CHRISTOPHER PALLOTTA
SOFTWARE ALDUS FREEHAND 2.0
HARDWARE MAC IIFX

KALEIDOSCOPE QUILT

DESIGNER CHRISTOPHER PALLOTTA
SOFTWARE ALDUS FREEHAND 2.0
HARDWARE MAC IIFX

DESIGNERS

Daniel Boris
1835 K Street NW Suite 500
Washington, DC 20006
USA
202 833-4333

Sara Burris
110 William St.
New York, NY 10038
USA
212 669-9232

Beth Ceisel
5705 N. Lincoln Avenue
Chicago, IL 60659
USA
312 275-3590

Kathleen Chmelewski
230 1/2 S. Anderson
Urbana, IL 61801
USA
217 328-4303

Adam Cohen
96 Greenwich Avenue
New York, NY 10011
USA
212 691-4074

Susumu Endo
3-13-3 Jingumae
Shibuya-ku
Tokyo, Japan 150

Sarah Hamilton
588 Broadway
New York, NY 10012
USA
212 274-0640

Steve Harlan
1835 K Street NW Suite 500
Washington, DC 20006
USA
202 833-4333

Karyl Klopp
5209 8th Avenue
Charlestown, MA 02129
USA
617 242-7463

Erol Otus
509 Bonnie
El Cerrito, CA 94530
USA
510 528-2053

Christopher Pallotta
311 Great Road
Littleton, MA 01460
USA
508 831-0541

Einat Peled
62/28 Cromwell Crescent
Rego Park, NY 11374
USA
718 275-6549

David Posey
1835 K Street NW #500
Washington, DC 20006
USA
202 833-4333

Tito Saubidet
25 West 45th Street
New York, NY 10036
USA
212 764-1212

Jeff Semenchuk
542 South Dearborn
Chicago, IL 60605
USA
312 939-6424

J. Otto Siebold
41 East 22nd Street #4A
New York, NY 10010
USA
212 677-4597

Michael Tiedemann
5 TV Place
Needham, MA 02192
USA
617 449-0400

Rudy VanderLans
48 Shattuck Square #175
Berkeley, CA 94704-1140
USA
510 845-9021

Lisa Wagner
1835 K Street NW #500
Washington, DC 20006
USA
202 833-4333

Victor Weaver
96 Greenwich Avenue #3
New York, NY 10014
USA
212 691-4074

Marc Yankus
570 Hudson Street
New York, NY 10014
USA
212 242-6334

Nida Zada
1022 Rue De La Banque #A
Creve Coeur, MO 63141
USA
314 994-3088

DESIGN FIRMS

A±B (Art More or Less Business)
Ljube Stojanovia 35
11000 Belgrade, Yugoslavia
3811 341595

Amber Productions, Inc.
414 West 4th Avenue
Columbus, OH 43201
USA
614 299-7192

Anspach Grossman Portugal, Inc.
711 Third Avenue
New York, NY 10017
USA
212 692-9000

Apple Computer Creative Services
Spalenburg R
4051 Basel, Switzerland
061 261 67 23

Roger Black, Inc.
1790 Broadway 12th Floor
New York, NY 10019
USA
212 459-7553

Bright & Associates
901 Abbot Kinney Blvd.
Venice, CA 90291
USA
310 450-2488

Margo Chase Design
2255 Bancroft Avenue
Los Angeles, CA 90039
USA
213 668/1055

Victor Cheong & Associates
31 Mosque Street 7D
Hong Kong

Cliggett Design Group
443 W. Woodland Avenue
Springfield, PA 19064-2239
USA
215 623-1606

Coleman, LiPuma, Segal, & Morrill
305 East 46th Street 11th Floor
New York, NY 10017
USA
212 421-9030

Colorpointe Design
21700 Northwestern Hwy. Suite 565
Southfield, MI 48075
USA
313 559-2880

Robert Cook Design
4803 Montrose Blvd. Suite 11
Houston, TX 77006
USA
713 529-9470

Cranbrook Academy of Art
Box 801
Bloomfield Hills, MI 48013
USA
313 642-9570

Creative Resource Center, Inc.
6321 Bury Drive
Eden Prairie, MN 55346
USA
612 937-6000

Culver & Associates
533 N. 86th Street
Omaha, NE 68114
USA
402 393-5435

Paul Dean Graphic Design
729 West Elm Street
Springfield, MO 65806
USA
417 831-9378

Design Center
15119 Minnetonka Blvd.
Minnetonka, MN 55345-1508
USA
612 933-9766

Design II
811 W. John Street
Champaign, IL 61820
USA
217 356-6288

Electronic Arts
1450 Fashion Island Blvd.
San Mateo, CA 94404
USA
415 571-7171

Emigre
48 Shattuck Square #175
Berkeley, CA 94704-1140
USA
510 845-9021

Exographic
23 Lincoln Way
Valparaiso, IN 46383
USA
219 462-5810

Diane Fenster Computer Art & Design
140 Berendos Avenue
Pacifica, CA 94044
USA
415 355-5007

Hans Flink Design, Inc.
11 Martine Avenue
White Plains, NY 10606
USA
914 328-0888

GeoStar Imaging Studio
P.O. Box 865 Peck Slip Station
New York, NY 10272-0603
USA
718 852-8557

The Graphic Expression
330 East 59th Street
New York, NY 10022
USA
212 759-7788

Hafeman Design Group
935 W. Chestnut Suite 203
Chicago, IL 60622
USA
312-829-6829

Handler Group, Inc.
55 West 45th Street
New York, NY 10036
USA
212 391-0951

Hanson Associates, Inc.
133 Grape Street
Philadelphia, PA 19127
USA
215 487-7051

Hornall Anderson Design Works
1008 Western Avenue Floor 6
Seattle, WA 98104
USA
206 467-5800

JANET + JUDY DESIGN ASSOCIATES
90 WAYWOOD ROAD
WEST NORWALK, CT 06850
USA
203 853-1740

PEAT JARIYA DESIGN
646 CHERRYBARK
HOUSTON, TX 77079
USA
713 932-6086

KOLLBERG/JOHNSON ASSOC., INC.
7 WEST 18TH STREET
NEW YORK, NY 10011
USA
212 366-4320

KUBOTA & BENDER
184 LAUREL RIDGE
SOUTH SALEM, NY 10590
USA
914 533-6391

LAPHAM/MILLER ASSOCIATES
34 ESSEX STREET
ANDOVER, MA 01810
USA
508 475-8570

LARSEN DESIGN OFFICE
7101 YORK AVENUE SOUTH
MINNEAPOLIS, MN 55435
USA
612 835-2271

LIQUID PIXEL
1412 W. ALABAMA
HOUSTON, TX 77006
USA
713 523-5757

LISKA & ASSOCIATES
676 N. ST. CLAIR #1550
CHICAGO, IL 60611
USA
312 943-4600

CATT LYON DESIGN
305 W. MCMILLAN ST.
CINCINNATI, OH 45219
USA
513 241-2448

M & CO.
50 WEST 17TH STREET
NEW YORK, NY 10011
USA
212 243-0082

M.A.D.
329 BRYANT STREET #3E
SAN FRANCISCO, CA 94107
USA
415 495-7968

MCI DESIGN GMBH
CORNELIUSSTRASSE 8
6000 FRANKFURT AM MAIN 1
GERMANY

DIANE MARGOLIN ILLUSTRATION
41 PERRY STREET
NEW YORK, NY 10014
USA
212 691-9537

MICHAEL MEYEROWITZ & CO.
175 FIFTH AVE. ROOM 609
NEW YORK, NY 10010
USA
212 353-1561

MORLA DESIGN
463 BRYANT STREET
SAN FRANCISCO, CA 94107
USA
415 543-6548

MAUREEN NAPPI DESIGN
229 WEST 78TH STREET #84
NEW YORK, NY 10024
USA
212 877-3168

NESSIM AND ASSOCIATES
63 GREENE STREET
NEW YORK, NY 10012
USA
212 677-8888

NEUMEIER DESIGN TEAM
7 ALMENDRAL AVENUE
ATHERTON, CA 94025
USA
415 856-8488

NOTOVITZ DESIGN, INC.
47 EAST 19TH STREET
NEW YORK, NY 10003
USA
212 677-9700

O&J DESIGN, INC.
9 WEST 29TH STREET
NEW YORK, NY 10001
USA
212 779-9654

PENTAGRAM DESIGN
212 FIFTH AVENUE 17TH FLOOR
NEW YORK, NY 10010
USA
212 683-7000

PERICH + PARTNERS, LTD.
552 S. MAIN STREET
ANN ARBOR, MI 48104
USA
313 769-2215

PHOTONICS GRAPHICS, INC.
815 MAIN STREET
CINCINNATI, OH 45202
USA
513 421-3345

PITTARD/SULLIVAN DESIGN
6360 DE LONGPRE AVENUE
HOLLYWOOD, CA 90028
USA
213 462-1190

POLLMAN MARKETING ARTS, INC.
2060 BROADWAY #210
BOULDER, CO 80302
USA
303 440-4827

PRESSLEY JACOBS DESIGN, INC.
211 WEST WACKER DRIVE #530
CHICAGO, IL 60606
USA
312 263-7485

QUALLY & COMPANY, INC.
30 EAST HURON #2502
CHICAGO, IL 60611
USA
312 944-0237

JOSEPH RATTAN DESIGN
4445 TRAVIS STREET SUITE 104
DALLAS, TX 75205
USA
214 520-3180

RBMM/THE RICHARDS GROUP
7007 TWIN HILLS SUITE 200
DALLAS, TX 75231
USA
214 987-4800

MICHAEL RENNER DESIGN
WEIHERWEG 3
4123 ALLSCHWIL
BASEL, SWITZERLAND
01 4161301 2502

RIORDON DESIGN GROUP, INC.
1001 QUEEN STREET WEST
MISSISSAUGA, ONTARIO L5H 4E1
CANADA
416 271-0399

SAMENWERKENDE ONTWERPERS
HERENGRACHT 160
1016 BN AMSTERDAM
THE NETHERLANDS

CLIFFORD SELBERT DESIGN
2067 MASS. AVENUE 3RD FLOOR
CAMBRIDGE, MA 02140
USA
617 497-6605

STEP-BY-STEP PUBLISHING
6000 N. FOREST PARK DRIVE
PEORIA, IL 61614-3592
USA
309 688-2300

JAMES STRANGE DESIGN
533 N. 86TH STREET
OMAHA, NE 68114
USA
402 393-5435

TOWERS PERRIN
200 WEST MADISON STREET SUITE 3300
CHICAGO, IL 60606
USA
312 609-9842

URBAN TAYLOR & ASSOCIATES
12250 SW 131 AVENUE
MIAMI, FL 33186
USA
305 238-3223

VAUGHN/WEDEEN CREATIVE
407 RIO GRANDE NW
ALBUQUERQUE, NM 87104
USA
505 243-4000

VIEWPOINT COMPUTER ANIMATION
13 HIGHLAND CIRCLE
NEEDHAM, MA 02194
USA
617 449-5858

WBMG, INC.
207 EAST 32ND STREET
NEW YORK, NY 10016
USA
212 689-7122

WCVB TV DESIGN
5 TV PLACE
NEEDHAM, MA 02192
USA
617 449-0400

WYD DESIGN
61 WILTON ROAD
WESTPORT, CT 06880
USA
203 227-2627

THE WALCOTT-AYERS GROUP
1230 PRESERVATION PK. WAY
OAKLAND, CA 94612
USA
415 444-5204

WHITNEY•EDWARDS DESIGN
P.O. BOX 2425
3 N. HARRISON
EASTON, MD 21601
USA
410 822-8335

WIGGIN DESIGN, INC.
23 OLD KINGS HWY.
DARIEN, CT 06820
USA
203 655-1920

WOLFRAM RESEARCH, INC.
100 TRADE CENTER DRIVE
CHAMPAIGN, IL 61820
USA
217 398-0700

ZENDER + ASSOCIATES, INC.
2311 PARK AVENUE
CINCINNATI, OH 45206
USA
513 961-1790

INDEX